Praise for *I Miss th*

Nancy's experiences described herein ____ ____ rewarded. Her courage and determinat ____ ____ into another life from her previous one, ____ ____naps for her, had become too familiar and comfortable.

I would think that many of us could learn or strive to live life to the fullest by following Nancy's example. Imagine venturing into new realms—especially at a later time in life when we possess meaningful knowledge for analyzing, but also for applying a critical philosophical perspective on new experiences.

I do believe this idea may have been in large measure what Mark Twain had in mind when he stated, "Travel is fatal to prejudice, bigotry and narrow-mindedness and many of our people need it sorely on these accounts. Broad, wholesome, charitable views of men and things cannot be acquired by vegetating in one little corner of the earth all one's lifetime."

I wholeheartedly recommend reading Nancy's book, at the very least for a great travel experience.

Gary Vizzo, former management & operations director,
Peace Corps Community Development: African and Asia

I Miss the Rain in Africa is an absorbing record of a woman's literacy work in Northern Uganda. It is also a record of the exploration of self by a woman who, at age 64, enters a remote area of Africa to work with an NGO. Ugandans were emerging from Joseph Kony's cruel and bizarre rebel insurgency, which had left the Acholi populace brutalized and mired in poverty. Assigned to an outpost in the north of Uganda, "where all bus trips begin with a prayer" and "bathroom breaks can be hazardous to health," Nancy Wesson begins to live and work with survivors and strivers.

Part adventure, part interior monologue, *I Miss the Rain in Africa: Peace Corps as a Third Act* is an account of 21st century derring-do by an intrepid, intriguing and always optimistic woman who will, undoubtedly, enjoy a fourth and maybe even a fifth act wherever she may find herself.

Eileen Purcell, outreach literacy coordinator,
. Clatsop Community College, Astoria, Oregon

This lovely book by Nancy Wesson is a primer in how to be a human being. At 64 years of age, she went to Uganda as a Peace Corps volunteer. Her post was in an area recently ravaged by war, impoverished, full of horror. It was also full of decency, humor, incredible acts of generosity and kindness.

Nancy's lively writing will take you there and teach you many things. You will become a better person for enjoying her account of two remarkable years. But, above all, her book is fun. She gave me a laugh in the midst of the most unlikely adventure; e.g. breaking a finger or being surrounded by gun-wielding soldiers.

Then there is the last part of the book, after her return: a very touching psychological journey to healing. This part is a primer in self-therapy. More entertaining than most novels, this personal account is a must-read.

Bob Rich, Ph.D., psychologist and author of *Sleeper Awake*

I Miss the Rain in Africa is a true and adventurous story of a wise woman of 64, who goes to Uganda as a Peace Corp Volunteer. Her account of this escapade is a rich, page- turning tapestry of events, emotions, cultural surprises and inner reflections that continue to be woven, even after returning to her home country.

Wesson's style of writing takes me right where she is—as if I am with her—living these unfamiliar situations. Wesson has become my eyes, ears and nose, as she weaves through these challenging environments during her Peace Corp service. This account had me laughing, cringing, delighted, frightened and more. Through her, I have met interesting people, been through dangerous situations and experienced both the frustration and the sweetness of understanding and kindness.

In addition to being an entertainingly written story, Wesson opens up an opportunity to reflect on our own lives and the meaning we give it based on the challenges in our own upbringing— an invitation in coming to terms with what we have become and, perhaps, how we continue to evolve.

Michelle DeStefano, L.Ac. CCH
acupuncture, hypnotherapist

I Miss the Rain in Africa is a great read. Nancy Wesson skillfully takes you on a surprising journey—not only into the heart of Africa through her Peace Corps experience, but also into her own spirit and mindset. Stepping into the strange and compelling world of Uganda, Nancy displays a unique courage that is only surpassed by her willingness to share her very personal experiences. You will feel connected to both her Peace Corps service and also to the universality of the human experience in all ways: emotional, intellectual and spiritual.

The book was meant to be a memoir about her Peace Corps service in Uganda, 2011-2013. In her writing Nancy quickly learned that her story was taking a surprising turn. What began as a journey into the heart of Africa evolved into a tale of reconciliation, self-awareness and healing. Nancy's story is universal. *I Miss the Rain in Africa* is written in such a way as to take you on your own journey. Nancy holds out her hand so that you can stand by her side in order to embrace her lessons learned and make them your own. You will be changed. You will have a deeper self-awareness, and you, too, will discover peace in past relationships and experiences. *I Miss the Rain in Africa* is that kind of book.

Holly Copeland, former family therapist,
Family Copeland Foundation, (Save a Life / Train a Midwife)

Service to others is the highest of callings. From my perspective, Nancy was already answering that call before she left for Africa. Her soul must have been calling her to step it up a notch, but maybe there was more to the calling.

In this insightful and touching account, Nancy shares her daily interactions with the rich culture, people and land of Africa during her Peace Corps tour, knowing intuitively that she would be changed at the end of her adventure, but not until its conclusion would she learn exactly how or how much.

By reducing her world to very basic needs—food, water, shelter—while in service to others who had similar needs, first-world comforts and distractions would, over time, no longer obscure her own inner landscape. Finding that balance between crises and opportunities would open up expansion, not only for those around her, but also for her inner world. Changing her entire life to accommodate service to the Corps would, in the end, reveal old wounds and bring new light and spiritual understanding to long-told stories of her "self."

Candace Craw-Goldman, founder BQH, Quantumhealers.com

Who knew, least of all the author, that a decision to step out of "regular life" and serve in Peace Corps would become far more: a journey that reveals new insights and an unexpected springboard for rescripting the author's history in a way that would change everything. At first blush, the book is a collection of blog entries that invites the reader to tag along with the author on adventures while on a two-year assignment in Uganda. Like Anne Lamott in the *Operating Instructions*, an honest and comic tale about the love-hate experience of new motherhood with a first born, or Peter Mayle's *A Year in Provence*, where Mayle paints a personal description of Provencal life, Wesson offers a montage of stories and experiences that introduces the reader to the colorful people and challenging life in Uganda. Wesson's observations are shared with humor, respect, and compassion. For anyone who has ever wondered what serving in Peace Corps or immersing oneself in a radically different life overseas might be like, this book provides a portal.

Even better, the author opens new possibilities for any reader who has flirted with the idea of "cliff-jumping" into a something new to find something more. Wesson's daring venture at age sixty-four—to chuck it all: career, home, and a comfortable life in The States—paid off. Wesson's journey shifts from blog entries to a re-examination of experiences from early infancy. With excitement and a sense of discovery, Wesson re-connects with her long-ago past to chart a new path forward, seeing differently now.

At this point in the book, I found myself examining my own childhood experiences and re-framing mental narratives that no longer serve. Through Wesson, we gain not only a deeper understanding about Uganda and life as an overseas development worker, but may also find the inspiration to dig deeper, see differently, and find a new path forward.

<div align="right">

Kathleen Willis, RPCV-Community Organizer,
former organizational development consultant

</div>

Inspiring and educational when it comes to what we can accomplish when we put our best foot forward, *I Miss the Rain in Africa* shows how Nancy Daniel Wesson and others are putting the needs of others ahead of themselves—and what we can all do when it comes to stepping out on faith and choosing to act.

Cyrus Webb, media personality, author, *Conversations Magazine*

I Miss the RAIN in AFRICA

PEACE CORPS AS A THIRD ACT

A TALE OF TRANSFORMATION

NANCY DANIEL WESSON

Modern History Press

Ann Arbor, MI

I Miss the Rain in Africa: Peace Corps as a Third Act
Copyright © 2021 by Nancy Daniel Wesson. All Rights Reserved.

ISBN 978-1-61599-574-5 paperback
ISBN 978-1-61599-575-2 hardcover
ISBN 978-1-61599-576-9 eBook

Library of Congress Cataloging-in-Publication Data

Names: Wesson, Nancy Daniel, 1947- author.
Title: I miss the rain in Africa : Peace Corps as a third act / Nancy
 Daniel Wesson.
Description: Ann Arbor, MI : Modern History Press, 2021. | Includes index.
 | Summary: "Wesson details her Peace Corps tour of duty as a senior in a
 remote corner of Uganda starting in 2011. This retrospective,
 supplemented by blog posts she made in country, is a comprehensive diary
 of her personal experiences working with a literacy NGO and how it
 shaped her life after returning to the USA"-- Provided by publisher.
Identifiers: LCCN 2021014909 (print) | LCCN 2021014910 (ebook) | ISBN
 9781615995745 (paperback) | ISBN 9781615995752 (hardcover) | ISBN
 9781615995769 (pdf) | ISBN 9781615995769 (epub)
Subjects: LCSH: Wesson, Nancy Daniel, 1947- | Peace Corps (U.S.)--Uganda. |
 Volunteer workers in social service--Uganda--Biography. |
 Americans--Uganda--Biography. | Uganda--History--1979-
Classification: LCC DT433.287 .W47 2021 (print) | LCC DT433.287 (ebook)
 |
 DDC 966.61044092--dc23
LC record available at https://lccn.loc.gov/2021014909
LC ebook record available at https://lccn.loc.gov/2021014910

Published by
Modern History Press www.ModernHistoryPress.com
5145 Pontiac Trail info@ModernHistoryPress.com
Ann Arbor, MI 48105

Tollfree 888-761-6268
Fax 734-417-4266

Distributed by: Ingram (USA/CAN/AU), Bertram's Books (UK/EU)

Contents

iii

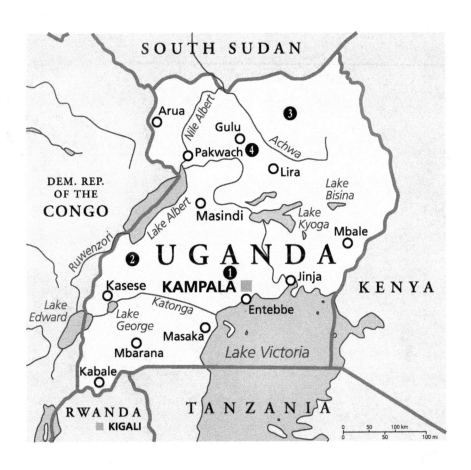

Uganda Map Key

1. Wakiso
2. Fort Portal
3. Kolongo
4. Palenga

See also: *A Brief History of Northern Uganda* starting on p. 258

Foreword

I Miss the Rain in Africa: Peace Corps as a Third Act, is an absorbing record of a woman's literacy work in Northern Uganda. It is also a record of the exploration of self, explored by a woman who enters a remote area of Africa at age 64 to work with a Non-Governmental Organization (NGO). Ugandans were emerging from Joseph Kony's cruel and bizarre rebel insurgency which had left the Acholi populace brutalized and mired in poverty. Assigned to an outpost in the north of Uganda, "where all bus trips begin with a prayer" and "bathroom breaks can be hazardous to health," Nancy Wesson begins to live and work with survivors and strivers.

Western privilege and pride in institutional roadmaps to progress have no place here. Daily life for Ugandans is a struggle unimaginable even to the poorest Americans. Life is indeed precarious in Gulu, yet education is highly valued, and solutions hammered out of almost nothing. Season and weather guide life here and everything is "about the relationship, not the clock." Westerners used to direct and quick solutions must adjust quickly to decisions made through consensus.

But serendipity lives in Africa, too. Nancy gets to know her landlady's son which leads to literacy materials made of jigsaw puzzles. The residents of Gulu leave a deep imprint on the author; in particular, Peter, whose education she sponsors. On trips to the bush, exhausting and hazardous, Nancy works with teachers to carve out learning spaces. Her work in Uganda would leave her a bit battered and re-entry to the States—shell shocked at the contrasts. "Recalibration" is sought and achieved through another exploratory journey into the maturing self, requiring a reckoning with remembrance, recognition and reconciliation.

With self-deprecating humor, curiosity in all things, and empathy for all, Nancy takes us through an account of acclimation, acceptance, and peace with all the different geographies she encounters—physical, communal, spiritual. "I had devised a portable life with total autonomy and it was daunting. Having infinite possibilities was both the good news and the bad news." Living in Uganda

brought home the knowledge that having choices is the ultimate luxury, to be made "wisely and often."

Part adventure, part interior monologue, *I Miss the Rain in Africa: Peace Corps as a Third Act* is an account of 21st century derring-do by an intrepid, intriguing, and always optimistic woman who will undoubtedly enjoy a fourth and maybe even a fifth act wherever she may find herself.

Eileen Purcell, Outreach Literacy Coordinator
Clatsop Community College, Astoria, Oregon

How It Started

Curiously, this is not precisely the book I thought I would be writing when I started. It began as the tale of the grand adventure of a sixty-four-year-old white woman (that would be me) in Peace Corps, Uganda, and the reinvention of self that followed. And it certainly is that...

But as I wrote, the story became so much bigger, as one shift in self introduced another—and then another—and another. Leaving it all behind for Peace Corps set in motion a personal transformation that evolved even as I wrote; in fact, the writing itself became a catalyst for transcending life events I thought were hard-wired in my psyche. No one was more shocked than I.

It started when I walked away from a largely successful career and lifestyle that were no longer serving me and stepped into the void—off a virtual cliff, some would say. I was operating on instincts that had never failed me, and trusting that the tools I had at my disposal would serve as a parachute.

Friends called it brave, others called it misguided, but it felt like neither of those. It was simply the next step in what has been an interesting life.

It's been six years since I returned from Uganda, and it's taken every bit of that time to understand the multiple layers of insights, gifts and life changes set in motion by that quest. Though the revelations are still unfolding and reshaping a new life, I am often asked what I got from that experience. While I am hard pressed to condense it, I would say *I left needing to break free of the gravitational pull that was keeping me in a constrained orbit, and returned with a new appreciation of who I am, how I can contribute, and the total freedom to reconfigure the life that is still unfolding.*

Although I didn't anticipate it at the time, Peace Corps stripped the veneer I'd accumulated over the years to accommodate jobs, husbands and kids—allowing innate abilities to blossom, masked fears to be reconciled, and profound wounds to be healed, representing nothing short of a total paradigm shift.

I have unearthed a heartfelt appreciation of my past. I had discounted its influence, but it is what helped me to both endure Peace Corps' hardships, and to mine the experiences for the gems it had to offer.

In the tale that follows, rain is a character in its own right, because of the way it inserted itself into every single aspect of life, emotion, and intellect, and the defining role it played in my unfolding. I still miss the rains in Africa.

Every Peace Corps story is unique and what one chooses to make of it, and while it may have a discreet starting point, the experience never really ends. My personal experiences elicited a depth of compassion, forgiveness, and an ability to be *present* that had previously eluded me, but have become constant companions in returning home.

In an effort to keep true to the progression of attitudes and emotions, much of what follows is taken either verbatim from or is an extrapolation of my private journal entries or the public blog, (ATexanGoesQuesting.blogspot.com*)* and are so noted. Other musings are purely mine and reflect the deeper lessons and emotions as I grew through the process.

Re-reading some of the entries is painful in the review of my judgments/feelings at the time. I ask forgiveness for those. I've purposely not edited these out, not because I think they are justified, but because they are honest representations of the often ugly difficulty of adjusting to new circumstances, coming from a life of relative privilege we enjoy as Americans. This very discomfort was part of my coming to terms with my own attitudes, blind-spots, and embedded attitudes that needed revealing before they could be acknowledged and examined. I pray you will not judge me too harshly.

I hope you enjoy the adventure.

Part One -
Muzungu: Foreigner

1 Welcome to Hell

We're pouring off the bus at midnight—black-as-the-inside-of-a-cat, into the first of many rains, ankle deep mud and a buzzing fog of mosquitoes invading every orifice of forty-six disgruntled, sleep deprived, starving trainees. We grope for anything familiar—luggage perhaps—but there is only chaos. "Oh God, what have I done! Please don't let this be real." But it is.

In the dark, I identify my luggage and separate it from ninety-some-odd other overloaded bags vomited forth from two buses into the slop under a huge tree. Rollers on my carefully chosen bags are useless in this mud and uneven ground strewn with random stepping stones, disjointed walkways, puddles, rocks and grumbling human-ity. That tree later proved to be a mango tree. Little did I know that I'd be spending much of the next two-plus years under them.

Weary voices float through the miasma of mosquitoes getting their quart of blood: "Where do we go?" "I need to pee!" "I'm hungry!" Is anyone listening out there?

Someone grabs my bag out of the mud. "My name is Gary. Can I help you with those?"

"Oh God yes! Please!"

He's smiling and looks calm—obviously not one of us. I plough through the obstacle course of human misery and the mosquito-gauze against my face and finally arrive at the door to a huge room dismally lit by one bare light bulb dangling from a cord. I'm aghast at what I see: wall-to-wall bunk beds and luggage piled so deep no one else can get in without mountaineering equipment. "One bath-room for all these women!" says a panicked voice I can't pair with a name; we've only recently met our other volunteers. Still, I can tell it's one of us by the tone-ragged desperation.

My mind is reeling with a mini life-review. *This can't be happening! I left a perfectly nice life for THIS!* I am definitely not in Texas anymore, and where are Dorothy's red shoes when I need them? *God, I wish I could click my heels and be out of here.* Gary motions us toward another cabin and we slog over to a small, round

hut with only four bunk beds. I land on the one closest to the bathroom and collapse.

Really? Is this what I was so excited about? Oh shit, is this what we had to change into our "professional" clothes for before even landing? After 18 hours of flight? Before departing, we were told there would be a dinner in honor of our arrival, so we abandon our luggage and thread our way to the main hall filled with long tables—two in the front loaded with *WHAT!* Stale bread, peanut butter and jelly, with tea to drink turns out to be "dinner." Oh, this just gets better and better.

The evening comes to an end at around 1:00 AM after a truly forgettable welcome speech. After another hour of finding tooth-brush and pajamas, jockeying with seven other women for bath-room privileges and repacking luggage to stash it under the bed, I collapse into bed, tuck in the mosquito net and consider the truly ignominious end to an already exhausting day. I congratulate myself for packing earplugs as the room fills with the sonorous buzz of snoring. I ponder the fact that a cold water trickle-shower and discomfort are foreshadowing things to come. I'm angry, exhausted, and forlorn, but no time for that; hurry up and sleep. Training starts at 8:00 AM and breakfast is *offered* at 7. Be prompt.

In the words of Dorothy Parker, "What fresh hell is this?"

WELCOME TO PEACE CORPS UGANDA!

Journal: Three Days Ago in Austin

Bleary eyed, nervous and with a lump in my throat, I left Austin after staying up most of the night to be sure neither my business website, *Focus On Space,* nor my book site, *Moving Your Aging Parents*, would expire in my absence. Updating contact information so my friend could handle things for a couple of years was the closest I could come to hanging on to any vestiges of what was fast becoming my former life. It was too late for soul-searching.

On our way to the airport, we had to stop and have a Power of Attorney (POA) notarized before I could leave on a morning flight getting me to Philadelphia for a fast and furious introduction to Peace Corps. This final chaos after months of preparation would characterize much of the next ten weeks. The first hurdle was luggage: two 40-pound bags packed to the bursting-point with the paraphernalia for living in the land-that-time-forgot for twenty-seven months. Packed and repacked, I prayed for the first time in my

diet-conscious life that my Weight-Watchers scales were right and that I wouldn't have to jettison anything.

That hurdle passed, I sat and waited—guarding my carry-on filled with life-line items: pictures of my sons, a computer I didn't know if I would ever be able to use, camera, solar chargers, infrared water purifier, and six months of any prescription meds I would require until PC supplies clicked in—in short, the things I knew I wouldn't be able to find in Uganda. Taking deep breaths as I boarded the plane, the reality of what I was about to do began to sink in.

I. AM. LEAVING. EVERYTHING. BEHIND.

In Philly, I checked in, found the impromptu lounge and watched as the other forty-four new recruits straggled in, in different states of fear, excitement and fatigue. Most were young. I wondered, *at 64 will I be the oldest?* In an assembly line, we signed documents, got our ID packets and walk-around money and were introduced to our first taste of Peace Corps. It was not the welcoming introduction I was hoping for and it took a long time for it to improve.

Already feeling a little undone by the prospect of being out of contact with my previously known life, family and friends for the next two-plus years, what I knew about Uganda didn't put me at ease. The infamous ruler, Idi Amin, the most notorious in a list of Uganda's barbaric dictators and immortalized in *The Last King of Scotland*, was the underpinning of my sense of the country. Somehow, Winston Churchill's calling Uganda, *The Pearl of Africa*, provided little solace.

In that frame of mind, I took it as a positive sign when I discovered I'd be sharing a room with the adorable Susie, a perky, twenty-something volunteer from Portland. In my need to find some good omens, I latched onto this one because one of my sons was living near Portland. The next morning started with paperwork, introductions and what would be the first of too many icebreaker games, prodding us into the Peace Corps frame of mind.

Having done years of training in other domains, I groaned. Feeling like I'd landed in a parallel universe between grade school and junior high, I hoped this would get better. It didn't. It was just a precursor to training in Uganda and a parade of activities I'd left behind decades ago. I'd need some personal attitude adjustment,

because I'd leased my house, closed my business, and had a fine going-away party.

The phrase, "Doesn't play well with others," came to mind. Crap! Have I become that person?

Simply put, it was time to let go of control and embrace the adventure.

Journal: August 2, Philadelphia

Training in earnest began. I was nearly giddy when I spotted a few gray hairs and wrinkles in the mix and realized roughly a third of our group was age fifty-plus, although the average age of a Peace Corps volunteer hovers around twenty-eight. We were six single women, a couple of single men and the rest, couples. Representing an incredible mix of talent and credentials, we were authors, CEOs, CPAs, professors, activists, speakers, counselors, nurses and entrepreneurs. As children-of-the-sixties, we were vocal, irrepressible, autonomous rule-breakers by nature. The relief was palpable as we identified each other, but bonding wouldn't take place until much later and would ultimately play a role in revamping Peace Corps training.

For all of us, the decision to step out of our regular lives, careers, businesses and families became more real when we were issued our Peace Corps Passports and Uganda Visas.

That night was spent making a last minute telephone call to Brett, my son still in-country—wishing I could also reach his brother, Travis, in Germany—and sending out a group message, my last email from the US. Not knowing when—or IF I would have access to a charged computer, much less Internet, for the next two years, I was already homesick—a malady I hoped wouldn't flatten me in Uganda. Although an early Close-of-Service (COS) is always an option, it wasn't one I would ever consider. I'd already sent out my final *So-Long-Farewell-Auf-Wiedersehen-Good-Bye* newsletter to the hundreds of clients and friends gathered over a lifetime and 15 years of consulting in Texas, Washington, D.C. and New Zealand.

I was kissing my identity goodbye, kind of like witness-protection, but without the crime.

Journal: August 3, Philadelphia

Afloat in a sea of emotions, each of us schlepping one carry-on filled with coveted electronics, meds, and enough entertainment to get us

through 18 hours of flight, our herd was corralled onto buses that would ferry us to JFK Airport where we would get to flash our new passports. Propelled forward on a flood of adrenaline, we individually and collectively wondered if we would get through luggage check unscathed. We were already dreading the mandate to change into professional clothes in the airplane bathroom, prior to our midnight arrival in Entebbe.

I was mentally hoping I'd not forgotten some essential details about the house I'd left with new tenants and hoping nothing would happen to threaten the owner-finance loan that would come-due in a year. I'm sure I wasn't alone in this last minute emotional turmoil. The collective holding-of-breath was palpable.

Journal: August 4, Arrival in Uganda

Arrival at Entebbe—for those old enough to remember the 1977 *Raid on Entebbe* by Israeli troops in response to a hijacking orchestrated by Idi Amin—brought on a frisson of anticipation. Combined with the knowledge that northern Uganda was just pulling out of a grisly twenty-year war, there was more than a little disquiet about what we would be facing. As it turned out, arrival was anti-climatic, and as we walked down the stairs onto the tarmac into a balmy night, there were only a few military guards in sight. Customs was blessedly routine and we were "most welcome," but where was the welcoming committee we'd heard about?

They were waiting, but I digress...

2 *WHY:* What I knew then

The Back Story

It seemed like a good idea at the time. No, it wasn't nearly so cavalier as that in one regard, but it *was* purely spontaneous in its infancy.

Fast approaching the age when people talk of retiring, traveling, and sipping margaritas, I had no retirement funds; most of my net worth was tied up in my home, and I'd been running a slightly left-of-field consulting business for fifteen years and was facing burnout: physically, spiritually and mentally. My work had been essentially spiritual in nature, but I'd had to *cloak it* to make it commercially viable. Twenty years ago, it was just too out there, and selling it meant selling *me* and my credibility.

I recounted the great adventures that had tested me—the year cruising on a sailboat, Europe alone, Tunisia, Morocco—and realized the gypsy in my soul was feeling neglected and thinking the good times were behind her. She had grown bored by both comfort and stress and needed another adventure—one of which stories are born—another year of living "dangerously," but one that might make a difference in the world.

Following a wine-fueled middle-of-the-night conversation with a friend, who asked, "Why not Peace Corps?"—I laughed, thinking I was too old. A week later, I fired off the first online query and thought: *what's the worst that can happen?*

Friends chimed in, some knowing I'd always questioned the status quo, sought the unknown, and embraced change; others were convinced of my stupidity.

As I deliberated about how to catalyze the change I was seeking, a few things became absolutely clear:

I needed stillness.
I needed to step-out to get it.
I needed to live the work, not sell it.
And so, I jumped.
And never looked back.

Hurry Up and Wait...

And so it began. When I got a nibble back from my query, I discussed my idea with my sister, who had, in the early, free rein days of Peace Corps, volunteered in Tunisia with her new husband. She summed-up Peace Corps in two words:

Life-defining.

At my age, would it still be *life-defining?* Could it *redefine* the second half of life? Knowing their experience and mine would be radically different didn't deter me. I gulped and plowed ahead with exhaustive questionnaires and essays designed to glean every tidbit of experience I'd had in my life. And I'd had a lot of experience.

Following a positive response, I had permission to proceed with the medical phase, equally daunting: EKG, colonoscopy, redoing all of my childhood vaccines. (Peace Corps held a low-opinion of baby-book immunization-records.) Medical records for some things had to be excavated from a vault somewhere.

On my end, there were hard deadlines, only to be followed by an interminable wait for PC's response. They even sent a letter defending the waiting as *good practice* for what awaited us as volunteers.

I was not amused, but my commitment had taken on a life of its own and there was no backing down at that point.

Off Like a Turd of Hurdles

My initial placement was Belize, with a presumed departure a few months out. I began packing and purging household items, trying to sell my house, and letting clients know of my plans in case they needed to schedule appointments. All they heard was: "She's gone." My business shut down at a calamitous speed, the house didn't sell, and Belize didn't materialize. What a mess.

After the tentative Belize placement, I consulted a highly touted Australian psychic, who saw me with very dark skinned people in a hot, desert-like area; I dismissed it. I'd told her of a prediction that I would study with a Shaman during my service, to deepen my innate

skills, to which she replied, "You are the Shaman you will meet; and you're *not* going to Belize."

Sure enough, the Belize placement was withdrawn and months later, I was offered Eastern Europe or Africa. I knew Eastern Europe, with its frigid winters, would spit me out after the first winter, because I can be a miserable, black-hearted shrew with a tendency to hibernate and whine when I'm cold. Besides, Africa seemed like the more quintessential Peace Corps experience I was seeking.

When the Uganda placement finally came through, the departure date was less than a month away, so life became a fire-drill. With the house still on the market and fully furnished, angst was at full throttle, and I had a decision to make.

I'd bought my home from friends who carried the loan and needed their funds. If I couldn't sell and pay off the loan, I couldn't leave. When it came down-to-the-wire, they extended the note for one year, which meant I could leave, but without the cutting of ties I'd wanted. It was a deal.

3 Fixin' to get Ready

With the requirement to sell off my plate, I needed to haul ass. The to-do list was exhaustive, including everything from finding renters, water-purifiers, medical supplies, and clothes for multiple climates, to updating website contacts. Chaos reigned.

A *week* before leaving I had the mother-of-all garage sales.

A few *days* before leaving, I was giving away what didn't sell and moving everything else into an 8 x 10 storage unit.

The *day before* leaving found me installing automatic soaker hoses to protect the old foundation and giant maple trees.

With that done, I thanked the house for three good years, did a blessing for the future residents, locked the door, turned my back, and walked away. Then I drove to the Subaru dealership, sold them the Impreza I'd bought two years ago, and took a deep breath as I climbed into my friend's car to drive into the rest of my life.

No car, no house, no clients, no income, and no friggin' idea of what was coming next, except to climb on a plane to go live in the heart of Africa.

~~~

I had packed my two suitcases a dozen times. My sons helped me with things like a Leatherman multi-tool, solar chargers, first-aid supplies, water purifiers, book lights, etc. Both have had survival and EMT training, do extreme sports, and have learned to pack light, but far beyond their guidance with gear, their encouragement and support meant I could leave knowing they were OK with my decision.

On their recommendations, I revisited my packing choices with the ruthlessness of an assassin and eliminated everything that didn't have *multiple* uses. The list of the 110 items that made the final cut included a French Press, antibiotics, haircutting shears, duct-tape, *Leatherman* tools, and earplugs.

## Blog Post: July 31, Pre-Departure

Whew!

Well—it's here: the night before leaving and a race to the finish. It really has taken a village to get me out the door and I'm filled with gratitude. Closing down the accumulated possessions and detritus of 63 years is daunting, and the requirement to get a house ready to lease created the perfect storm. Still, it is done and what is not—well—I suppose that's part of the journey: time to let go and trust.

Suitcases have been weighed and measured to conform to Peace Corps regulations—it's about to get real!

# 4     Boot Camp: You're in the ~~Army~~ Peace Corps Now

## Week One

Despite the differences implied by their names, the military and Peace Corps have more in common that one might think. For starters, members of both are serving their country, often living overseas in minimalist, if not miserable, conditions. Both put their members in harm's way, even if unwittingly. In some justifications, both are serving the cause of peace and both can make your life a living hell during training. At least the military owns up to it. Also, the military is paid and has benefits. Peace Corps Volunteers get a stipend averaging about $300 US a month, and there are no post-service benefits. We know this going in, so there's no defense there, just a topic for discussion.

I am not going to sugarcoat training; ours was not for the weak-of-spirit or constitution. The blogs I wrote in Peace Corps were "politically correct," since they were public domain and PC let us know they would be read. Required on every blog was the disclaimer: *The views expressed herein are not those of the United States Government or Peace Corps.* And truthfully, I didn't really want to alienate Ugandan readers or our trainers, who, as a rule were fun, smart, committed, passionate and compassionate people with our best interests at heart, and who put up with a lot of crap from trainees who entered with a first-world attitude and no real-life experience. True, there were a couple who had either been there too long or whose behaviors telegraphed hostility, but they were in the minority.

In the military, the first thing done to new recruits is to remove as many as possible of the identifiers that make a person unique, starting with clothing and hair style. Military sends personal clothes home in a box. As a mother, receipt of that box after my oldest son enlisted was terrifying, until I realized he was still alive and well, just depersonalized. Then comes the head-shave, and sleeping in dormitories, and enduring the untold indignities and depersonalization

known as BOOT CAMP. Alien foods devoid of personality are the order of the day, as close quarters and stress often result in epidemics of various maladies.

And so it was with Peace Corps—with the exception of the head shaving and taking away your street clothes, which have already been left behind in favor of culture-friendly clothing that can endure termites, bleach, possibly being washed on rocks, and other forms of abuse. The mandate is to be as unobtrusive as possible for safety as well as respect. Customary personal hygiene and beauty rituals all but ceased.

We all understood this going in and it was appropriate, but the totality of these changes coupled with being away from our families, flush toilets, showers, familiar food, and sanitation, was the perfect setting for emotional and physical fatigue, dysentery and unhealthy coping behaviors. There was very little adjustment time between our First World lives and the realities of living in the Developing World.

For the first week, we lived in a compound called Banana Village—eight to twenty people per dorm with one bathroom and one cold shower per unit; sanitized drinking water; breakfasts of stale bread, boiled eggs, peanut butter and pineapple—nutritious, but not soul-nourishing.

Lunches became local food pretty quickly, transitioning to starch-heavy meals, and lots of beans. A typical meal, nearly devoid of any salt or seasonings, served every day for ten weeks, could explain why women typically gained ten-to-twenty pounds and men lost the same. It's an unfair universe. Here was the menu:

- White potatoes
- Sweet potatoes (not a yam, barely sweet)
- Rice (often with bits of rock)
- Posho (hard-cooked grits)
- Matoke (steamed and mashed green bananas)
- Some form of meat butchered by hacking, leaving bone shards
- Beans (with the occasional rock)
- Greens or shredded cabbage
- Water/ hot tea
- Ground-nut paste (a pinkish, peanut gravy)
- Pineapple or bananas

By day three, half of the women's dorm had serious dysentery and the rest of us had the diarrhea that comes with most foreign travel. Thank goodness for my personal stash of Cipro.

In the midst of all this, though, I was able to step out and marvel at being surrounded by sounds of giggling children, chattering monkeys, and bird-calls that sound like laughter. A few days in, someone apparently dispatched the rooster that had been crowing all day and night; things got quiet, and *lots* of chicken appeared on the buffet table! An old camel arrived in the village; we hoped camel meat would not follow.

Antimalarial drugs were started immediately, and, although we had to be up to date on the usual childhood vaccinations, plus a last-minute Yellow Fever Vaccine, we hadn't even begun the multiple rounds of required immunizations: Hepatitis A and B, rabies, flu, meningitis, typhoid, tetanus. A few of us, myself included because of a friend's ordeal with Guillain-Barre syndrome, tried to opt out of the flu vaccine and were asked when we'd like to go home.

In short, the first week was hell. That, I suppose, should have been expected, but hell just took on greater dimensions as the next two months of training progressed. Had I known...

Just about the time we thought we'd reached our limit, admin arranged a trip to the zoo and botanical gardens; a sorely-needed diversion.

One day, we were taken to Kampala for an introduction to the city—and its taxi parks—that would become the transit hub for travel in-country. It was also to become our go-to city for everything from a haircut to medical care. We treated it as a treasure hunt, and the prize was survival.

Maybe visitors traveling in the US from smaller countries have a similar indictment of New York City or DFW airport, and I suppose it's all in what you get used to, but it was terrifying at first glance, although a little less so over time.

### The Ninth Ring of Hell: Taxi Parks

We were introduced to the two taxi parks, which on the face of it sounds reasonably civilized. Nothing could be further from the truth. Imagine a hornet's nest that has just been kicked: angry hornets buzzing in all directions, stinging whoever comes near. Now, imagine that those hornets are spread over an acre, and they are now 16-passenger taxis filled with 24 people, all parked or moving in different directions metal-to-metal, honking, drivers yelling. Add

a zillion vendors of every known substance, hawking their wares; thieves looking for fresh victims; molesting hands sweeping over you; snarling wild dogs; and begging children, and there you have it: the Kampala taxi park. Because of its location in the lowest part of the city, it floods quickly, liberating latrine sewage and other assorted garbage. Add fumes and other smells.

All of us came back in shock, realizing what we would have to negotiate when transiting Kampala between destinations— essentially a requirement. At the end of that day, I was as near to tears as I had ever been before or since.

Travel in general is not for the faint-hearted. Squalid latrines, goats, chickens, people sitting on top of you, crying babies, suffocating dust, lack of ventilation, and countless other indignities were just part of public transport, but braving the taxi park required a group, or a level chutzpah I did not possess. Some of the younger ones brazened through, but several of those were also robbed, molested, or otherwise accosted.

In short, it was the ninth ring of hell.

### Journal: August 8, Training

Monday—the first night's sleep with no interruption. Wonderful. It's a gorgeous cool morning with the usual creature cacophony. As an act of self-preservation, I'm learning to love the new coffee drink: instant coffee, sugar and hot milk. I'm a Louisiana girl and was weaned from mother's-milk to coffee-milk. Dark-roast flows through my veins. Today brings a different perspective of Kampala, now that we've survived our trial by fire. We straggle into an open-air thatched gazebo along with the monkeys, and are introduced to Ugandan English (Uganglish)—an interesting blend of proper British English and Luganda expressions. "Now means *whenever*; "now-now" means NOW sort-of! NOTHING in any language means NOW in Uganda—although *chawa adi* in Acholi comes closest.

We got our language assignments today and mine is Acholi, meaning I will be in the north, near Gulu, the area hit hardest by a recent war and the same region mentioned on the Peace Corps website as strictly off-limits to PCVs. That was a little unnerving.

At first I was alarmed and a little disappointed, due to its isolation, but I believe it offers great potential and I love our group.

The day was improved by being able to talk to my sons, Travis and Brett, after buying airtime. Knowing we will have greater

15

contact than I first thought will make it easier to deal with other challenges.

~~~

The gazebo was where most of our training occurred, including that day's medical session and receipt of our medical kits: a plethora of tiny packets of generic antihistamines, antacids, condoms (in brown-camo packaging, the necessity of which I question), and analgesics—any of which would be hard to find in a local pharmacy, where we would likely be "diagnosed" with a *touch of the Malaria* and be given anti-malarial drugs. For anything beyond the basics, getting to Peace Corps Medical would mean a day's ride.

For stomach maladies, we were told to give it a day or two, to be sure it was more than just *the trots*, but by that time, if it *was* more serious, the ride on public transport with no bathroom could be grim and humiliating. If we were deathly ill, PC would possibly send a car, but sciatica, "normal" dysentery, Malaria, parasites, conjunctivitis, etc. wouldn't make the cut.

Journal: August 10, Training

This is our last day at Banana Village, so we have time off to repack in preparation for taking only ONE suitcase to HomeStay, our-home-away-from-home for the next two months. We've been instructed on what our roles will be there, as well as what we might encounter with our families. I've spent little time processing feelings at this juncture, but I've been happy about emerging friendships; and being busy contributes to not feeling homesick. Mostly we are just exhausted. There are still six volunteers down with dysentery. Some of it is jet lag I suspect, but we are in such learning, emotional, and sensory turmoil that all systems are stressed to the limit.

Periodically though, we have time to wander through the community, typical of small villages: red dirt roads—impossible to ride a bike on, but people do—boda-bodas (motorcycle taxis) racing everywhere and in all directions at once, cars, dukas (little shops) made of any kind of wood that can be thrown together with a door—selling everything from TP and beer to sim-cards!

We get our HomeStay assignments tomorrow as we move into Wakisu, so tomorrow will be spent in someone's home.

Alliances have already been formed and it's clear who the friends will be, although we may not have access to them.

PostScript

There is a saying here that you're not really in Peace Corps until you've "shit your pants." Just as I was walking to the bus yesterday—it came without warning. Thank god I was wearing a skirt. I stepped out of my underwear, threw them in the garbage, and climbed aboard. Nothing left to do but to go with it.

I'm officially in Peace Corps.

5 HomeStay

The first ten-weeks of Peace Corps Service are dedicated to training on topics ranging from safety, using a night bucket, how to take a bucket bath, and doing laundry (no kidding), to language and customs. What's a night bucket? Think chamber pot. It's not safe to go outside to the latrine at night: there's no light, but there are snakes, feral dogs, holes to step in, and the occasional collapsing latrine. A few years ago a volunteer fell through a latrine floor into four feet of fermenting feces and it was too deep to climb out. I hear he was treated with every known antibiotic and sent home. So compelling was this threat that more than once I chose the bush and the possibility of a venomous Black Mamba over a latrine with a wooden floor.

The initial stage behind us, the remainder of the training took place in the small town of Wakiso, where we lived with families who had applied to have a PCV live in their homes.

Peace Corps pays an allowance to cover food, and some families make out pretty well from this. A few clearly do it for the money, others for the prestige, and others, like mine, because they really love the cultural exchange.

When some friends asked their HomeStay host what prompted her to participate in the program, she replied that she'd tried raising a couple of goats for extra income, but PC paid more, even if volunteers were more trouble!

It would appear that we are one notch above goats on the profit scale.

Florence, My Host

The gods must have been smiling on me, because I hit the jackpot with Florence, a beautiful, educated woman with short-cropped hair, excellent English, a ready smile, and a warm heart. Beaming with excitement, she rushed over to give me a real hug, which I sorely needed. Florence shared her mud-brick home with two of her

orphaned grandchildren, Nabossa and Ernest (ages five and eight respectively), and two young adults rescued from dire circumstances. Nearly everyone in Uganda is housing someone outside of family.

As a property owner—a rarity among women—and the only one in her village fluent in reading and writing, Florence was elected Local Commissioner. She was proud of her bookcase displaying books gifted by previous volunteers and let it be known that her dream was to start a library in her home, because she knew the community would never do it. Ugandans are the first to tell you: "If you want to hide something, put it in a book." Florence, however, as the daughter of a medical doctor who had been the physician for two of Uganda's presidents, had attended the best schools and married well, so she was a reader.

In one of Uganda's military coups, her husband was imprisoned for alleged disobedience to the regime that took power. When he died there, Florence, fearing for her life and that of her four young children, fled north, across the Nile, and into the bush where she raised her children in hiding, scavenging for food and shelter.

Sometime later, her brother-in-law discovered them and deeded Florence the small plot of land, including a tiny mud-brick building, inherited by her deceased husband. Since Ugandan wives often inherit nothing and seldom own land, that act of generosity was nothing short of miraculous and gave Florence a fresh start. She raised her children in the shed, surviving off gardens she'd planted, as she made enough bricks from the soil around her hut to build a house, one room at a time.

By the time I met Florence, three of her children had died from HIV and other causes, which is how she came to be raising her grandchildren. Her surviving son is married, has a good job and lives wherever he needs to for work, a common practice in much of Africa.

The House

Florence's house, situated on a hill, held some prestige with its tin roof and small front porch bordered by flowers (another rarity). Out back was a vegetable garden with lemongrass for stomach aches, elephant grass for the cow, a banana tree, and the standard issue cassava, beans and potatoes. A separate building—the boys' quarters—large water tank, clothes line, and kitchen shed where the goat slept at night and where Florence had first raised her children,

filled in the backyard. A cow for milking and Pinky, the watchdog, completed the ensemble.

Florence's house boasted a flush toilet and bathing room, both of which were luxuries, because both were usually relegated to the backyard and offered little privacy. The toilet flushed directly into the side-yard, using water poured into the bowl, usually with water left over from a bucket bath.

Although Florence had the foresight to wire the house for electricity as she built it, she couldn't afford the utility connection fee. Every time she had a few extra shillings, she bought a fixture, then a stove—all waiting until she had the hook up fee: $100 US.

Every task done in the twelve hours of inky, Equatorial darkness is done by the dim glow of a kerosene lantern.

Knowing her story and her steadfast resolve to take care of her family and her community, my gift to her when I left was the money to have power brought to the house. That one simple act changed everything.

My Room and Life During Training

My room—mercifully adjacent to the toilet, had a small window overlooking the backyard, and two bed frames, one of which I used as a rainy-weather clothesline and storage area, the other, my bed. I considered myself extremely lucky.

Peace Corps furnished a foam mattress, insecticide-treated mosquito net, pillow, blanket, bathing bucket, and an itty-bitty solar reading lamp. We provided our own sheets, towels, night bucket, toilet paper and all else. The headlamp I brought with me was a survival essential since, in the rainy season one could never depend on being able to charge the solar lamp. Candles were the soft wax variety that stick to the floor, melted in about three hours and offered functional light, but not enough for studying. Therefore, we all schlepped solar lamps, phones, cameras, and computers to training, in the hope of safely charging there. Florence warned me *never* to leave my solar pack unguarded at her house, because it would "grow legs and walk off."

Every couple of days I found a fresh gallon of boiled water at my door; boiled over a wood fire, it always had a smoky taste, as did the mild African tea she boiled for my breakfast. In fact, everything smelled of the smoke that wafted from the outdoor kitchen— infusing freshly washed clothes that hung to dry, bedding and

anything hanging in my room, as well as my hair. I would later miss that smoky tea and the emotional comfort it offered in those days.

Along with smoky tea, we were acclimating to Uganda's equal portions of daylight and dark. We awoke and dressed in the dark, grabbed a backpack loaded with books, extra shoes and other paraphernalia and hiked forty-five minutes through the brush and mud, over streams and barbed wire, past goats and cows and chickens and kids to the training site. Often encountering angry Ankole cows along the way, one member of our motley group was lifted onto the horns of a particularly ill-humored beast, but pulled off by a friend before being harmed.

By the time I'd dressed, Florence had a boiled egg, bread and tea waiting for me on a neat placemat at the dining room table. Pinky-the-dog waited patiently for me to finish.

Arrival at training ushered in eight hours of disorganized presentations and games, interminable waits, and random cancellations. As newcomers used to a westerner's allegiance to the clock, these delays were infuriating, but the next two years and the realities of life would mellow my perspective. Rain, blowing through the windows, often shut down everything with its deafening roar on the tin roof, and often followed us home.

By the time we walked home and had dinner, it was dark again, time for another bracing bucket bath and hunkering down under the mosquito net to study until the solar lamp died, then sleep.

HomeStay was challenging on many levels, so it was a godsend to be with a good family. Mine was lovely in every respect, but Home-Stay pairings were a crapshoot. I assume some families felt the same way in reverse.

Living with a family put us a little ahead of the curve by the time we went to site, by allowing us time to adjust to radically altered circumstances while we still had a safety net. The stresses of training, culture shock, dysentery, having to poop in a fly-infested latrine or a night-bucket, mosquitoes, cold bucket baths, strange diets, being away from home, language, and living under a microscope continued to wipe us out on every level.

Our Ugandan families provided an anchor and a semblance of oversight, since they were aware if we didn't make it in at night or if we were sick. Florence made me lemongrass tea when my stomach acted up, made sure I had dinner upon my arrival home, and that it was something I liked, not always the case with other volunteers who frequently had to wait until 10:00 PM for whatever food was

offered. A fried egg on bread worked for me and also meant we weren't tied to each other's schedules. Florence's flexibility and attitudes were clear evidence of her positive history with foreign visitors, and her innate generosity.

Mud was a constant companion in rainy season, and the powder-like quality of the dirt, when mixed with water, reminded me of my aunt's favorite expression, "slick-as-goose-shit," as we tried to keep from slipping on our walks to training. We practically lived in gumboots, which were scrubbed at each end of the daily trek and lugged our regular shoes along to wear at training. I was completely taken aback the first morning I came out to see that Ernest had proudly washed my shoes for me.

I was given such sweet care.

Wakiso

Wakiso treated us well, even though we were all identified as, "Hey, Muzungu!" Small enough that we couldn't get into too much trouble, it offered a couple of beer joints, one restaurant a serious hike away, and a hardware store that sold the mud-boots we needed.

It was essentially one long, main road through town with a few crossroads, so it was easy to find most of whatever was available (TP and chocolate topping the list) from the dukas or small open-air market. Our focus was pure *escape* provided in the form of beer, Smirnoff Ice and chips (fried potatoes), sufficient for the most part, because we were too tired on the weekend to do anything but wash clothes, study, and collapse.

During a couple of those weekends, I taught Florence how to knit and make dolls to sell, while the kids watched. In a couple of days, Ernest, with his enviable aptitude for spatial memory and motor skills, had not only produced a doll, but had taught a couple of other people to knit as well. I also read to Ernest and Nabossa, and taught an energy-healing class to a group of PCVs in Florence's living room.

It felt good to tap into some of my old life. Reading to Ernest and Nabossa was good for the soul and stirred memories of hours spent reading to Travis and Brett, and teaching the healing class tapped into my past as an energy worker, though I was careful to clear it with Florence beforehand. In Uganda, such things can be considered witchcraft, which is still alive and well.

Florence had had her own experience with that, prompting her to have both of her grandchildren *marked* at birth—piercing her granddaughter's ears and making a small cut on Ernest's arm. Small children were still used in ritual sacrifice, but those with any marks on the body were rejected. That knowledge saved Ernest's life after a couple of men abducted him while he was walking to school.

Thanks to Florence's *marking*, they let him out and sped away.

6 Pinky, the Teflon Dog

I don't think I can really do justice to Pinky, whose purpose seemed to be to love Muzungus—and especially this Muzungu. The fact that she has her own chapter is testimony to how much her affection meant during those early days.

First of all, who in Uganda has a dog named Pinky? In fact, most Ugandans don't have pets, period, but Pinky was loved, and was a good Mama dog even before she became a Mama. Muzungus were her pack and she mothered us well.

Blog Post: September 5, Training

Dogs here are guard-dogs, fed scraps, and often mistreated. Wild dog packs are known to eat livestock and attack people who dare to venture out at night, even the short distance to the latrine. We don't have a latrine, but if we did, I know Pinky, a nondescript female of unknown years and loyal watchdog, would be at my side. The fact that she is mostly a pet makes her an aberration.

All dogs in Wakiso look alike with few modifications in design, save personality and the look in the eyes. There are no spotted dogs, black dogs, different breeds of dogs. Pinky is happy and gentle, with soft eyes and a sweet personality.

She has adopted me as part of her pack, follows me to school and to town-and-back, likes to curl up next to me anytime I'm outside; even checks on me to see that I'm keeping up and leaving for training on time. She has accepted other Muzungus in her pack as well, but I'm her favorite, until someone offers her a food handout. Then she turns fickle.

Because we are attached to Pinky, it was a great drama when she was hit by a car yesterday. Neither cars nor boda-bodas have any regard for people, much less animals. I heard the car smack Pinky and keep on going as Pinky yelped and was hurled off the road; the whole Peace Corps community knew about it within moments. We searched.

I called Florence, whose response was, "Ah! She is a dog! Don't be fearing!" Sure enough, Pinky returned home with little more than a scrape on her lower lip. How she was not injured, we don't know. Except, there's an expression that *everything is tougher* in Africa because it has to be.

Pinky is now known as the *Teflon Dog* and I'm wondering if I will be tougher after two years in Africa.

~~~

Pinky was precise about getting me to training on time and became very agitated on weekends when I took my time at breakfast, often daring to come inside to get me. Her habit of sleeping under my window was a great comfort for both of us.

Dogs were absolutely banned from the training compound, but Pinky expertly wormed her way into the hearts of even the guards by refusing to leave without her Muzungu. She became the surrogate for pets left at home, and the day I left Wakiso ran behind the bus until she couldn't keep up. There wasn't a dry eye in the group. Pinky would be missed.

A year or so after I left, Pinky had had her first litter of puppies, some of which went to Peace Corps volunteers, continuing her legacy in the hearts of trainees. She continued to love Muzungus and was often seen trailing along with them through town.

Ultimately, a thief stole Pinky in preparation for his return a few nights later for the family cow. Pinky's loss was emotional, but the loss of the cow was a serious blow to the family, both nutritionally and financially.

Florence recently let me know they have another dog, but there will never be another Ugandan Village Dog like Pinky.

# 7    Haircuts and Chocolate

## Self-Maintenance

Haircuts were a constant source of angst and bartering, because no one outside of Kampala knew what to do with Muzungu hair. One could get amazing braiding, but honestly, most Muzungus with braiding looked a bit ridiculous, no matter how spectacular the braid. Many Ugandan women had wigs or elaborate braids with other materials woven in, but we were left to our own devices and scissors.

I learned to cut my own hair when I was twelve after I begged for short hair and Mama threw up her hands. My hairdresser said, "Honey, don't you worry 'bout a thing. I'll teach you how to cut your hair," and with great flourish, he did.

The skill served me well in Uganda, as I traded haircuts for Snickers and Smirnoff.

By the time I hit Uganda, I had let my hair return to its natural gray with a white streak in the front. While at Florence's, I was beginning to look like the wild-woman-of-Borneo, so I took my paraphernalia to the front porch and draped in my blue hair-dressers' smock, commenced cutting.

I hung my mirror on the burglar bars with my back to the street and it wasn't long before giggles erupted from behind the privacy-hedge, where a gaggle of boys with bright, toothy-smiles pushed-and-shoved to watch the old Muzungu cut her hair. White hair was an anomaly in Uganda, because few people live long enough to get it.

## Laundry

Laundry was another of those necessities best done with planning and a sense of humor. Water, even if one were blessed with an inside tap, was still scarce and unpredictable, so orchestrating laundry required strategy.

26

One thing Uganda had plenty of were plastic buckets and basins of varying sizes for bathing, bathroom, laundry, scrubbing the floor, bathing the baby... Because water was so scarce and red dirt so prevalent, clothes took on a vague rust undertone, definitely not my color. The process was time consuming, often starting one day and ending the next, because of the soaking required.

After scrubbing, the first round was rung out to reduce the soapiness before the first rinse in the *next* basin, and *another* rinse in the *third* basin containing cleanish water. Basins were gradually rotated, so the final rinse water became the first wash water for the next batch. And so it went as the dirtiest water was used to mop the floor or flush the toilet. Once again, the year of living on our sailboat had been good training. Who knew I would still be reaping the benefits of an adventure I'd had thirty-plus years ago?

We were young then; Bob had just finished his Ph.D., and I'd been the Director of Welfare Medical Program, my dream job in those days. It was our last gasp of freedom before serious adulting and a hoped-for family. We'd saved enough money for a year of cruising aboard our 29-foot sloop, named *Legacy* for Dick's (my deceased father's) history with the water and humanity's legacy of seafaring and exploring the unknown.

Relative novices to ocean sailing, we had our butts kicked routinely; rationed water, lived minimalistically, negotiated territory (he controlled the helm, I wrangled sails, anchor and foredeck), and discovered hidden strengths and foibles. We learned to wait, tune into the visceral, respond not with intellect, but with other skills honed by being ONE with natural forces, much like tuning into the stillness and whispers of Uganda.

That experience translated well to Uganda when confronted with everything from time and waiting, to laundry and mango flies.

Because things usually took days to dry in rainy season, we were cautioned about mango flies laying eggs on our clothes—eggs that hatched with body heat, liberating larvae to burrow into your skin. For that reason, some people ironed their underwear. A scarcity of clothespins meant clothes left on the line occasionally blew off and became fodder for termites or larger critters. One volunteer pulled most of her skirt out of a cow's throat.

Hiring someone to do laundry was possible, but it was highly improper to include underwear, for which you'd be charged extra. When I moved into my first apartment—a third story walk-up, I'd just hung a week's worth of lacy underthings on the inside burglar-

bars—content that no-one would see them—when a new male neighbor came to introduce himself. Great first impression. Crap! Modesty had a short shelf life in Uganda, which I re-discovered after walking two blocks with my skirt hiked up in my waistband, exposing my lily white behind, until a young woman walking behind me jerked it down.

And who would think that laundry could be a hazardous affair? The clotheslines were so high I stood on a stool to hang my wet things or slung them up and hoped for the best. One volunteer fell backward off the wall next to her clothes line, broke her shoulder, and was shipped off to South Africa for surgery.

### Blog Post: August 28, Training

Three weeks in and boredom has struck with a vengeance. Rainy season is living up to its reputation. Cut my hair—too short—styling possibilities grim. God I hope I can find some electricity and do something to make me feel less worn and gray. The combination of lack of product and dryer is deadly if you're used to looking like a professional. I look ten years older. Shit. Well, so much for vanity; it's part of the veneer that gets stripped away. It has rained heavily most of the day and sweet little Nabossa, who seems drawn to me, has snuggled close. I wish I had some picture books for her.

My HomeStay folks go out of their way to make me comfortable, and the trip to the zoo yesterday has diffused some of the sense of *Groundhog Day* and our continuing frustration with training and the sameness of food. This business about needing variety in diet seems to be peculiarly western, and a luxury, as is our propensity to need privacy and space. I wonder if our families might feel intruded upon, although mine has never shown any sign of impatience.

I can't say that I'm sad or depressed, just a bit flat and ready to get on with things. I don't doubt my decision—just impatient. Don't know about this as a spiritual experience either—not feeling terribly charitable toward others or myself. Perhaps that's the spiritual challenge after all.

Need escape. Mind bent.

~~~

Re-reading my blog, I am appalled by feelings that now seem trivial and privileged, but they had the effect of jarring me out of the numbness and malaise that had seeped into my former life. In real time, they reminded me that even the least privileged of us have an opportunity to *decide* how to respond, instead of just reacting.

Fortunately, training usually offered surprises and distractions before I went too far down the road toward bitchiness.

No stone was left unturned and while I/we didn't have to apply *every* technique—how to light a Sigiri, double-dig a garden, or clean a latrine with fire—it deepened my appreciation for life here and my gratitude for my life in general. It also added a dose of humor and perspective.

And This Litle Piggy--Blog Post: September 2, Training

Today we learned to castrate piglets. Well, to be honest, I can't say we really LEARNED it—that would imply that we had an opportunity to practice and that we did not do. But we did witness the process and I will tell you that little piggy squealed all the way home.

We were also introduced to the olfactory treat of pig urine streaming down its own trough to mix with other savory smells in the collection vat used in the production of biogas for lighting. Brilliant and forward thinking, if a bit smelly.

Tomorrow, we'll learn to cook on a charcoal stove called a Sigiri, part of a Cross Cultural cooking-day exercise meant to teach us how to survive when they cut the umbilical. Included in my survival gear are Mexican spices, and some will be put to good use in soft-chicken-tacos. Jean Marie, our language trainer, has mercifully agreed to sacrifice the chicken—a requirement of cooking day. If you want meat here, ya gotta kill it. This is probably the last meat I will have here in a meal I cook.

Blog Post: September 3, Training

I'm sitting here listening to soft rain as the storm that has been rumbling for the last hour moves away and Ernest and Nabossa have finally wound down after running naked and shrieking through the downpour.

The storm over, we head off to meet the family hosting us for Cooking Day, dreading the required slaying of chickens.

We arrive at 9:00; and find the chickens, black and glossy and beautiful, awaiting their fate on the ground with their feet tied. The rooster comes over, pecks them and has his final go at them.

Jeanne Marie arrives, but Russ and Patrick heroically agree to be the executioners. It's grisly; the knives are dull. Finally the slaughter is complete and we have to pluck, clean and disembowel the victims,

finding an egg in one. Many mishaps occur, but we each do our part. I pluck...

Fast forward—we are now going through the bulk rice to remove the little stones that break teeth and are probably at the root of dental problems topping the list of health issues in PC Uganda. We take our task seriously while the Sigiri coals burn down enough to start cooking. The chicken is boiling and I wonder if I'll be able to partake, with disemboweling images fresh in my mind.

Several hours later, we pull together a scrumptious meal including fabulous Spanish rice, Guacamole, and Chapati, the local version of tortillas.

Part of the training is to wash everything in bleach water, a key to staying healthy here.

And so goes another day deep in the heart of Africa. It's still raining and rumbling in the distance, dusk falls, and Nabossa has just snuggled up with a picture album.

Blog Post: September 19, Training

Today felt a bit like turning a corner. We have 24 days of training left and have had both our personal assessments by trainers and a mock language test. The best news was that I didn't fail my MOCK Language Proficiency Interview (LPI).

We are all feeling the continuing stresses of training and culture shock, keeping everyone's emotions just below the trigger point.

A sweet young male volunteer headed toward his COS sat next to me on the ride to the Embassy celebration of Peace Corps' 50th Anniversary. We spoke about his struggles to define himself and his close relationship with his family, forged through many trials and tribulations. He mentioned that he'd told his mom how much her guidance and patience through the hard years had meant to him, but wasn't sure she'd really "heard him." I told him what a gift it was to parents to hear those sentiments, and he was really surprised at how powerful that was.

He really needed another mother to tell him how much that meant, and for the hour's drive back from the party we were surrogate mother and son to each other. For the entire weekend I was tearful, missing my guys. (Even now, years later, I tear up reading this. I wasn't even aware of how hard the separation was until I was back and broke into tears when someone suggested I work abroad again.) Some of us are moved to tears by how much the memory of, or relationship with parents and siblings means when you're

halfway around the world. Email, telephones, and mail are the lifelines. It's easy to understand how deep friendships are forged quickly here.

So we are reveling a bit at having made it halfway through training with no departures.

On a final note, a few days ago a toddler in a sparkly yellow dress ran up the road and threw her arms around my legs in greeting. God bless the Muzungu who prompted such affection in a baby-girl that she gave th*is Muzungu* a much-needed hug.

8 Gulu Town

First Glimpse

My first visit to Gulu Town, to meet with my NGO, Literacy and Adult Basic Education (LABE), prior to living there was devastating. After we'd crossed the iconic Nile River and slowed down for a troop of baboons demanding treats, the lush landscape began to dry out and flatten, trees thinned, greens turned to rusty reds and browns, roads deteriorated, and tarmac gave way to dirt and rocks. Closer to town, the steady parade of boda-bodas, bicycles, goats, cows and buses careening and swaying as they dropped into potholes, created a miasma of dust, exhaust, and detritus of a town overcome with litter. Commotion issued forth from a cluster of bars, humanity, and the town dump.

Having been informed that the area had only recently extricated itself from a grisly, twenty-year war, I expected emotional and physical hardship, but wasn't prepared for what I was seeing. I'd been told Gulu was a beautiful town with a tree-lined boulevard, not this. It was as though every emotional trauma had manifested into form.

Joseph Kony and his Lord's Resistance Army (LRA)—many of them abductees themselves—kidnapped thousands of women and children, forced them to slaughter other family members, to become wives of rebel soldiers, or to become soldiers themselves. Children, their parents gone, were turned into killing machines, often after identifying their parents' body parts floating in caldrons of boiling liquid.

Over time, the prevailing regime forced families to abandon their farms and homes to live in squalid Internally Displaced Person (IDP) Camps for their "protection." Women were repeatedly raped by their "protectors," and no one was allowed to return to their homes to tend crops or animals. Further east, soldiers slaughtered herds of cattle, decimating the cattle-herding heritage of the Karamajong tribe and that entire region.

Tribes were torn asunder; spiritual leaders separated from their people and ceremonial artifacts, annihilating any spiritual or emotional support. HIV had been weaponized, leaving an HIV epidemic and thousands of orphans in its wake. Sanitary facilities, education, and work possibilities for men were nonexistent; creating a culture of alcoholism that is among the worst in Africa. All cultural and spiritual memories died in the camps, as did those for farming and animal husbandry. Any sense of worth and connectedness was systematically demolished.

When the war more or less ended, people were gradually released from the camps or from their bondage as soldiers and allowed to return to their lands and what was left of their families. But their lands could not be identified without their ancestors, now dead, and families often shunned returnees, thereby revictimizing them.

People who could not sustain themselves on the land, due to the loss of skills, were drawn to the cities and even now, there are thousands of homeless and hundreds of street kids in Gulu Town alone.

This post-conflict area with all its traumatic memories was to be home for the next two years, and its wounded population would be my organization's beneficiaries, and my neighbors and friends.

The dismal environment I encountered entering Gulu seemed a fitting match for the area's history. I wept on the inside and wondered how I would survive in this place haunted by memories, grief, and no doubt ghosts.

I was going to be severely challenged by the atmosphere of this place, because of a long history of sensing the unseeable, feeling the energy of a place, and seeing and clearing ghosts. I had wanted to "live the work," and Gulu presented that opportunity.

I started with strengthening my own energy field and inviting the light, to ensure I would resonate with whatever was good about Gulu, and there was much, as it turned out.

The Language Debacle

I should probably start by saying that the official language for government and commerce in Uganda is British-English, but once you get out of a city, people speak their mother tongue, of which there are about sixty-five. Acholi, a Nilotic, tonal language where the elongation of a vowel can mean the difference between *thank you* and *rabbit,* or *water* and *feces,* held the potential for some

interesting conversations for Americans unaccustomed to such tonal variations.

With Peace Corps' history and experience teaching language, I trusted them to be fairly expert. While that's probably true for well-documented languages, it wasn't the case for Acholi, with its ongoing orthography, spellings and pronunciations differing by area and among native speakers. It was a nightmare, but the fault was not with our tireless and good-humored trainers. The disorganization of materials provided, general lack of consensus on approach, and lack of Acholi speakers with whom to practice during HomeStay offered little chance of success.

A third of our whole group failed the LPI, and a disproportionate number of those were in the Acholi group.

An interesting perversity about language training was that while I had a helluva time with Acholi, I could come up with answers and phrases in Spanish, German, and a little French—languages I'd studied a lifetime ago and in which I had *no* fluency.

The night before swearing-in, the non-passing LPI group was called together and thoroughly told off, our results blamed on laziness and lack of commitment. In an apparent change of policy, we were threatened with being sent home if we didn't achieve a certain score on round two, regardless of our achievements at site.

We were completely blindsided, and close to mutiny over this treatment. There was serious talk of leaving. Many of us had walked away from businesses, careers, sons, daughters and grandkids to join Peace Corps, so the insults were incendiary. By the next morning, there was some shift in the threat, but the damage was done.

Although we all stayed, were sworn in, and ultimately passed the LPI, that event left a residue of diminished trust, even as it strengthened our bond with each other.

On a positive note, as a result of the conflict, leadership worked to revamp and strengthen language training and HomeStay protocols, to the benefit of future trainees, and the restoring of a level of trust.

As a postscript, I'd been at site a year and my Acholi was pretty good, when I asked a duka-keeper if she had any tomatoes, *Nyanya*. I had asked correctly for *Nyanya*, and got a defiant look that translated as something close to *idiot*. Asking again, she *answered* in English, so I *asked* in English, "How to say tomato in Acholi," to which she answered, "*tomaaahto!*" So much for our survival depending on fluency in Acholi.

9 The Light at the End of Tunnel

The Rwenzori Mountains: Coffee Co-op Training

Training was winding down, the last big push being a trip to the Rwenzori Mountains for on-site training. Economic Development, a wide-open field, ranged from Village Savings and Loan Organizations (VSLOs) and helping a group develop Income Generating Activities (IGAs), to working with an NGO to make better use of their funding. It was totally site dependent and often up to the volunteer to determine what their organization needed, and how to help make that happen *in a sustainable manner*. Since there were so many possibilities, we were introduced to a variety of business activities.

This part of our training took us to a coffee co-op nestled in the Rwenzori Mountains, near Uganda's border with Democratic Republic of the Congo (DRC). Just getting there and back was part of the training.

Blog Post: September 30, Training

The trip was a pounding six-hour ride in a bus filled with mostly Ugandans and poultry. Driving into Fort Portal was like crossing a time-space continuum and landing in Europe, with rolling hills and tea plantations. We stopped for lunch and ordered hamburgers and after a considerable wait we discovered that the chef, wanting to please us, had gone in search of ham to wrap around the meat patty to create the "HAM" part of the burger.

On full stomachs, we continued the thrill-ride, crammed into the backseat over the rear axle and arrived, nauseous and in a deluge, at a teeming taxi park to negotiate the final stage of travel. We found a *full* Matatu (taxi-van) designed for *nine* and they were damn well determined to shove the ten of us in, with our luggage. After much pushing back and loud "negotiating," we rounded up an almost-empty taxi, meant for seven, and piled in. Wrapping ourselves

around our luggage, we wound our way through the mountains for another two hours.

Arriving at dusk, we were shown to our quarters—four to a room, no lights, no screens, a single toilet and a few latrines tucked away at the opposite end of the dark complex.

The next day we found ourselves in a small village of coffee farmers cultivating mountainsides a goat would have trouble climbing. In the context of improving negotiating-power and profits, the Coffee Co-op works with 3800 individual farmers (1-2 acres of land each) and is changing the culture in the process. Some women, having escaped war camps to live in the bush, are now successful coffee farmers with their own huts, and money for school fees.

Success is Measured Differently Here

To access the model farm, we hiked up a 45-degree slope to reach a landing the size of a one-car garage, where a family of ten lived in a mud-brick hut, cultivating 500 coffee plants. Multiple times per day, wearing flip-flops and moving like gazelles, they hauled water and everything else needed for daily life. In contrast, we *trudged*, hanging on to any available limb or rock.

The family has quadrupled their harvest in the last year or two and looks forward to building a larger mud-brick hut near their current house. Everyone works—with plants, harvesting, rotating compost, or fetching supplies—and all post-harvest work is done by hand.

I have a new appreciation for my morning addiction.

~~~

The most surprising takeaway is how the co-op is using *profit to* reduce the domestic violence churches have been trying unsuccessfully to address for years:

- By not beating your wife and children, they will work harder and *increase your profits.*

- Stop spending money on liquor and you can buy more coffee plants and *increase your profits.*

- Allow your wife to help with planning and decision-making and... *increase your profits.*

Arriving back from training, I was greeted by another eye-opening discovery of a different kind.

## Puzzle Epiphany — Blog Post: October 5, Training

Tonight, as I did my homework after returning from the Rwenzories, Ernest brought in a handful of pieces from an incomplete *Snow White* puzzle and began shoving them together with no concept of matching patterns, colors, border pieces—concepts already well in place with most American kids his age. I joined him on the floor to help, eliciting many "Aaaahhs" and "Yeses" as we matched patterns and re-created the design.

At one point, Ernest looked stricken, and I asked, "What's the matter?" He gasped, *"It's a picture!"*

It was a new concept—he'd been putting pieces together because they were there. Because of the activities built into play and education in the States, we take many processes for granted, not realizing how much teaching is going on. These beautiful children are well supported in their education by Florence, but there are huge gaps in their rote learning. In doing the puzzle, I began to see a fraction of why problem solving, abstract thinking, and so on are lacking in the culture at large.

~~~

This single insight, demonstrated so elegantly by Ernest, would later result in soliciting puzzles from States-side friends to integrate into the new early-childhood-education phase of LABE's training, but more on that later. In the meantime, on my next visit to Kampala, I spent half a day tracking down puzzles for the kids.

They were fast learners and caught on quickly, but Florence, who wanted so badly to do puzzles with them, couldn't grasp the concepts regardless of her intelligence and education. The activities that support pattern recognition, spatial awareness, abstract thinking, and other cognitive processes had not been part of the education available to her, and furthermore, had probably not been necessary in a culture largely reliant on different skills and holistic knowledge. The need might only arise when moving toward a more technological culture, as was happening and was their goal.

If I'd been there longer and we'd had more time, we might have had a different result. Another Muzungu had given her a 1000 piece, monochromatic puzzle and she insisted we put it together. I could hardly see the colors, but when I went to bed, she was still working by the dim glow of her lantern.

The fallout from the puzzles was exciting. With his new puzzles, Ernest was off and running—literally! He put them together on the

front porch and ran up the road to collect his friends to share this wonderful pastime.

In Peace Corp lingo, it was the perfect example of *expanding capacity:* teach one person and they teach others.

Later That Night

A bit later I heard some banging noise and it was Ernest and Nabossa working in the pitch dark, trying to straighten a rusty nail with a rock. I asked Ernest what he was doing and his answer was something incongruous, like *eraser.*

The pieces he had assembled didn't match up to any eraser I'd seen, but just wait. He attached a scrap of fabric to a random piece of wood, still using the stone hammer. My curiosity mounted. Pretty soon, he slipped a ratty chunk of foam into the pouch and nailed down the other side.

Voilà! An *eraser* to use so they could practice math problems on the concrete floor, and then erase them.

Last week he was making a rake out of a plastic part, some rope and a stick. Ernest is an inventor, and I wonder how the local school system will be able to serve him.

These are my days here, discovering how part of the world puts life together using only what's available and every day, I learn something new.

Part Two –
It Begins

10 Getting to Site

Swearing in and Getting to Site

After the turmoil and drama of training, one volunteer had been sent home, and we were ready to be sworn in as Peace Corps Volunteers (PCVs). Dressed in our best, we were bused to the home of the American Ambassador's Charge d'affaires, where we were fêted, ceremoniously sworn in, and fed massive amounts of American food.

A few of us also got personal alarm devices from Fred, PC's Head of Security, who always had our backs, as did the drivers. On that front we were fortunate, because there would be times when Fred would have to come to the rescue, or we would need to depend on the drivers to ferry us around when we should have hiked to a bus or Matatu. There was real camaraderie, trust and friendship there.

We partied late into the night, wrote our last emails before the radio-silence that would ensue until we bought our new modems at site; and repacked to incorporate stacks of training materials, a two-burner stove, and a growing collection of cooking utensils we would have to schlep to our sites.

Weighed down with a truckload of supplies, getting to site was a mix of goodwill, chaos, and terror. With few exceptions, we had to devise our own transport and some sites were 7-10 hours away, in regions so remote it would require multiple vehicle transfers—unreliable under the best of circumstances. Most volunteers had no alternative but to rely on public transport, hope that all of their stuff made it, and trust that someone would be there to meet them. One young woman was delivered at night to an empty building in her remote village and waited hours until someone came along. NO ONE knew she was coming.

My friend Betty and I, both assigned to LABE, were among the lucky ones, and got rides to our respective regions, each a day's drive away. Betty's site was in Arua, half-a-day's travel from Gulu, if you knew the shortcut, and a full day otherwise.

An Inauspicious Arrival — Blog Post: October 17, In Service

You'll be disappointed, as I know some of you are picturing me in a thatched roof hut somewhere, stepping out of my door to see giraffes, elephants and the occasional lion. Instead, I'm in the industrial heart of Gulu Town, the third largest city in Uganda.

I'm in a third-story apartment in what feels like the projects, but has luxuries like occasional electricity and water, a flush toilet (when there's water) and a hot water heater, so *if* I have water at the same time I have electricity, I might wrangle a warmish shower. I'm lucky.

When I arrived at dusk, in the rain, the electricity was *finished*, every centimeter of surface was covered with a thick layer of red dust and cobwebs, and furniture was *not-there*. My supervisor, almost as dismayed as I was, explained, "Ugandans don't believe you will arrive until they see you." So we set about getting the bed, desk, chair and bookcase our host organizations are required to furnish along with housing. All of these are hand-built from mahogany; no IKEA here.

It all arrived courtesy of Ojok, our intrepid driver-and-more; we assembled it, then went out in search of cleaning supplies and a mattress so I could at least sleep here. Nothing is easy. Now totally dark and still raining, the market and most of the dukas are closed and the streets are swarming with people rushing to get paraffin (kerosene) for their lanterns.

We found enough to get us by, and my male supervisor cleaned the bedroom sufficiently for me to use it. You have no idea how rare it is for an Ugandan man to do cleaning, much less for a woman. This was a good omen and much appreciated.

The place is fifty feet off the busiest and noisiest highway in Gulu. Within an eighth of a mile, there are two bus terminals, a furniture manufacturing site, four gas stations, several boda-boda stages (where the drivers hang out and wait for business), an old market now inhabited by a furniture duka and random critters, and an untold number of clubs, judging from the racket.

There is a calamitously slick white tile floor, two bedrooms, living area, bathroom, and a room intended as a kitchen, devoid of appliances. I have my stove, but there is no propane in the city, so I am living off PBJ sandwiches and packaged soups I can make with boiling water, when there is power. I have an electric kettle, because we have to boil all of our drinking water. There's also a balcony overlooking the abandoned market.

~~~

The approach to the building was a dark, narrow alleyway not safe at night, but I didn't intend to be out at night. Burglar bars on the windows and a formidable locking gate to my balcony made it very secure *once inside*. It was a lovely place on the inside, but no one could have predicted what would transpire on almost a daily basis beneath my balcony.

### National Handwashing Day? — Blog Post: October 18, In Service

Today was an interesting day—I went in a bit late because I was told everyone would be busy preparing for a meeting with the donors I would be expected to meet-and-greet. I dressed accordingly (long skirt), though by the time I tried to iron my clothes the electricity was finished again, prompting me to put on my least disheveled option.

By the time I arrived, plans had changed and we would head to the field instead.

Driving out on an otherwise deserted road, we met a marching band playing full-tilt, leading an orderly herd of children, dressed in their school uniforms. Ojok informed me they were celebrating their win of a *National Handwashing Day* contest. Lack of hand-washing in a country of pit latrines, eating with the hands, and no running water is a major source of dysentery; thus a contest to promote the healthy practice of Hand Washing. In PC training, we were taught how to build a tippy-tap, a home-made hand-washing station made with sticks, string and a jerrycan. Training meets-real-world.

Our excursion to schools to monitor the program was telling. Ojok's report listed 11 sub-standard latrines for 1116 students, no text books, teachers unpaid and under-motivated, and poorly disciplined students. Although the practice of caning is now illegal, teachers are not trained in other forms of discipline. I tentatively offered ideas on behavior modification using positive feedback, and was met with, "hmmmm—like a reward system?" So there's potential.

### Blog Post: October 21, In Service

On an unrelated note, today's excitement is "cream" for my coffee. No refrigeration means no cream. Sameer, the Indian grocer near me has managed to find *Coffee Mate* for $10US.

~~~

In more important news, this is the "Shut up and Listen" phase of my work here. Probably a good thing from other perspectives as well. I am flat out exhausted by midday, and if I had to be more productive, I couldn't be.

A newly minted volunteer here is like a fresh battery drained at quadruple the expected rate—so it's depleted quickly and often. My age has little to do with it and is actually an advantage because I have experience and coping mechanisms in my favor. All systems are on full alert at all times and the challenges are interesting, because they aren't what any of us expected. Here's a typical day thus far:

- Wake up groggy after a night of unceasing noise.
- Take drugs for the sinus infection fed by dust and toxic fumes.
- Dress professionally for the 1.5 mile walk to work through dust or mud.
- Greet everyone I pass in a language I haven't yet mastered.
- Explain, again, to boda drivers why I am not permitted to ride.
- Engage in a conversation with an adorable schoolgirl who tells me she wants to be seen walking with a Muzungu.
- Explain to another Ugandan why I cannot sponsor him to go to America; that the streets are not paved in gold as he literally believes, that the government will not support him, and knowing how to cut grass with a panga will not get him a job.
- Arrive at work and attempt to converse with my new colleagues in my limited Acholi.
- Strain to hear them. They are a soft-spoken lot.
- Run to the latrine, a block away and hope I make it. Don't forget TP.
- Return home via the market.
- Check at all four gas stations, again, to see when they might get paraffin.

- Arrive home; ask the landlord if she has contacted the plumber, because the toilet has not healed itself in the last three days.
- Walk up three flights of backwards-tilting stairs and collapse, hoping the electricity comes on because I could sure use a fan.
- Go back to work, repeating most of the aforementioned.
- Walk back home after work amid the same conditions.
- Check the Post Office for packages.
- Find food.
- Take a cold bath.
- Wash undies in bath water.
- Take my daily Mefloquine for Malaria, even though the military has banned it for its psychological side-effects.
- Climb in bed, insert ear-plugs, tuck in bed-net.
- Attempt sleep

Blog Post: October 29, In Service

I've been in Gulu for two weeks now and remain challenged. I'm a fairly resilient person and have dealt with a number of challenges rather decently in my life, but the current one of poor air quality is a surprise, though it informs me about the difficulties not immediately recognized for those who call this home.

My place overlooks a market, which sounds quaint. That said, I am awakened, pre-dawn, gasping for breath from the smell of hair being burned off of assorted goat parts mingling with that of burning plastics and tires.

Around 7:00 AM, the traffic begins to pick up and noxious fumes are added to the mix.

Growing up in Baton Rouge, with "wet" air infused with petro-chemicals and bauxite, I remember moving to Austin, Texas and asking what that smell was. That *smell* was my first real whiff of clean air, to which I've become accustomed. Traveling to Beijing, Mumbai and Ho Chi Min City, I remember being assaulted by fumes one might expect in such congested cities, but not in rural Africa. Of all of the things one might be able to mitigate, do with less of—air is not one of them.

So the next time you have to pay for your emissions test to pass a car inspection, or the cost of goods is high because the Clean Air Act forced some emissions controls on a factory—take a breath—in fact take several and enjoy the sheer beauty of clean air.

Just breathe...

~~~

This experience marks the beginning of my daily practice in *gratitude*. Every day is a visceral reminder of the *real* cost of poverty, and every day I am reminded of the *grace offered by simply having choices in life*. Although I *choose* to be here, many others are here by default.

# 11    Shut Up and Listen

A primary tenet of training was "Shut up and Listen" when you get to site; don't start trying to fix things. Give it some time: observe, listen, wait, do your research, learn, ask questions, and listen some more. What you *think* people need and what they *actually need* may be light-years apart.

In this regard, coming in all starry-eyed from comfortable and privileged lives, there's a tendency to think big, general, and unrealistic. If they only had more schools, if they just had books in those schools, if they just...

In one of our economic development training sessions, the idea for an IGA was introduced and quickly moved to franchising and licensing, by-passing the realities of where the money to purchase materials would come from, how to obtain the supplies on a reliable basis, how to store the product, how to sell it... In short, all the realistic questions that had to be addressed in order to hatch even a basic plan had been overlooked.

And therein lies much of the challenge. Those who have a deep desire to help often come in with an idea that so far exceeds the level of understanding and experience of the rural beneficiary that there is no point of reference from which to begin. Assumptions made about what we *think* is needed may not even be on the horizon for the recipient.

That said, the tendency to make assumptions wasn't limited to PCVs. One skilled LABE counterpart, Joy, told me about an interview with the elders in a particularly needy village, where she assumed they would want solar lamps, literacy materials, or any number of things typically on the shortlist. It turned out they wanted something much more fundamental: help with managing the garbage accumulating in their compound, not because it was unsightly, but because it was a breeding ground for mosquitoes and chronic malaria.

But back to basics.

## Can We and Should We? A Rant

Something I still struggle with is how *much* of what the developed world has to offer is transferable to a culture that is functionally agrarian, socially tribal, and cognitively holistic? This is not a moral query; just an exploration of how we bridge the gap between their present circumstances and the future they desire.

Neither is this a matter of doubting whether we should intervene or intrude where we are not wanted. Peace Corps *serves only by invitation* from both the *country and the organization* with which we work. The same is true of the European version of PC, Volunteers Serving Overseas (VSO).

There is a great chasm that no amount of good intentions and generosity can bridge. Years of missed cognitive, educational and societal development between the agrarian/hunter-gatherer ages and that of industrialism and technology cannot be updated overnight. Uganda has been exposed to the promise of a better life seen through movies, advertising and social media; they believe it, and want it now. That timeline jump works in some areas, but not others.

Food insecurity is a huge problem in Uganda, even though there is an abundance of fertile land for rain-irrigated farming. Among the challenges in the north is the reality that the generations raised in IDP camps lost much of their ancestral knowledge in the skills needed to sustain themselves.

Once released from the camps, unable to live off the land, people were drawn to the cities, where many remain homeless, or congregate in slums to this day. Kampala's slum is one of the largest and has become a tourist "attraction," to get foreigners to contribute.

There has been no scarcity of humanitarian aid in Uganda to the present day, and Gulu was ground zero, especially after the war. The function for many NGOs was to reconnect IDP dwellers and abductees-turned-soldier with their families and their land, a process that was ongoing when I was there. Among the greatest efforts have been the reduction of malaria and HIV, and improving the rights of women and *the girl child*. All of those are necessary and there is some success.

Uganda has one of the fastest growing populations in the world, in spite of the challenges. Improved survival rates and Museveni's *go forth and populate* mandate contribute to this exponential growth as do the churches, most of which discourage any sort of family planning, considering it a sin.

Many women, whose bodies and spirits are exhausted, want control of their bodies, but risk abuse or expulsion from their families if they attempt it. Such a tragedy unfolded at the local clinic after a young woman, who failed to get pregnant following the birth of her ninth child, admitted to using an IUD. Her family had literally dragged her to the clinic to confront the doctor and force him to remove it.

With similar resistance in other areas, the process of change feels like trying to move in quicksand, and requires not just offering a service, but deep, basic education of the entire culture. Programs aimed at *lifting* women and children through education also educate men, who as head-of-household, are threatened by the independence afforded a woman who can sign her name or count money.

So the question isn't if services are needed, but how to deliver them in non-threatening ways that are a match to the receivers' ability to utilize/ benefit, and have the greatest long-term impact.

In reality, organizations and church groups arrive all the time and build schools that remain vacant because there are no teachers. A hospital was built and furnished with beds and mattresses, but never staffed, and the mattresses were stolen. Bed nets are used for wedding dresses or curtains or fishing nets, because the recipients don't understand the long-term benefits of sleeping under one, or the need for food is more immediate.

A case in point was that of Peter, a young man whose education I came to fund at a residential school. Peter repeatedly missed school due to malaria, even though I'd supplied him with a treated net. A mix of factors was a play, but Peter would not install the net until I made it a condition of his funding.

Churches come to teach of God's love and salvation, but few offer any skills to improve life in the present. Gaggles of wide-eyed young girls arrive to spend time with the orphans, take them to local swimming pools and introduce them to luxuries—then leave them with no possibility of having the things to which they were introduced.

Foreigners come individually to *find themselves,* but live in nice hotels, walk around town delivering sweets and small-money to street-kids, and leave proclaiming they've lived like the locals because they can't get ice or their hotel doesn't have air conditioning. I'm not making this up: I met them every day in Gulu and elsewhere in Uganda.

Yes, I believe people in under-developed countries need love, but love-in-action: i.e., skills to take them beyond the learned dependency that comes with handouts, which, when withdrawn, leaves them dependent on the next Muzungu.

## And That's Where Peace Corps is Different and Where Peace Corps Delivers

Not all organizations knew what they needed when they requested a Peace Corps Volunteer, but were operating from the misguided belief that the mere presence of a Volunteer would fix it, or that we would have access to the magical elixir of money, which could heal all wounds.

Although neither of those assumptions are true, they resulted in some uncomfortable situations and placed us in circumstances from which there was no graceful exit.

In my case, I was almost immediately placed in charge of all of the operations in the North—a huge and complex region. Within days of my arrival, despite my total lack of knowledge, I was expected to usurp the role from Ugandans with expert knowledge and years of institutional wisdom. It wasn't my place to accept the assignment, which would have been calamitously disruptive, but I needed to finesse my refusal without being disrespectful or being labeled insubordinate, the ultimate offence. My job, in PC vernacular, would be to *expand capacity*, i.e., offer training and support to aid the staff in place to do their jobs more efficiently and sustainably. With that in mind, I took a deep breath, thanked the Director for the honor and respectfully declined, quoting the Peace Corps position. I went to site and "shut up and listened."

The Gulu office was the headquarters for operations in the north, and as such, it housed all program materials. What I found was a cramped two-room office and a hall, holding three desks, a few bookcases and a cabinet overflowing with bulging binders, loose papers, vehicle parts, tires, tarps and teacups; and five totally committed, well-educated staff—who didn't quite know what to do with me, but welcomed me with warmth and enthusiasm. I tagged along on field visits and acted as the photographer by way of explaining my presence to the villagers, and this introduced me to the challenges in a way no amount of listening or reading could have.

Soon, I discovered two file cabinets, and opened the drawers to an explosion of papers and oddities. As a former Professional Organizer, I'd hit the mother lode and thought: *this is something I can do that will help us both.* My counterpart was dumbfounded

when I offered to organize it. The process was tedious, requiring a lot of staff-interaction and explanations, but it was foundational in learning about the program. More importantly, it built reciprocal trust and respect, and kept me engaged while I still had no idea of my function. Simultaneously, it helped me *craft* that function and understand the role I would play.

Thankfully, that project was a success, and expanded to the rest of the office. Hanging files, tabs and another cabinet were ordered from Kampala, but oddly enough, nowhere in Uganda were any file folders. I made my own from construction paper.

As I began the front office, Ojok, not only the driver, but a program-trainer as well, was skeptical. Early on, he had decided my role was to solicit charitable donations from my friends to build a learning-center in *his* compound. In that effort he was shameless: "Ah! Madam Nancy, it would be named after you! All of your friends at home will be so proud of you that you have a learning center dedicated to *you,* all the way across the world!" Each time, I would smile, and let him know I didn't come with money. After months of trying, he gave up, but for a while, it was clear he doubted my value to them.

He was vocal in his dismissal of the organization project: "But Madam Nancy, what is the purpose of all this? Surely—it is a waste of time!" I guaranteed him, "next time you are looking for a document, you'll find it in five minutes or less." We didn't have to wait long for the opportunity to present itself. I was vindicated, and a believer was born. From then on, in Ojok's eyes, I could do no wrong.

The entire office took months, but transformed record keeping and audits, as staff became comfortable with the systems.

Other processes were designed to coordinate and track trips to the field with the roll-out and maintenance of new programs, resulting in fewer trips, less downtime, reduced expenditures for fuel and vehicle maintenance, and fewer unmet expectations in the field. Over time, Excel Spreadsheets were designed to document aspects of the program that previously required days or weeks of collating, counting and totaling to justify the programs.

By going through all of the files, I learned things I could not have any other way. It was a form of listening that kept me busy, inform-ed, and contributed in a way they didn't know they needed. And that's part of the balancing act. Later, that in depth knowledge and

understanding of program delivery earned me a level of respect and trust that made me an integral part of the team.

## Calamity

That earned trust and the good relationship between Geoffrey, my counterpart, and I also saved me when I accidentally sent a copy of a document meant for my eyes only to my Director *and Geoffrey*. Geoffrey had been bumped up to a management position for which he was ill prepared, and although he was an amazing trainer, he lacked training for this new position. His micro-management was driving a lot of conflict; everyone was suffering and Ugandan staff were on the brink of leaving—even Geoffrey. But I was afraid Geoffrey would be fired before he got a chance to leave on his own terms, and that I, too, would be caught in the conflict.

In case it all hit the fan, I had been documenting events in a private file. Geoffrey and I had had productive conversations, things had settled down, and I had forgotten about the file. It was all on my computer, so there was no possibility that it would be seen, *until in some bizarre turn of events,* it was. I'd accidentally sent it with a requested document, needed by both the Director and Geoffrey, so they'd both been sent *the file,* on a Friday.

Monday morning the Director called, alerting me to the catastrophe. I'd put both of us at risk, but it was Geoffrey I worried about.

I was stricken, felt a hard knot form in my stomach, my pulse raced—I could hardly breathe. My heart ached; I adored Geoffrey and would *never* have done anything to damage our friendship, or his position—especially by such a betrayal. He'd said nothing, but had had plenty of time to read it. I was literally shaking and knew I had to face it, face him, and be willing to resign, assuming I'd irreparably damaged our working relationship and destroyed our friendship.

Tearing up, I told Geoffrey what had happened, apologized, offered to call the Director and explain the circumstances—offered to resign. He listened quietly, his expression the picture of neutrality and calm. He responded: *yes, he'd read it*; knew I'd been concerned, because we'd talked about it all. He'd had a conversation with the Director, had improved his performance, and as far as he was concerned, my document and the manner in which I'd described the events, was simply *evidence of my fairness and total commitment to* improving the program.

I was aghast—had not expected this generosity, this gentleness—and was so filled with gratitude and respect for this man, I could hardly speak. In the States, I may have received a stern reprimand, or been fired, but in Uganda, it was an offence for which people really *are* poisoned, or worse. Yet this humble man, so generous in his praise, had recognized it for what it was, a terrible mistake.

He'd found the high road and taken it, when it would have been so much easier to take the other. Uganda was a land of contradictions, and surprised me and humbled me every single day.

This interaction stripped me of any illusions I may have entertained that I was there to teach them.

In his capacity for compassion and forgiveness, Geoffrey had taught me about both.

## 12    New Digs

### House Hunting

The combination of toxic fumes made me so ill, I was functioning off a cocktail of meds, unable to sleep at night, and dragging through the days. I needed a new place to live.

Searching for a place to rent can be a hassle no matter where you are, but with the exception of one estate-agent for high-end properties, there was no centralized listing in Gulu and the word-of-mouth network was fraught with assumptions about Muzungus and our imagined money. I just needed a modest, safe place within walking distance to my work, and one LABE could afford. Essentially there were two choices: mud-huts or high-end Muzungu properties.

In a country where teachers earn the equivalent of about $60 USD/month, from which they pay school fees and everything else, affordable housing is a hut, so I was fortunate to find a house in a marginally fenced compound with tenants living in the back, locking gate, burglar bars, and windows that approximated closing, but no screens (a PC requirement). It was at the dead-end of a dark alley next to a bar/event center, a mile-and-a-half from work, and close to a market, churches and a mosque. The back door looked onto a large garbage pit that served the compound.

### Reprieve

One catch. It wasn't ready. Too sick to return to the apartment, I called PCHQ and asked if they would pay for a room elsewhere for a few days.

That set off a round of frenzied conversations with PC, because I hadn't told them I was moving. They demanded I wait until someone from PC could schedule time to vet the house—maybe in a week or so. I knew I'd lose it if they confounded the process with an already skittish landlady who only agreed to rent to me because I'm "a white." After much ado, I convinced them that, as a sixty-four-year-old prior landlord, I knew how to assess a property. That said,

LABE checked it out and made some demands of the landlady prior to signing the lease.

### Blog Post: October 31, In Service

I cherish the first bit of hope I have felt since arriving in Gulu. And Hallelujah! The light at the end of the tunnel is not a train! It's a hotel room with the comforting sounds of Gulu Town settling into a quiet night. I sit on the hotel room balcony sucking down a "Slurpy Yogurt" from a plastic bag and munching on a slice of Banana Bread—my first taste of almost-sweet pastry since being here. Uganda doesn't do sweets.

From my overhead perch, I witness the exodus of school children in various colors of uniforms: blue, lavender, green, brown. They are all ages; P1-P3 can represent kids anywhere from age six to the teens. Some kids don't enter the system until much older, having been either in the bush, working the fields, or perhaps just now, their families have been convinced of the value of education. Oblivious to traffic they saunter home in a constant stream that lasts for about an hour.

A mama dog lounges across the road, looking ever hopeful for someone she knows or maybe a handout, and three young women, carrying enormous open buckets of splashing water on their heads, simply step over her.

Somewhere down the road a marching band strikes up. This feels so much more normal and I am grateful for the return to something that looks like I may be able to do this for two years.

Charcoal-colored clouds roil over the city promising a storm, not just rain. The city quiets, rain begins and lights flicker off. I tuck my chair further in, nudging closer to the door. I'm in heaven and take a good deep breath—a clean breath!

I can do this...

### The Mental Ward — Blog Post: November 1, In Service

There's a new adventure every day here. Today my supervisor and I went to check the progress on the house and found them painting, replacing window locks, putting wire mesh over the open wall vents etc. There was considerable discussion about who will be in charge of "slashing" the yard. A slasher is a modified machete. I don't know how to slash.

My landlady, Caroline, a nurse at a local hospital we've been cautioned about, called and said I could meet her there to get the

lease. So I hiked over, stood with a long line of Ugandans waiting for the guard to decide the fate of their appointment, and was relieved to be allowed through without waiting. Caroline has told me to ask for the "Mental Ward" and I admit to feeling a little wary about this.

Walking past several buildings where people are having minor open-air procedures, I make it down the hill, to the long building with bars on the windows and locked gates. The hair on my neck stands up as I see through the windows into large rooms, with rows of beds, mattresses covered in plastic. I think: *asylum,* and scary music plays in my head. Visions of being misidentified as a patient and having a *One Flew Over the Cuckoo's Nest* experience creep up on me. I hurry and I am lost.

Someone is finally sent out to find the white woman wandering around. Easy to spot, I am rescued and directed to the back of one of these prison-like buildings where Caroline informs me a man has just been brought in biting everyone. But *not to worry,* he has been sedated and dosed with an antipsychotic drug. At some point he'll be released with a week's worth of meds. This is not his first time here; he's back because his wife left him.

And so the day continues. I go back to my safe little chair at LABE where I remind myself to always behave and not bite anyone, no matter how much they deserve it.

### Thwarted: More Realizations — Blog Post: November 4, In Service

Things just get stuck here. Always bring something to read; forward motion here is made at great odds. I have never seen so much effort and industry applied simply to live life; it is not for lack of effort that things don't get done.

Electricity is the common denominator for many things. Rain is another and they are related somehow. Not having electricity/power at my HomeStay was just a minor inconvenience.

Here in Gulu, *access* to power can be an illusion because its availability is totally random. When it's *finished*, it could be for an hour or several weeks. There are five computers at LABE and all work stops when the power goes down, which can occur multiple times a day. If deadlines loom, there is a mad scramble to find an office sufficiently funded to afford a generator—and fuel, where a laptop can be plugged in and work continued.

Consider how little progress would be made in the U.S. if, at random intervals, access to computers, lights, all electrical things that keep civilization running, simply ceased for an indeterminate period.

In poor countries like Uganda, other challenges are just around the corner. First, not every organization has a vehicle. Mine does and it is the absolute heartbeat of the program, because they deliver services and materials to roughly 30,000 kids and adults in rural areas. The Gulu office has one Toyota truck Ojok has christened *The Daughter of Japan*, and some of the Program Officers have motorcycles or bicycles, all of which are subject to road conditions. Many times a planned trip is aborted because the Program Officer gets most of the way there only to discover a pot-hole the size of Vermont, or three feet of mud that not even the all-wheel-drive *Daughter of Japan* can outwit.

Today, an important trip to another organization was cancelled at the last minute, because we were still awaiting a registration sticker that should have arrived yesterday by bus from Kampala. Mail? Nah, seldom used here because most places have no address, just a description, i.e., main house behind *Diana Garden*, or yellow building with an elephant statue in front. The lack of a sticker can mean jail-time for the driver, unless he pays the fine on the spot. For that reason, my anticipated move to my new place was also aborted.

Cell phones are the only phones here, and that's another illusion of availability and progress, since they also rely on power for charging and the dubious availability of airtime—reloaded when money-is-there. In the field, power might only be available at kiosks with generators and there is a fee for charging anything. Since money is also frequently, *not there,* charging doesn't happen. That means if a trip actually occurs, there may or may not be anyone at the other end, because communication may or may not have happened. People show up when they see you coming and several hours of delay is customary.

There are too many variables here to even contemplate, but the end result is that nothing happens in an orderly fashion and a backup plan is always necessary.

This is just a tiny slice of life here. Dry season is apparently just around the corner, hosting different challenges.

### Oreos: Black Gold – Blog Post: November 6, In Service

Joy comes in unexpected ways. Today it came in the form of a newly opened box-store, sort of a mini-Walmart.

After I had dinner of beans and rice consumed at the Happy Nest eatery across the street from my hotel, the rain finally slowed to a splatter, so I ventured out wanting something slightly not-good-for-me. Dizzy with the freedom of being in town and able to go out at dusk, I remembered the rumor of Uchumi's opening.

It was positively orgasmic walking in. It's been months in the teasing stage of opening, and with no fanfare whatsoever, it opened silently yesterday. The next closest one is in Kampala.

It's not fully stocked, but really, walking down the aisles, I felt a warm glow in my heart when I saw Dove soap, Oreo Cookies, packaged sheet sets, body lotion, and western magazines of the sort I would never pick up in the States, but now suddenly cause my heart to skip a beat. There, next to *Farming Digest* and *Kenya Homes* was Katie Holmes supposedly starving herself—getting back at controlling Tom Cruise. Who knew I even cared? Well, technically, I don't, but it all seemed so normal. Surveying the aisles like a little kid before Christmas, I was overwhelmed. So many choices—so little money!

I will have to pace myself. But I can get wine—other than the kind in a sippy-cup with a juice straw. I could EVEN get a bottle of Bailey's Irish Cream... but will I? That 50,000 shillings will buy half a dining table, or fabric to cover the bare windows, or a month's worth of groceries at the *cuk madit* (big market).

So I wandered, and wondered what would give my heart the greatest pitty-pat and taste the most like home—not some impostor that is *sort-of* like something I've tasted at home, but the actual thing that, were I home, I could pick off the shelf. I settled on a small pack of Oreo Cookies. I guarded them like contraband on the way home, secreting them to my cave lest some other Muzungu see me carrying them and want me to share. Not to enjoy them all at once, then to be left wanting, I exercised the greatest restraint and ate just one as I searched frantically for my modem to check email. Then I had another, and showered—yes, in cold water. Then another. I have now eaten half a package, feeling sufficiently sated that I can move into the rest of my night and save some excitement for tomorrow.

Who knew so little could make the heart sing? There is a large white ant flitting around. Were I an Ugandan I might leap at this treat, rip its wings off and eat it, but thanks to my Oreo fix I am not in the least tempted.

# 13   Rain

## The Rains Begin in Earnest

I know there has been much reference to rain, but it is completely life-defining in this place, and to talk about life without mentioning it is like writing a novel without mentioning the protagonist.

Here in Gulu, the arrival of the rainy season is celebrated as dust settles and the town quietens just a little bit. It means planting season or welcome irrigation, but it can also obliterate crops. Ushering in this rain was the last blast of the dry season, a rolling, suffocating, impenetrable wall of red silt that hit me in the face, enveloping me and everything around me. It was suggested we bring bandanas to wet and wear as breathing masks during dry season. Glad I brought two.

When the rain arrives, it is mythic. No polite, spitting rain this. It is glorious, torrential, and loud in its own right, but rains here don't usually come alone. Soul-rattling thunder accompanies lightning strikes that kill hundreds every year—entire schoolrooms of children at once. Lake Victoria, near Entebbe, boasts the highest number of lightning strikes in the world according to Google Maps.

There are no lightning rods. The few that have been installed in schools, most having tin roofs, are immediately stolen, leaving the building vulnerable to strikes that go to ground in the concrete floors reinforced with rebar. Bare-foot children, feet on the damp floor—rain having blown in through open windows—make excellent conductors of electricity.

Since the end of training, this arriving rainy season would be my first of many, teaching me a few lessons about how the daily rains wreak havoc with getting things done. My first trip to the bush with my group, planned for the next day, meant I spent the day before getting household necessities as well as supplies for a day in the deep bush.

## Blog Post: November 9, In Service

Today I start home at a good trot, having brought only my umbrella (aka lightning rod—probably why Ugandans don't use them) and see black skies moving in. The deluge starts with big fat drops—up with the umbrella. Three schoolgirls in blue uniforms appear under my arm and giggle about walking with the Munu (Acholi for Muzungu), telling me their friends will be jealous. This is the big time: walking under an umbrella; the Munu is just extra. Up the hill, straddling puddles already, I finally give it up and stand under the awning of a bar.

No one is on the streets; all movement stops when the rain comes and this one's epic. Soon, people abandon the covered porch and scramble inside because the porch is flooding, the ditches are over-flowing, bringing boxes, bottles, schoolbooks, crates, and large pieces of wood screaming down the street. The water continues to rise and this is a real frog-strangler with thunder and lightning. I wait about 30 minutes—a small table floats by legs-up—and head out when the rain abates and I can jump across the river. I slog behind a small swarm of boys as they navigate the least flooded parts.

Finally at home and sitting on the cement floor, because I have no seating yet, I recall the schoolchildren and high-tail it to my foam mattress to get my behind off the floor just in time for a terrifying lightning strike that takes out the transformer across the street.

I tuck in the mosquito net, let the floor-candles melt down, turn on my headlamp, and read myself to sleep.

## To the Bush and Back

We set out at about 9:00 AM, but I got to the office at 8:15 for a promised early departure and found no one. Went to Uchumi to get treats for the trip and by the time I got back there were two small marching bands assembling in the parking lot.

I have been warned that it's a *long* day when we go to Amuru—the roads are bad, even on a good day. I've packed rain gear, water, phone, Acholi dictionary and notebook, PBJ sandwiches, a Snickers bar, hard candies for fellow travelers, an apple, hand sanitizer and wipes, hat, sunglasses... Still, I'm sure I've forgotten something. The day will tell.

I've lost one of my Sea Bands and improvise by squeezing a hard candy between my watch band and the pressure point, hoping that this spark of genius works to ward off motion sickness.

Now on the road for about two hours, bouncing around in *The Daughter of Japan*, I try to think of parallels in the states and all I can come up with is those carnival rides that make you need to throw up. I'm not being disrespectful; Ugandans feel the same way about travel. As we slip-slide through the mud, careening ominously around craters and deep ruts, we notice a great assembly of humanity on the road. Easily 100 people are standing around: women (and children) with babies on their backs—the women balancing enormous head-loads of ground-nuts or matoke; men shouldering hoes and *pangas* (machetes); bicycles hauling six-foot-long bundles of charcoal or wood on the back and chickens bound by their feet hanging from the handle bars. Many of the women carrying babies and a head-load are also heavily pregnant.

As we climb out of the truck to wander down and investigate, there in a trough of the road are three mammoth vehicles tipping perilously in different directions. Passengers have climbed out of the two buses coming from Sudan and a vintage open-back agricultural truck has unloaded its cargo of woven rice-bags. A team of six men are trying to push the cargo truck upright, while others shove wood and rocks under the wheels.

We take pictures, and rub our chins. *Hmmmmm*, an entire conversation, is shared with other onlookers and we realize there is no way the road will be cleared in time for us to make our rounds.

Precariously, we turn around and find a detour. The road continues along happily enough for a while, but then turns into more of a trail. The grass gets higher and soon reaches over the top of the truck and holes appear. Now there is no trail, just the hint of one where the grass in the middle is only four feet high, not six. I am trapped in a National Geographic special and no one is filming.

Finally out of the grass, a road appears and we continue on, stopping at learning-centers that consist of some logs on the ground, set up in rows, theater style. A group of men sketch a map in the dirt, noting the location of the new bore-hole (water well) for the village. It's a huge deal. A gathering of women sits on the ground—backs rod-straight and legs together out front, nursing babies while little kids hover around the Munu, me.

Onward like this for the next few hours, visiting other centers, one of which is very advanced because it has a thirty foot long

thatch roofed, mud-dob (dobs of mud fill the space tree-branch slats) structure where classes can be held when it rains, which it does while we are there. The wind is howling, it's getting cold and the roof leaks.

I'm shivering and realize the item I have forgotten was a jacket.

It pours torrentially and we set out for home, the roads getting worse, but the three vehicles are cleared out by the time we return to the muddy trough, and I'm thinking we're home free. Not so.

Just ahead, the road slopes down and the heretofore-shallow river has swallowed the road, yet Ojok is convinced we can make it across. Thank God, there is another vehicle stalled in the middle— water up to the windows—so he does not attempt it. We turn around to find another detour, picking up a drowned-out motor cycle and its two passengers on the way, loading them into the bed of the pickup. Hours later, having driven nearly blind through the pitch-black night, narrowly avoiding other vehicles doing the same from the opposite direction, we are back in Gulu.

I kiss the ground when I arrive safely home, discover a friend needs to spend the night because she is too ill with malaria to go back home, and set up the air mattress and sleeping bag for her. Starving, we attack the bread, but discover it is moving.... ants. I suggested we make toast, thereby killing the damn things and getting a little protein in the deal, but she declines, reminding me she is a *vegetarian*. I scramble an egg for myself and climb in bed, mud and all.

A friend today asked what I want her to send in a care package. Top of the list was ant bait. It seems I have not fully acclimated.

# 14   The Quest

Just before leaving, I started my blog, *A Texan Goes Questing*, as a way to keep up with friends and as time went by, the more I realized I was on a true quest... ill-defined as it appeared to be. But often, the object of the quest isn't known at the start.

Merriam Webster Dictionary defines quest as: a chivalrous enterprise in medieval romance usually involving an

- adventurous journey
- to search for
- an act or an instance of seeking

No chivalrous romance was involved, though I did have *seven* marriage proposals—most of them by derelicts, but a few from others offering me the honor of being their second or third wife. Hard to resist, I know, but I assured them an American wife might only bring heartache, as American women can be uppity, independent, stubborn (both a curse and a compliment here) and somewhat demanding of a husband's participation in all things household and child related. That was a deal-breaker.

Adventure? Of course. I'd be halfway around the world with nothing to offer but my inner resources and a bag of tricks, and while it was a substantial bag, could I apply them in Uganda, and if so, how adaptable would they be, and how innovative could I be? Since I would have no point of reference for much of what I would encounter, flexibility, curiosity and adaptability were going to be the mortar that held everything else together.

Was I searching? Yes, but for what? Me? Relevance? A new purpose for the second-half of life? (And yes, I do plan to live a long time.) A deeper thread that connects us all? New ways to contribute? An internal shift so complete as to produce a transcendent shift in consciousness? Yes, to all of the above.

My best moments have occurred when immersed in a reality that required new skills: storms at sea, fire department, Tunisia, reno-

vating houses, even raising babies! The idea of stepping into a different timeline was intriguing.

Was it an act of seeking? Absolutely. I knew all of my buttons would be pushed; that I would need to face fears, the unknown, doubts, challenges, possibly a lot of time alone and equally trying—possibly too much time *not-really*-alone. I knew I would have to face *myself*, without the benefit of having anyone else to blame for inadequacies or witness my successes. *Just me.*

Who would I be without my usual escapes and ego-identifiers? Would they like me? Would I like me? Was I *enough*? Would I ever be?

It was non-linear and illogical on many levels. It was out-of-time as we know it: visceral, intuitive, requiring trust, and being absolutely wide open.

The gifts and lessons of this quest are still unfolding years later: *patience? presence? authenticity?* still unfolding; *gratitude?* ever-present in the smallest of happenings; *joy?* in the most mundane of daily activities.

All of that is true, but also a little esoteric and belying the inner *turmoil* that the triggers set in motion. Facing the wilderness inside is messy business, and not all of what follows classify as triggers, just opportunities for insight.

### Time and Its Cousin, Waiting

It's counter-intuitive, but one of the most prevailing challenges and gifts was *time*. Having grown up in a culture so dictated by clocks, being thrust into one where there are so few—and those that exist are essentially irrelevant—can be a slippery slope. It makes total sense, because agrarian cultures are season and weather driven. More importantly, family and community trump schedule, and people show up when family, weather, road conditions, and transportation allow. And... because Ugandans know to make all of these allowances, they start the business of travel *only* after there is evidence of your being there—as was the case with my dismal arrival in Gulu.

Quite apart from the tension that arises when an agrarian culture begins to interface with the demands foisted on them by the inevitable encroachment of modern life and development, there's the fallout in how individuals deal with it. Culturally developed entities—both NGOs and their people—arrive with all of our

attachments to schedules, as well as our psychological neuroses around timeliness and respect.

Regardless of our intellectual grasp of the causes, many of our daylight hours were spent emotionally coping with waiting: for services, for an event, for leaving your site (because others are working and you have no apparent task—but it's not OK to leave), for power to come back on, for water to "be there." I don't know a single westerner who doesn't have some issue around time, i.e., It's a sign of disrespect to make someone wait, even worse—to not show up or call saying *I'll be late.* Few, if any of those assumptions about being late *work* in a developing country. Being late just *is,* and it's seldom personal.

So endemic is the challenge, it's wormed its way into the language to re-define words like "now."

We all had our escapes: blogs, computers, kindles, books, substances, but there was still the unexpected fallout. My computer and Kindle were lifelines and when one or the other went down, it was like falling into the abyss.

Personally, that waiting helped me learn to be *fully present*—to the sights, sounds, scents, and feelings. It was magical, surreal, joyful, painful, awe-inspiring, and transformative—often all at once. And in case it's not clear, RAIN played a leading role. Not only was it one of the sources of the need to WAIT, it, like darkness, prevented escape and gave permission to be still, to go inside, go deep.

Back in the hubbub of the States, I've been able to recapture some of that, but the art of being present is a lifetime pursuit.

Once, when my aging mother moved near me and was always wanting my *time* for something, and I had little of it, I suggested she make a list, so we wouldn't *waste* so much *time.* Her response made my heart leap, "All I have is *time.*" And then she didn't. She died of pancreatic cancer four months later.

I realize now that my greatest gift to her was the *gift of my time* and being *fully present.*

At one point well into my service, time had become so skewed I hardly knew what day it was. One day, I went to work at my normal time, and finding no one in the office, sat down on the steps and watched bright yellow petals drift down from a Golden Rain Tree announcing the tapering off of the dry season. By the time the ground was carpeted in yellow, I began to wonder why the entire

complex of offices seemed almost vacant. Surely it was a holiday and no one had bothered to tell the Muzungu.

Getting rather beside myself, I finally called Geoffrey and asked why no one bothered to come in today. He ever so calmly explained he was just having his morning tea, because "usually, *we don't work on Saturdays,*" but offered to come in if I needed something. "Oh Geoffrey. Really? Saturday?"

My embarrassment was consuming. I walked back home via Uchumi and bought a calendar, salved my humiliation with a cup of Cappuccino at Coffee Hut, and went home to read another book (163 by COS).

There, we had *too much time*. Here, sometimes there is *too little*. Whatever the case, I learned that appreciating *the moment* helps capture whatever gift may be waiting there.

Seeing the way Ugandans deal with time could be maddening, but there was always *that gift*.

### Time — Blog Post: November 23, In Service

Life is taking form. It's hard to argue with a good day. The couch came on the back of a boda and it always amazes me how they can do that, but when you see a woman carrying 100 pounds of firewood or a five liter jerry can of water precariously balanced on her head, you realize that most of life here is a matter of balancing things, both physical and emotional, we've never thought about.

Trips to the bush are part of that. Yesterday's was no exception. The mission of the day was to check in with schools to pick up forms left a week ago and determine if they are benefiting from, or even using program materials designed to give children a voice and a reason to read.

Part of the process is to give kids a chance to read aloud. Last week as such an opportunity was wrapping up and as staff were leaving, a little boy ran after us, sobbing and angry.

He was crying because he hadn't had the chance to show that he could read—a point of honor for him. So they waited, sent someone to get the book, and there on the playground, everyone stopped and gave him all the time he needed to read, to be heard. More time

It's about the relationship, not the clock.

Again and again, I'm reminded that schedules are low priority and I have to learn to slow down my mental clock, slip into a different consciousness about what's happening in the moment.

Family, feelings, courtesy, protocol and acceptance of the challenges all take precedence, and it is as it should be, but it can be wearing.

In all of these villages, children are getting excited about learning. When we arrive at schools, we are surrounded by kids and shouts of excitement at the arrival of a vehicle and a Munu. We all pile out, go into a small office and chairs are brought for everyone. Introductions are made, followed by handshakes—a three-part process. It is poor form to fail to greet anyone and the standard greeting we receive is: "You are most welcome." A few teachers are rounded up (time) and we finally get to the purpose of the meeting. Signing the Visitors' Book (time) is a must for documentation for audits and there is the matter of prestige. This is repeated at every school, without fail. It takes more *time*.

It's Saturday, the day villages can hold their learning sessions, but it's a rather loosely scheduled event. When we arrive, chairs are brought out for teachers and important people, and Papyrus mats are brought out for the first two *learners*, as students are called. News of our visit is telegraphed to the surrounding area, and *slowly-by-slowly* as the expression goes, more people, chickens, goats, and the occasional pig arrive until there are about sixty students and a dozen or so officials. People are still arriving when we leave. Learners range in age from toddlers to elderly (65+). Making it to the ripe old age of 60+ is still rare, and those with gray hair are shown respect. I am often called grandmother or Mama, a term of admiration and recognition.

Toward the end of the day, we returned to the schools that said they would have their forms ready and staff had already gone home.

It would be easy to be offended by delays and lateness, in the western way that assigns blame. But time here is just different and so, when we go out to the field, we prepare for any eventuality.

Carl Sandburg said, "Time is the coin of your life. It is the only coin you have, and only you can determine how it will be spent. Be careful lest you let other people spend it for you." So, do I go with this sentiment or *New York Times* writer, Bonnie Friedman, "An unhurried sense of time is in itself a form of wealth." Seems it might be related to what we have the least of and want more of—or once again, achieving some balance.

**The Vagaries of Language**

One day at the office, Geoffrey and I were having a serious conversation and I asked him a question that begged a detailed

response. He took a great long time delivering his answer. When he finished, I said, "Thank you Geoffrey, but I have no idea what you just said," to which he replied, "But I am speaking English!"

We laughed hysterically, but had a hard time bridging the gap. There's an assumption that since we were both speaking English, that would be easy, but it was complicated by the fact that English was not his first language and Acholi was not mine. His source language, (although he spoke other African languages as well), is a tonal language and, like any language, carries cultural references for which there are no one-to-one-equivalencies in the target language. Geoffrey, an intelligent, well-educated and well-spoken man, spoke British/Ugandan English fluently, but my American ear, with no translatable references, didn't experience it with the same fluency.

I didn't expect this problem when going from one lexicon of English to another, but it makes sense. Our cultural references and geographical references are different, as are the contributing languages that have influenced them.

All academic explanations aside, the intersection of American slang—and its propensity for innuendo—with Ugandan English (cock=rooster) could have hysterical results. This conversation was reported by a young PCV:

Walking home one day, the young woman senses that she is being followed and turns around to confront a Ugandan man, "Why are you following me?"

He responds, "Ah Madam, I have lost my cock!"

The volunteer, on alert, "Ooooh? Where do you think it is?"

"Oh just there, it is in your bush!"

Enjoying this, she replied, "Oh I think I would know if your cock is in my bush..."

"No madam, you first let me look!"

Volunteer, convulsed with laughter—can't respond.

Then there are eyebrows. It took me a while to get that one. A quick upward-jerk of the eyebrows meant, "yes!" I learned this one day when my colleague, Joy, and I were talking about travel plans, and I needed detail.

We'd been going back and forth, getting no closer to the specifics I needed. In frustration, I finally said, "Joy, I really need a "yes" or a "no!"

"I said 'yes!'"

"Joy, I'm standing right here, I didn't hear you say anything!"

"Ah! but you weren't *looking*.

Finally looking up, I said: "What's that have to do with anything?"

Wiggling her eyebrows, "I said, 'yes!'"

I still miss Joy's sense of humor and that infectious laugh that caused her eyes to leak. And so... an expression was born in this Muzungu. It took me a year after getting back to the States, to stop wiggling my eyebrows for "yes."

A lot of time could be spent clarifying what I/we thought we heard. My training in dispute resolution actually served me well on a day-to-day basis just navigating the difference in language and avoiding verbal land mines. In the local office, I felt completely safe and respected as we danced around language and cultures. Such was not always the case elsewhere.

## Language and Conflict

There's an intrinsic relationship between language and how we deal with conflict. It can range from words built into the language itself—to establish cause, or the perpetrator—to the framing of a question, or the cushioning of a query in social protocol.

I once took a fan back to a store because it died two days after I bought it. Not only is this generally "not done" in Uganda, I'd made the mistake of starting the conversation with the issue at hand. The store clerk took offense and let me know I'd not shown proper respect by talking about business first. I should have started by first asking him about his day, asking him how he passed the night, asking about his family (whom I did not know), and discussing the weather before talking about the problem. And so it was: *Apwoyo (hello / thank you), I buto maber* (how was the night / did you sleep well?) etc. etc. He didn't exchange the fan.

These things were learned over time, but in a post-conflict culture that already considers Americans loud, brash, and too direct, failure to honor protocol through proper dialog—including stance, tone of voice and eye-contact—can lead to misunderstanding and hostility where no offence is intended. A simple conversation can take a lot of energy, and is anything but casual.

I found myself constantly questioning my assumptions, the intention behind my words, the sensitivity of my interaction and my judgments. In short, I became hyper-conscious, not only about my surroundings, but the energy/intention I was putting out in every interaction and my corresponding choice of words.

68

It was eye-opening and humbling and—again, exhausting. The patience and understanding of a culture so different from mine mirrored the patience and understanding my counterparts extended to me. They had welcomed me into the fold and I never felt an ounce of frustration from them as they helped me find my way through the cultural maze.

For a writer, whose identity is so tied to language and the ability to use words to convey nuance, it was humbling to be laughed at—even in good humor—and to constantly have to think in terms of how *not* to use a larger vocabulary, but as few words as possible and those a non-native speaker would be most likely to understand. I know they did the same when speaking to me in Acholi and I had a much smaller working vocabulary!

When I returned to the States, I felt a bit aphasic because half of my vocabulary was simply gone. I have a visual of big words—fancy words—strewn all over the landscape in Africa, like the detritus of a forgotten life.

## 15    You Have Been Lost

Thanksgiving dawned with a house full of volunteers draped on various beds, air mattresses and the new couch, an open wood-frame type to discourage homesteading by critters. The couch had been christened the previous night as we sat eating fresh popcorn, scrunched together watching a bootleg movie on a twelve-inch computer screen. Popcorn was ubiquitous in Uganda and available in any quantity, anywhere, but it popped unevenly with hard kernels lying in wait for the unsuspecting tooth, thereby keeping Kampala dentists funded. I broke two teeth while there, one from popcorn, the other from a bone shard. However, no teeth were harmed in the making of Thanksgiving, which was amazing considering the array of food that presented itself, and the manner in which some of it was prepared, including turkey.

No Butterball brand turkeys here—this one was strutting around the day before—unaware of its impending fate of having a beer can shoved up its behind, being covered in foil, and smothered in hot coals.

Eventually, whisky made an appearance as did wine and warm beer. We were a happy group and got happier—if not more inebriated—as the day wore on.

The next day, our first trip to Murchison Falls Wild Animal Park, defies description, but our small contingent spent the day riding atop a safari vehicle gaping at a grand assortment of wild creatures in their natural habitat. We were renewed. That was followed by a Perma-Gardening workshop, and by the time I returned to work, I'd been gone five days, an absence approved by LABE.

**Another trigger: Blog Post: December 7, In Service**

When I returned from Thanksgiving I was greeted with "*You have been lost?*" Well, my hackles went up... "Noooo, I *told* everyone where I'd been and.... and... and..." The comment hit me as sarcastic, like my mother used to ask, when I'd not written for a while,

"What? Did you break your arm? You haven't written...blah, blah, blah."

Then I remembered soon enough to save myself from humiliation. "Have you been lost?" or more literally translated, "You have been lost?" is Uganglish for, "You've been gone a while!" No sarcasm intended, not accusatory, just "Hey, we've missed you; noticed that you were not here!"

Such are the cultural and emotional land-mines, but I find it is more of an opportunity to get face-to-face with my own foibles than anyone else's, so I had to laugh at how easily my insecurities were triggered.

~~~

By Thanksgiving, we were just getting our footing at site. Things were still new, and having just flown the nest of HomeStay, we were still getting the lay-of-the-land and there had been little chance to apply the things we'd learned in training.

Learning where to find things, the personalities of our office-mates, and the work of our organizations, we were wide open and anything and everything could actually be a trigger. *You have been lost?* had absolutely no malice in it, but it was a trigger for me because of a lifetime of having been observed and criticized. I'd been hyper-responsible all my life and nothing had changed, *but in this case,* old networks lit up and I reacted with old feelings of having been blamed. You'd think you'd outgrow these things, but not so.

And that's what triggers do—reveal the skeletons in the emotional closet, exciting the neural networks created by past trauma and left to fester.

The good news/bad news was that Uganda was a trigger-rich environment, because we were at our most vulnerable, without the usual defenses. In our customary milieu, we can avoid most things until the proverbial two-by-four hits us in the head, because there's always another distraction. Uganda offered plenty of t-i-m-e to reflect and dive deep. A person could slay a lot of demons if so inclined, and I was.

Hypervigilance

Our general sense of disequilibrium was aggravated by an abundance of physical risks. One could come to grief almost as easily on the sidewalk as walking in the middle of the road. Walking home one day—well off the road on the sidewalk, a steel beam carried on

a boda missed my head by an inch. It was pure luck—I didn't see it until it was abreast of me.

In another freak incident, two young Ugandan teachers hopped off a bus and onto a boda for the trip home. The boda hit a rock, throwing both women into the path of an oncoming bus. Life in Uganda was perilous.

While the physical risks were more identifiable, the resulting sensory and adrenal overload from being constantly aware had the undermining effect of making us more reactive to things that might not otherwise have registered.

The entire north surely must have suffered from PTSD, stemming from the atrocities of war, and alcoholism was rampant—even children were seen swigging homebrew from small plastic pouches. Roughly half the foot-traffic at any given time carried pangas or long knives as tools of their trade. When you blend trauma, alcohol, and pangas, what could possibly go wrong?

Hypervigilance developed pretty early in the game, but mine had started in childhood from an unending litany of freakish incidents. That may have served me well in Peace Corps, but when it bled over into other aspects of life, it was problematic. Peace Corps offered me yet another opportunity to examine this tendency and ultimately to resolve it.

The Fish Bowl

We'd been told we would be treated like rock stars without money, which turned out to be pretty accurate, except people thought we had money, and although we didn't, we certainly had more than they did. We truly did live in a fish bowl—every action was observed, people knew where we lived, what we ate, what kind of beer we drank, and who our packages were from. We were on parade wherever we went and Peace Corps reminded us often that we were essentially ambassadors—so behave! Sometimes it was the locals who had to remind us to pay attention.

Take Caroline, my landlady: when I had to have keys duplicated for my back door, it was she who flew into a full tirade, letting me know I'd probably be robbed or murdered in my sleep. She reasoned that the key-maker surely made a clay impression to use in duplicating my key later, and he would know where I lived, *because everyone knows where the Muzungus live and work*. Her closing volley: "You Muzungus are always watched!" And we were, but usually not with ill intent.

Boundaries and Self-Advocacy

In a culture that is less individualistic by nature, and where we were objects of curiosity and misperceptions, we had to learn early on to set some boundaries and advocate for ourselves. Because of my age and the fact that elders are held in such deep regard, I didn't have as many issues as some of the younger women. As a result of my energy work, I also knew how to create a "safe-space" for myself.

My experience has been that if I take responsibility for the intention I bring to a situation and for my own energy, meaning the energy that extends naturally around my body (biofield), I need to set fewer boundaries verbally. If I do need to verbalize it, the emotion / frequency I bring to that contributes to how it's received.

Still, there were times I had to get very clear about what I would and would not do. One of those times had to do with night travel, discouraged by Peace Corps for good reason. After a few harrowing nighttime returns from the bush, I finally screwed up the courage to let my colleague know I wouldn't place myself in a situation where we would be on the road at night, and that meant opting out of some trips to the field. I let him know I wouldn't be returning for the next day's field visit, and his response was: "Oh, Madam Nancy, you are so funny!"

"Happy to be so entertaining, Geoffrey, but I'm still not coming," I rejoined, and we both laughed, but he *heard me*.

Sometimes, self-advocacy meant stepping out of my comfort zone and honoring my inner bitch. Growing up in the fifties in the South, I'd been trained to squelch inconvenient aspects of my personality. The rules of a constrained society and mom's depression-era, full-of-fear-and-hope mothering conspired: it wasn't acceptable to be too much of anything—too energetic, too public, too intuitive, too expressive, too independent, too sexy, too fat, too defiant, too weird, too—*different*. An argument with Mom was likely to end in her threat to have me institutionalized. I learned that disagreeing was dangerous.

I had to learn to advocate for myself without putting myself at greater risk for having done it.

16 The Teakettle

Blog Post: December, In Service

So catching up... To those of you who noticed that I "have been lost," thank you. And the story is:

Somehow I have managed to avoid the ordinary things that send one to Medical: malaria, diarrhea, broken bones, mango flies, tsetse flies, cracked teeth.... Yet I have been in Kampala at Medical since Saturday receiving daily care—not for any of the above, but for second and third degree burns caused by an electric kettle.

Friday had been a really good day: a half-day at work. I rounded up makeshift curtain rods for my makeshift curtains made from Congolese fabric, hemmed using my Midget Stapler, and hung them all before dark. As I sat at my computer, surrounded by candles, the electricity came back on, and while this is normally a good thing, that night had a special treat in store.

Smoke was coming from the empty kettle: an electrical short?

I gasped and walked over, grabbed the handle to get the kettle off the heating element and the entire bottom fell off. It was kind of an "Oh shit" moment until the thing hit the floor and splattered the molten contents on my foot. Then it really turned nasty.

When I grabbed my foot, the skin on the first three toes stripped off. I dropped the kettle, which wasn't on fire *at the time*, but it burst into flames when it hit the Papyrus mat, causing it to follow suit. It would have made a great "Keystone Cops" episode had it not been for the obvious.

My shriek of pain brought my Ugandan neighbors running. Shoulder to shoulder—faces pressed against the kitchen window, they shouted, "You are hurt? Let us in! What has happened?" I'd locked myself in for the night, so couldn't even unlock the damn door, because—while skirting the fire—I stepped on a patch of the molten-something on the way to the key! I managed to find a couple of water bottles and threw water on my foot and on the fire, causing both to sizzle.

Hopping around the house, I finally located other keys. Water! I needed water! Water was finished. I had filled the jerrycans before this fiasco so everyone ran around, found the jerrycans and basins, filled one with water and I submerged my foot. Only then did I realize the remaining skin on my toes was furled like curly wood shavings.

What to do? We're not supposed to go to the local hospitals and how the hell would I get there? No one has a car. Can't ride a boda. *Call Medical. Where is my purse? Where is my PHONE?*

I found both and to my great luck, my friend Karla was coming into town with a ride. Medical approved a trip to Gulu Independent Hospital, and 20 minutes later I hobbled in with my foot wrapped in a wet pillowcase.

A very competent doctor assured me debriding the wound did not include stripping the skin Hannibal Lecter style—this after I'd asked for morphine—but only if I could see the needle come out of the package (for safety reasons). My blood pressure, usually a mellow 110/74 pegged at 180/85. Pain will do that. He suggested we wait, fearing a stroke if I had to endure more pain.

He refused my morphine request and after begging, he consented to ONE Tramadol and a few Tylenol, but only after debriding with no pain killers. Several hours later, I returned home to the scene of the crime and commenced figuring out a ride to Kampala. No one in their right mind travels in Uganda at night, but the next morning, Medical sent a car.

For better or worse, I am here for at least a couple of weeks and will be allowed to return to site when all burns are completely healed. There have been some tense moments as I overheard whispered worries like *skin grafts* and *she'll want to keep that toe.*

Karen, the nurse tending to this on a daily basis, is deft with dressings, tweezers, and scissors. Kinda makes you wince doesn't it?

PCV's response when I warned them about this kettle:

"WHAT? *You mean you have power?*"

The Aftermath

Daily debriding and re-dressing of the burns kept me in Kampala for weeks, as each toe was carefully debrided, wrapped like a delicate piece of crystal, and my foot tucked into a festive, blue plastic bag. Any outside germs from Uganda's smorgasbord of possibilities could have cost me my foot or worse. During treatment I was offered Demerol, but declined, knowing I would be stupid all day if I took

it. Instead, I'd learned a trick of pressing my thumbnail on my instep as hard as tolerable, to distract from the pain of the debridement. Not sure where I learned it, but it worked.

I had a new problem: I couldn't walk and had to keep my hoof above my heart for the next week. That meant no moving around, no finding food, no showers, but Peace Corps had a solution: Nurse Betsy.

Nurse Betsy, a Ugandan woman, shared a home with a well-off woman in Kampala on the condition that the place be used to help Peace Corps volunteers who weren't dire enough to justify a hospital, but incapacitated to the degree of needing care. Nurse Betsy was a treasure—the perfect mother away from home, preparing lovely, nutritious meals presented with flourish and artistry, washing my clothes, and ironing things that have never seen an iron (no mango flies on her watch), setting up an ingenious wand-shower, and pampering me.

After I could hobble without passing out from pain, I was moved to a Guest House within walking distance of other services, though Peace Corps still provided transport for daily wound care.

This went on for another few weeks, me still teetering around on crutches and still sporting a bright plastic bag. Daily visits to Medical put me in the thick of things.

Blog Post: December 12, In Service

One PVC came in today with a *jigger* in her foot. No, no, don't get excited—not like a jigger of tequila—a little flea that torques under your skin when you walk through grass with open toed sandals. It's a nasty little beast that literally augers its way in, lays eggs and sets up housekeeping until you cut the skin and pull it out.

Another volunteer came in looking like death warmed over—probably Malaria. It's busy there, even if only medical happened, but this is also admin headquarters. There are 175 of us in-country and something is always happening: workshops, meetings, lost passports, passing through.

Bits of conversations: "Hey, howyadoin? Get those test results back?" "No?" and "Oh, you need another stool sample? I'll see what I can do... Can I just bring it in a jar?" "You have a rash *where? Is it moving? It's alive?*"

The fact that this seems normal is bothersome. It's something one can only hear in Peace Corps where the conversation turns to things

scatological and pathological—dysentery, parasites, stool samples, fungus, bites, bruises, on and on—ad nauseam.

A friend was at the guesthouse for two weeks with bilateral *conjunctivitis*, caused by a little girl touching her eyes because she'd never seen blue eyes and didn't think they were real. Another was sent home with parasites; still another left with brucellosis. While medical staff is protective of privacy, the volunteers have no such compunction. And just to be clear, these conversations don't only happen in medical, they're at dinner tables wherever PCVs gather.

Every morning as I sit down in this Petri dish of the prurient, next to me is a beautiful Papyrus basket with bright red foil packages in it. *What are those? They're awfully sparkly and what a nice red. Christmas candies? Oh! Condoms of course.* We are in a high risk AIDS culture, so you can pick up a handful of condoms like you might pick up a handful of peanuts or M&M's elsewhere.

A while back, I went to the National HIV/AIDS Prevention Celebration in Gulu. They were giving free blood tests and circumcisions. Men would wander out of the circumcision tent with the tip of their gauze-wrapped penises sticking out of their trousers; a few wore t-shirts announcing, "I've been circumcised." A woman came by with a big box, cheerfully handing out long strips of what I thought were treats. *Oh, I want some!* Oops! The men are grabbing; the women are giggling, and some are snatching them and hiding them quickly. *Oh, condoms, again. Well, never mind.*

If the number of used condoms littering the ground on roads and public areas is any indication, Uganda's drive to end unprotected sex must be working.

Christmas Debacle

Being in the thick of things also meant I had an insider's view of the raging dispute over the fast-approaching Christmas holidays, our first Christmas away from home.

We were all homesick for family and familiar things, and I was just out-of-sorts in general—sidelined from work and therefore prevented from doing whatever it was I came to Uganda to do. Little evidence of Christmas anywhere added to the malaise. In all the time I was at the guest house the few weeks before Christmas, *footing-it* (Uganglish for walking) in the midst of the commercial district, I saw only one Christmas tree and that one, artificial, but fully tinseled. Held upright in one hand, like a trophy, the tree glided through traffic as the cyclist holding it deftly threaded his way

through the afternoon crush. Nevertheless, Christmas and what to do over the holidays was on our minds, since Ugandans enjoy nearly a month-long break.

The rule regarding newly minted PCVs would prevent us leaving our sites during the first ninety days of service; neither could we receive visitors. Because the 90-day period included Christmas, this mandate translated into our being forced to be by ourselves over our first Christmas away from home and across the world. The prospect was grim.

Peace Corps Wall A-Tumblin' Down

As time dragged on, I still felt like a Blue-Footed-Booby, hobbling as I navigated through mud-puddles, traffic, and rain to find meals.

Medical had ceased picking me up. Instead, it was coming to me. The rains had unseated the fifty-foot retaining wall lining the steep, winding driveway to HQ, and it was spewing bricks and mud, barring access. Having passed the skin-plucking stage of wound care, the young Dr. Quissaga brought supplies, so I could begin bandaging myself, making my Christmas trip a possibility. Even more problematic was my nearing Peace Corps' limit for medical time away from site, meaning my service would be terminated and I'd be sent back to the States if I couldn't finagle being released. I was lobbying heavily.

Against the ambient angst created by admin's handling of the Christmas-furor, which was resolved by giving us four days away, each of us had our own life events unfolding on the home front. Just because we were half a world away didn't mean the other half of our lives had come to a halt. Adult children still had challenges and we weren't there; aging or ill parents and in some cases spouses, were planning Christmas without us, and some of us—including me—were juggling challenges with properties back home.

Most of us had settled on some semi-predictable contact with families. I worried about Brett, risking life and limb rescuing folks off the mountain, and Travis's work with a HUMINT (Human Intelligence) defense contractor in Iraq. Although Brett had a scheduled call every Tuesday night, Travis and I had to rely on email: no telephone contact possible, but by Christmas, he'd returned home. When the phone rang and I saw his name appear, I knew this was going to be interesting.

It was the day *before* my sixty-fourth birthday, so I knew it wasn't a birthday call. When he told me he'd been robbed ($100)

mailing my package, I thought *rates must have really gone up!* But an actual gun-wielding bandit had demanded Post Office clerks come out from hiding and give him money. When they refused his invitation, he robbed the patrons instead.

So next time you think you've been robbed by the cost of mailing a package, be glad you weren't in this particular Twilight Zone.

Christmas

My constant lobbying for medical release finally paid-off. Although I was still sporting the beautiful blue foot decoration and changing bandages, I was released on the condition that I had someone with me who could help with bandaging and mobility, but *only* if I was mostly stationary for another week or so.

Best friends, Bill and Holly, (collectively known as Bolly) picked me up for our planned trip to Wildwaters Resort, an elegant and remote hideaway on a tiny island in the middle of the River Nile.

If training and the burn were versions of Hell, Wildwaters, approachable only by canoe, was evidence of heaven-on-earth. Each room faced the rapids, meals were epicurean delights with no trace of beans, rice, posho or matoke, and each room had a claw-footed tub gracing the private verandah.

Each morning dark-roast French-press coffee magically appeared at my door, and I had just been granted limited "freedom to bathe." The claw-footed tub beckoned. Even with all that, the pièce de résistance was the homemade gingerbread man left on each of our pillows on Christmas Eve.

It was worth taking funds out of my meager savings to buy this slice of much-needed pampering and escape before returning to the realities of the next two years.

Homecoming

When I finally returned to Gulu after over a month's absence, I was still on crutches, still sporting my blue wrapper, but hobbling along at least to grocery shop. The drivers at the boda stages—always scanning the road ahead for a possible fare—spotted me. I was hard to miss.

In a spontaneous act of welcome I will never forget, some twenty boda drivers streamed across the road and started cheering: *Madam! You have been lost! Welcome home!*

I was indeed home.

17 Emotional Rollercoaster

Beginning to Thrive

Despite all manner of diseases, broken bones and the resulting trips to South Africa for orthopedic surgery—two volunteers thus far—various as-yet undiagnosed, but churning maladies, and the Christmas blues, we were beginning to thrive. By four months in, we had developed some coping skills, upped our individual and collective patience, tolerance, and sense of humor and are beginning to form real friendships with our Ugandan counterparts. There has been a lot of laughing, because Ugandans like to laugh and nearly everything here is an opportunity to share a laugh or a joke, most of which culturally bypass me.

The things that drove us crazy earlier had either become part of the weave of life or mere annoyances, and we were learning resistance was futile. We were in Africa as guests and helpers who could leave at any time, and some of our group had indeed already gone or been sent home. Before getting too bent out of shape, it helped to remember that this was a choice we made and whatever challenges we faced, how we reacted was also a matter of choice.

We all had our coping mechanisms and avoidance strategies, but packages from home were at the top of everyone's list.

Gulu was practically the end of the line in the north, but it served as a gathering place if you needed to escape to a hotel with a swimming pool, connect with other northern volunteers, or get a package.

The Post Office was at the far-end of the wetland road, marked at the beginning by a towering dead tree bedecked with 3-foot tall Marabou storks, sentinels that set the mood for the pre-dawn walk on travel days. In the daytime it was a never-ending parade of transport and humanity as the only road to my work, the Acholi Inn, and all-places-north. Our friends, the Post Office clerks, watched for us, especially if there was an unclaimed package.

At one point, running perilously low on both coffee and my OTC sleep-aid, I emailed Travis, begging for a mercy-shipment of reinforcements. Even though Uganda produced wonderful coffee for export, it was sold only in Kampala; elsewhere, there was only the canned instant stuff.

When the box arrived, a voice called out from behind the fence as I walked to work, "Madam Nancy! Madam Nancy! You have box waiting! From your son! I think it's coffee! You first come!" And so it was coffee—I could smell it from five feet away. Even though triple-bagged, some grounds had been slung out in transit. Packages often came with a note of apology to the effect of *we're sorry we screwed up your package, but think/hope everything is intact.* Mostly it was.

Brownie mix was another source of ecstasy, in spite of the fact that no one had an oven. Ever the optimist and because I sometimes had electricity, I finally bought a countertop toaster-oven in great hopes of baking something. Everything was baked in segments— segments of time, segments of recipe—and it made for some very interesting results: things partially-baked, misshapen, burned, or all three at once. Frequently we would just forego baking and eat the mix with a spoon. It didn't matter; it was a taste of home. Raw batter? Salmonella! No problem! In the face of all the other possible diseases, that never made our shortlist.

Like water, another thing Americans take for granted is eggs: they're always available, usually healthy, and essentially fresh, having been refrigerated. Eggs in Uganda were a luxury and the fact that my host family spent the money to be sure I had them was a testament of their affection.

What was most surprising was the color of the yolk and how that influenced taste. Sameer offered both local eggs (whitish yolks, dusty taste) and more expensive Kampala eggs, with rich golden yolks that tasted like home. We used the *float test* to determine freshness: if it floated to the top of a glass of water, it was tossed.

Meat was a crapshoot. The mystery meat available as street food could carry brucellosis, HIV if monkey-meat, Ebola, parasites, salmonella and any number of other bacteria from partial cooking, etc. I avoided it at all costs, taking packaged tuna or chicken to the field and claiming a fussy stomach to avoid offending my hosts or achieving Ugly-American status.

The Doldrums and the Noise Within

The concept of *thriving* is relative. After Christmas break, when life seemed to be leveling out and I had one-and-a-half working feet, LABE let me know work wouldn't gear up until January 15th. Under ordinary circumstances, two more weeks of vacation would be greeted as good news. Here, not so much. Friends had gone back to site and Gulu had become a veritable ghost town.

To pass the time, I read, put together puzzles and occasionally hobbled around town or to a Catholic Charity known for its work with women and children living with HIV. The walk took me down rutted, dusty roads populated with bodas hauling everything from a family of five to couches, full-grown cows, and refrigerators. Small compounds of thatched roof tukuls (mud-huts) with naked babies playing in the dirt lined the road; pregnant women—most hauling a baby in a back-pouch, worked their gardens, made home-brew from Sim-Sim (Sesame) seeds or mopped their front porches in the way Ugandans do, folded over at the waist, legs straight. I passed an outdoor gym, where guys were doing squats and dead-lifts with steel poles using cement blocks for weights.

At the compound, gates opened into a common area with workshops to one side. The place hummed with creativity: women dying brightly-colored fiber used in weaving exquisite table runners, shawls and cloth; freshly tie-dyed fabrics drying in the sun; and women rolling paper beads for necklaces—all sold in the on-site shop. I never left empty-handed if my stipend would allow it.

Blog Post: January 4, Year One

When our group of twelve was posted to Northern Uganda, five of us in Gulu Town, we were told it's NGO central. I don't have a list of all of the non-profits here, but suffice it to say, if you threw a rock, chances are high that it would hit someone associated with one. At no time has this been more evident than with their *absence* during Christmas break.

The doldrums have struck. I have: eaten everything that's not nailed down or wriggling, walked until I ache, spent until I can't, responded to the pitifully scant e-mail, checked at the Post Office for packages that haven't arrived. I've washed mud boots and muddy work gloves for Chrissake, studied Acholi until I now dream in Acholi, and am now reduced to homework.

I have even considered buying a hoe and scraping the weedy patch in front of my house, but it's not in my budget.

The marching band that practices just behind me has tuned up and I thought they might have added a measure to their four-measure favorite, *When the Saints Go Marching In*, but it was a false alarm.

The doldrums are an interesting experience we've all been warned about. Down time in the States would be pregnant with possibilities. Here, the result is sometimes just a stillbirth. When all else is "not there" or out of reach, the terrain one has available to explore is *self*.

Where's my map and do I even want to go there? Maybe there's still time to go get that hoe before dark...

Channeling My Inner Plumber

Some excitement arrived in the form of a plumbing crisis, revealing latent skills. Somewhere between homework and the marching band, I heard spewing water and headed toward the sound. Wasting water is never something to take lightly. Running toward the source, I met a lake coming into the hall through my bedroom door, and promptly fell on my butt. Uttering profanities, my housemate came to see what the fuss was about and helped me up. As a hefty Russian told me years ago on a flight, while tossing my suitcase in the over-head compartment, "Sometime a woman NEED a man." Apparently so, but he was no plumber.

Treading carefully, we went to the bathroom to find water gushing out of the tank and opened the lid to be blasted by a geyser shooting up from the broken inlet valve. No water turn-off on this toilet, so I stuffed one of those soft local candles in the pipe and the housemate held it long enough for me to find the broken part lurking in the bottom of the tank.

I can't even imagine how long it would have taken to locate such an obscure part, so I needed to fix it.... Dental floss! Tough, water proof, pliable. Ever since childhood, when I watched my dad repair everything from engines to gizmos around the house, I've had a propensity for fixing things. Granted, they were often the things I had broken, but I developed a mechanical aptitude and it's served me well here.

I wrapped the floss around the gizmo, tied everything back together again, with more dental floss and VOILA! a repaired toilet, proving again the old saying: Necessity is the mother of invention.

18 Screams

Uganda is complex, as I believe is true of much of Africa. Although every country has its own history, most of Africa has experienced colonization, war, disease, and crushing poverty. It is far more tribal that anything most Westerners know and in that regard, there is shared suffering and loss, as well as shared joy. In that context one might assume that one person's pain would cause friends or neighbors to either intervene or at least inquire.

I am no expert on the etiquette in such a communal culture, where there is little privacy in living situations and where the protections to which we have become accustomed simply don't exist; so what happened on a rare quiet evening was startling and left me filled with questions and unrest.

Blog Post: January 11, In Service

After an exhilarating round of Mosquito Zapping with my new tennis racket zapper, I settled into a quiet night reading *Pillars of the Earth*.

Being Sunday, it was a quieter night, power was finished, and there was neither the white noise of the fan nor the thudding bass of bar-music to mask the bloodcurdling, guttural screams that pierced the silence around 10 PM. It went on-and-on. It was the kind of scream that, in the States, would wake the neighborhood and result in multiple calls to 911. Here there is no such thing, although there is a 999 which rarely results in action. And after all, it could *just* be "wife beating," an offense that, while formally discouraged by the powers that be, is still largely a culturally accepted event.

What to do? We have had discussions about this during training. Do we intervene and if so, how, when and to what degree? I remembered one of the primary tenets of my EMS and Victim Services training: *consider your own safety first*. With domestic violence here, there is usually liquor, sometimes a knife or weapon, and chances are—bloodletting—which also means a high probability

of the presence of exposing self to HIV/AIDS. According to my housemate, whose room backs to the tenant's quarters, their conversation simply continued with no apparent concern, or at least not enough to result in action.

The screaming went on and there were no other voices, no talking, yelling, running feet, furniture crashing etc. It finally trailed off into the town and was replaced by some male voices in the distance, then came back to the neighborhood in slightly less violent tones, and then settled into sobs and retching. My body felt called to action: stomach was tightening, heart racing, senses tingling, but I knew not to follow through.

The next day, I asked the Ugandan nurse who lives in the quarters behind my house about it. She gave me a slightly deprecating smile that implied it was nothing, then said, "*it is nothing to disturb you!*" Hmmm. that's not doing it for me, because one thing is certain, I was certainly disturbed. So I prevailed, and was told, "She was probably being beaten by her husband. But it is not for you, it is for them." Well *that's* certainly reassuring.

Later, I asked my visiting houseguest, who lives on the compound grounds of a residential secondary-school for girls, and she told me that such screaming is not uncommon and is not always proportionate to the event. *Well now I feel better.* None of this was helping. She explained that they often get that level of drama from self-imposed exorcisms and teacher-inflicted caning, still used in corporal punishment. Still not helping.

All day, I was left looking at everyone I passed on that street to see if there was any evidence of what went on in the middle of an otherwise quiet night in this small town in the middle of Africa, knowing that this and similar scenes are probably played out time and time again in other little villages where no one really intervenes or talks about it later.

This is Africa.

Mob Justice

Related to the general question of intervention, was the more specific one of how we should handle personal attacks, purse snatchings, or other incidents where we ourselves needed intervention.

The legal/justice system is poorly developed, cumbersome and riddled with fraud, and the tribal structure of village elders, who might have dispensed justice prior to wars and colonization, no

longer exists. In the absence of reliable legal remedy, redress fell to mob-justice—swift and brutal.

We were cautioned that if we were robbed in the market and reported it when the offender was present, mob justice would likely see the perpetrator beaten and/or killed—even for a minor infraction. We really had to make a choice between our loss being "acceptable," or accepting the probability of someone losing his or her life over a stolen *whatever*.

If we felt absolutely compelled to intervene in an instance of family violence, we were told to find another villager, who would be better at accessing what should be done, if anything.

The incidence of extreme measures taken for a minor offence were not uncommon even among individuals, as became evident over the course of my service. A newspaper reported a son having beheaded his father with a panga for killing one of the son's chickens to feed unannounced family guests.

A friend living in the next town lost a young Ugandan counter-part, beaten to death for being unable to repay a debt of a few shillings, the equivalent of a nickel.

Another first hand report came from a volunteer living in a small village compound, where the second wife took offence to a privilege given the first wife, and poisoned the first-wife's five-year-old daughter.

Around the time of Mid-service, when I took offence to a headmaster beating Peter, the young man whose education I was funding, I was cautioned to stay in at night and not go near the school for the next few months.

In such an environment, when a disgruntled babysitter in the compound became angry after I asked her (politely and repeatedly) to stop opening my curtains to watch me in my own house, I bought bottled water for the next month, afraid she may poison my water-tank.

It was a culture of contradictions. People were kind, generous and generally joyful and "God-fearing." So often, walking down the street, locals stopped us, saying "thank you for your work." But these same people were so damaged by their history and their circumstances that even honorable people might take your belongings to buy food or medication for their family. It wasn't about character; it was about survival. What they stole from us wasn't life threatening, but their *reason* for stealing often was a

matter of life or death, perceived or real. And they were right. we usually *could* replace our stuff. We'd be pissed, but wouldn't die.

How we dressed, conducted ourselves, made an effort to greet people in their language and honor their sensitivities: those were the fabric of our safety net and most of the time that worked, but not always.

One good friend, traveling with her NGO, was involved in an automobile accident caused by road conditions; a combination of factors that resulted in the death of a child.

Wielding machetes and rocks, an angry mob of villagers surrounded the car—ready to exact their pound of flesh. My friend was able to contact PC just before the phone died, and quick police intervention saved them, but not before the crowd also threatened to burn down the police barracks, where they'd been taken for their own safety.

~~~

The paradox of all of this is that when I yelped in pain on the night of the burn, I wasn't even aware of it, yet my neighbors were there in a heartbeat. It wasn't apathy that prevented them from acting in some circumstances, nor innate brutality that generated mob violence in others, but understanding or predicting the behaviors between these two ends of the continuum was confounding.

# 19 A Day in the Life of a Bus

Every January, *Literacy and Adult Basic Education, LABE,* holds its annual planning meeting in Kampala and we were all headed down on the bus, and it's not the Post Bus. It was the first of only two times I rode a bus other than the Post Bus, because there were no other options. The reasons will become obvious.

### Blog Post: January 16, In Service

There are reasons I'd rather drink bleach than ride a bus to Kampala, and yesterday I remembered all of them.

The morning started at 8:45 in theory. Actually, mentally I started two days before, by asking the staff, "Now, how are we getting to Kampala?" Praying against hope that we would go in a vehicle other than the bus, this was not to be. One would think, with this conference being on the books for essentially a year, that advance plans could have been made. I am not casting aspersions on my LABE colleagues; they are lovely, intelligent people who deliver amazing services under difficult circumstances. This is not about them. It is about buses...

The problem is, one cannot actually buy tickets in advance, even if one might perchance go to the bus office—if there is one—and try. Either it doesn't run on Sunday, no one is there, "tickets are finished," or my favorite—it's just not done. "You just come and see," means come early and wait-to-see: if the bus arrives and if so, are there any seats.

This is not as straightforward as it sounds. The drill, with few exceptions, goes something like this:

Arrive at least an hour early and stand around the dusty, chaotic bus park waiting to see what comes along or which ones are there and planning to go to your destination. Try to keep your hands on your luggage and pray that you have packed light—meaning a bag you can put between your feet, on your lap, or, if you're terribly brave, in the overhead. But if you do that, put it across from you so

you can keep an eagle eye on it every time someone gets on or off the bus. Don't doze; your bag may walk off while you catnap. Take it with you when you go pee at the one stop between embarking and wherever.

When/if the bus arrives, run like a bat out of hell to the door and join the crush waiting to force their way in the door as *others are trying to force their way out*. None of this polite crap about letting people exit, having someone SEE how many vacant seats there are, etc. No, no! The rule is: if there's space for a hair between you and the person in front of you, you are not close enough. Someone else will see this as a break in traffic and insert themselves. As another PCV said, if your front side is not pressed against their backside (I've cleaned this up—the original version was much more graphic), you're too far apart. Ignore the crush of vendors hawking their wares at the windows and the arms and legs sticking out of the windows for various reasons. This does not instill confidence.

As the door opens, quickly insert as much of your body as will fit, shoving your foot up to reach the step that is two feet off the ground and grab something—it doesn't matter: a rail, foot, arm, piece of clothing, chicken or leg of goat. Insert self. Force self through one-foot wide isle against traffic and get as far back the isle as possible to be SURE there are no empty seats. When you discover there ARE no spaces, repeat the process in the opposite direction.

Against all better judgment saying, "there are NO FRIGGIN' SEATS IN THIS BUS," and I would rather die than get on this bus, our entire group of five persisted in this process (one carrying a two-year-old) and all of us carrying luggage. I followed like a lemming because if they magically get on and I do not, I have to repeat this process alone. And face it, apparently this is really the only way to get a seat. Those that wait don't get on the bus—ever! Unless you take the following approach:

*Wait* and see if an empty bus waiting (if there IS a bus waiting) will actually fill up to leave sometime that day. After missing that previous bus (called The White Bus), and another (the Homeland Express) which was booked with a private party, and another in a different bus park, I finally pleaded the case of finding a nice window seat on the empty bus 10 feet away, before that one too, fills up while we wait for a phantom bus.

We do this, just before the crowd emerges out of nowhere to take remaining seats. Sometimes this process takes most of a day and—for the most part—buses DO NOT LEAVE until all seats are filled.

This usually means not only are all the seats filled, but in some seats there is the passenger (usually a mother) with three to seven small children in or around her lap or standing in the isles as was the case on our bus. Friends who recently took a bus and sat in the front— known as the suicide seats for obvious reasons—had to climb over mounds of luggage, a baby goat, a pile of live chickens, and assorted people to get out.

This scene is repeated hundreds of times per day in bus parks all over Uganda and is absolutely routine. If you are lucky enough to be traveling on a weekday, you might be able to show up at zero-dark-thirty and get on the Post Bus, the only one that leaves at a pre-specified time and sometimes sells a ticket in advance (but often not). Still, arrival way ahead of time is the only way to ensure a seat and there are still goats and chickens and one latrine stop.

It's customary for the driver to lead everyone in prayer before departing. This might seem like a good idea, were it not for his asking that the bus be covered in the blood of Jesus. Symbolic or not, it seems like asking to be covered in anyone's blood is just inviting trouble.

P.S. The White Bus that left two hours *before* us arrived *after* us as we waited for a taxi at our destination. The *other* bus, which was having a flat tire fixed as we left, had an accident en route, colliding with a large transport truck—injuring 30 people in the process.

Just another travel day in the Pearl of Africa.

## 20 The Way Things Are Done

The annual workshop was one of the few times Kampala Leadership and field office personnel responsible for delivering the services at the local level came together. It was a fascinating look at decision-making in a country driven by consensus-driven problem solving and a strict avoidance of any one taking the lead. Challenges of program delivery aside, this was an education in *how things are done*. It was illuminating.

### Blog Post: January 23, In Service

Last week's workshop was an intense cultural immersion. The people I work with are totally committed to their work and trying to create systems that may be old-hat in the States, but are new here. This means examining *process*: what's working and what's not. And that, of course, has been largely my business for the last twenty years. So I guess—for better or for worse—the universe dropped me in the right place; though doing it here is another "not so straight-forward" process. Everything here is consensus-driven, and that can be a sloth-like and tedious bit of work.

By far, the most exhausting part of the week was being immersed in the labyrinthine dynamics of how decisions are—or are not—made and feeling my way through the morass of differences between the *Ugandan Process* and what a similar meeting might be like in the States. For someone who has enjoyed the total autonomy of acting as a committee of one for the last two decades, I have not had to work within the confines of group decision-making. So this could be frustrating even in the U.S., but the degree to which consensus is required here has become an *art form* and offers a lot of insight into the business of life here—or maybe it's just the life of a business. I have been doing a lot of tip-toeing.

Ugandans have told me that theirs is not a culture that delegates responsibility, and it's been a study in delay to see how systems operate around that. It is an outwardly polite culture that functions

within a very tightly wound tangle of protocol, policies, rewards, punishments and Byzantine power struggles. This is hard for those of us who have operated in organizations that allow for and expect some autonomy and out-of-the-box problem solving. Nevertheless, they have been very respectful of my comments, and indeed have embraced my ideas and committed—at least verbally—to implementing them. This is both gratifying and terrifying.

This opportunity to spend some time in the belly-of-the-beast was the result of the Director's mandate that Betty and I take notes on the meetings and provide a summary of the previous day's activities. At the end we were to produce a detailed report, which is turning out to be dispiriting and intimidating. There are pages-upon-pages of flip chart notes on countless exercises that have dissected equally-countless field operations, but never corporate level operations, producing the same results each time. The verdict is out on how this approach worked, but it has produced a lot of action items and gained consensus, meaning nothing is going to happen without it. So, I will need to take a deep breath and buckle in, because I'm not on the bus alone and there are eighteen other people who actually get a vote. I do not.

This has also been a study in ceremony, acknowledgements and formality. The act of acknowledgement, "We thank the honorable chairman;" "We appreciate very much the contributions of our esteemed colleague, however..." is endearing to some degree, but compared to the faster pace of American business, where such things are assumed, evidenced in body-language, or bypassed, it feels interminable. (This polite veneer also masks underlying animosities.) Any attempt to truncate this foreplay would be an unacceptable and long-remembered breach that would render useless any information offered after the fact.

I am reasonably polite, diplomatic, observant. However, many of the behaviors informed by the double-edged-sword of colonialism and tribalism are confounding to Americans, whose DNA derives from a bunch of strong willed, rowdy malcontents with a deep suspicion of authority, and a tendency to "talk back." So, to be plunged into a system of such formality, while also trying to reconcile a lack of privacy and personal space, is somewhat of a conundrum.

This demand for formality has also been made evident through language lessons where I've been learning scenarios for meetings: introducing leaders, addressing agendas, and acknowledging

everything from the date of the meeting, to where it is held, both pretty obvious. Restating them is redundant, but omissions here would be considered a flagrant act of disrespect.

As if to underscore the point, Day One *started* two hours after the stated start-time and morphed into a very democratic process of voting on the start-time on subsequent days, as well as times for morning-break tea, lunch, evening-break tea, end of the meeting, and dinner. In the states, it would be: listen-up! Here's the agenda, be there, be on time and organize your life around these factors. Anyone two hours late would be sacked or not admitted and who cares if you like the schedule. Adapt. Needless to say, Day One was instructional.

In a paradigm where no one person is responsible for a decision, no one can be the bad guy, lose face, or be considered pushy. I'm sure this is not consciously thought out, but it is an interesting dynamic explained by a trusted Ugandan friend. I recognize the indicators in American culture—indeed in some relationships. I've occasionally been guilty of that and as is said, *it takes one to know one.* If no one makes a hard decision, no one can "be blamed." It's a scenario discussed in conflict resolution workshops I've taught, and the fallout is that important decisions are delayed or not made. When it's a deeply embedded cultural standard, and operates in every context, it's challenging to work around.

This is also a very literal culture. In business, process cannot be curtailed; no leap-frogging ahead. There is an externally derived and mandated policy for everything, except for being fired for non-performance, which is totally subjective and can be done at a whim. It keeps folks in line. Well, enough. I will do my best to play by these rules, but I don't know if I can behave myself for two years (21 months and counting). Time will tell.

~~~

Early on, I realized I was living in a pervasive state of cognitive dissonance resulting from the contradictions at play between my rigid policy-driven NGO and the holistic culture in which it was attempting to drive change. My mental image is of someone trying to push an amorphous, gelatinous mass uphill with a stick.

There were so many instances where both staff and services could have benefited had staff been able to make an autonomous decision based on their intuitive grasp of a situation in the field. Instead, they were boxed in by policy and the fear of termination for making an executive decision, considered insubordinate.

21 Dry Season, Lizards and FIRE

Blog Post: January 29, In Service

I have become a lizard... A few months ago, Joy, the only woman in my office, told me, "In February you will want to leave. Your heels will crack, your skin will flake, your hair will get dry and break, and your lips will bleed." She is psychic...

I have spent the last two hours horizontal in the heat, much like the lizards languishing on the brick wall, and the one who looks mummified in place on the screened vent in my room. And really, it's not even hot here compared to other parts of Africa; well hell, not even compared to Texas in the summer. But Texas has AC and iced tea.

The fan has come back on, and for that I am grateful. My housemate has returned after having left to catch the bus to Kampala hours ago, only to be told that it is "not coming." Seems some poor unfortunate busload of people is stranded somewhere between here and Kampala, much like the one we passed on our return trip last week. One Muzungu rider reported to us, "the bus is completely spoiled." That was an understatement.

~~~

The problem with the dry season, beyond the sense that I'd been shrink-wrapped by my own skin—horrific skin cracking, shriveled sinuses, and scratchy eyes—was the high demand for electricity, and although plenty is generated by the Nile, it was sold to adjacent countries, leaving Uganda wanting. Therefore, when it was hotter than the hinges of hell, *power was finished*. Sleep was elusive with no fan, and windows closed against the bloodsuckers. Many nights were spent basting in my own juices, the dense foam mattress acting like a second heating element.

A friend sent me the tiniest little personal fan about the size of a pack of cigarettes, and I couldn't imagine how effective that could be, until it sat on my chest blowing on my face, just long enough to

allow me to fall asleep before the batteries died and the heat woke me again. Several cold showers later, it was time to go to work.

The local lizards were the only content species, running along the tops of compound walls and clinging to the sides of buildings. They flaunted their comfort as the rest of us grabbed our hats, sunglasses and umbrellas—not for rain, but for sun. When I found a locally made straw hat with a straight brim and tied one of my scarves around the crown, the boda drivers announced, "Madam! You look like the Queen!" Almost insulted by the age implications, I realized they were referring to Queen Elizabeth's penchant for hats with a stiff brim. I loved that hat and was sad to leave it behind.

Aside from the monstrous clouds of dust that roll down the streets and ash from surrounding crop-burning suspended in the air, I would go to bed in clean PJs and awaken covered in a fine dust. Never mind *my* choking on dust; I was warned my computer would suffocate. When I first arrived, I was afraid of rain drowning my computer; its demise from suffocation never occurred to me!

I ended up buying a zippered sleeve made of beautiful Swahili fabric as well as a rubber keyboard cover for when it was in use. It had already become home to tiny black ants, and it didn't take long for the previously white case to develop a rust-colored patina.

### And Then There was FIRE — Blog Post: February 10, In Service

It's been an interesting night, as evidenced by the fact that it is 3:02 AM and I am doing *what?* as the Ugandans would say, and then answer themselves. I am blogging. It's the new cure for insomnia.

It's the first night in about a week I've been able to just nod off. Friends came over and by the light of a few candles, a kerosene lamp and a micro-lantern, four of us managed to cook a relatively gourmet meal and drink a little warm wine. Karla regaled us with her description of getting a ride to Gulu, but only after the driver stopped to put a goat in the trunk. Someone's dinner I suspect. We chased a mouse, hauled water, and fell into bed.

I fell asleep fairly quickly, but the smell of smoke-residue from crop-burning hung in the air. Later I awoke to suffocating smoke and a crackling sound just outside my window, and discovered the side yard engulfed in flames moving in the direction of the house and beginning to lick at the tree canopy. I grabbed my headlamp, threw on clothes, woke Karla, and went to investigate. The male housemate snored on.

We were wondering if we should wake David and Joseph, who live in the compound, only to discover they were already standing there—one in boxer shorts, the other with a towel around his waist—casually watching the fire, apparently unconcerned.

I managed to say, "Is anyone thinking of doing anything to put out the fire?"

Men in unison, "There is no water..."

"Well I have a few gallons, shouldn't we try?" Hmmmm, there's an idea. So I ran to get my water and a bucket and one man said, "just sprinkle it," either oblivious or resigned to the threat.

As an ex-fire department volunteer, I thought, *sprinklin' ain't gonna work here,* and I voiced the thought. They weren't listening, nor were they going for water. I wondered, *What the hell is the matter with these guys?*

About now, you are probably thinking, "Silly girl, why didn't she just call the Fire Department?" That's because we ARE the FD; there IS no municipal FD here. Karla and I began tossing water and the flames were really kickin' up as the breeze picked up. Begrudgingly, the guys managed to flick in a few water droplets.

Frantically, I suggested we get a shovel or a hoe to smother the fire with dirt; plenty of that around here.

"Can I borrow your ho(e)?" I asked.

They both gave me that deer-in-the-headlights-look. There's a question you don't get to ask every day... They are dumbstruck...

I clarified, "Your garden hoe. You have one, yes?"

Ah, they were visibly relieved... and answered, "It is lost."

Neither David nor Joseph could find their ho—I meant hoe. A ho—I meant hoe—is a terrible thing to lose. So I walked over to Diana Garden, the event center in my front yard, and asked the guard if they have a hoe... no really—like a shovel and a hoe? Now he got it. No, he couldn't find their hoe either. See? Where's a good ho(e) when you need one?

OK, I've milked that one as long as I can. In the future I will be more precise. But he did finally find the hoe and I left with her—I mean it—and a shovel. The ground was rock hard, so we literally just scooped up the inch of dust we could find in patches. As things progressed and with the hoe, Joseph finally began rearranging the fire and dragging burning logs to the driveway.

At least the Diana Garden guard sprang into action and generously offered to share their water—a couple of full jerrycans, and by the end of two hours, we had the fire under control. It's hard

96

to fight a fire with 20 gallons of water—and a ho. I mean hoe. I must remember to thank a firefighter when I get back to the States. Although I think Joseph has FF potential.

~~~

Way back, when I was hoping to use my skill-set here, it never occurred to me I might be teaching a couple of Ugandan men how to fight fire with dirt, but I think it saved the house and maybe even the neighborhood. The fire was started by a neighbor emptying charcoal embers from their Sigiri into the dry leaves at the fence line.

Blog post: February 19, In Service

I awoke to a rush of white noise—oh *no!* Another fan meltdown? It usually exhibits a methamphetamine-like frenzy just prior to the death-throes. Turning off the fan, I realize it's a tease of rain, months ahead of schedule, and I giggle. Spent the day putting together a puzzle.

It's been that kind of a weekend, but larger issues loom: seems I broke a back tooth on a popcorn kernel. Why is it always a back tooth?

It means the usual 4:30 AM wake-up and walk—in the dark, around puddles, past the bars, through the wetlands—to get there by 5:45 to get a seat on the 7:00 bus to Kampala. This *trip* is my trial by fire—my first time *solo;* no trustworthy backup to watch my belongings when I get off to go to the latrine.

I am truly dreading this trip, the bee-hive bus park at arrival, finding a place to stay, the dentist, and walking again in the dark to catch the bus back home. Travel here is dangerous, exhausting and unpredictable unless you can travel in a comfy NGO vehicle with an experienced driver. Ninety-five percent of the population travels by bus, piki-piki (motorcycle) or bicycle. A significant percentage of travelers never reach their destination.

Another looming issue: despite his vow to remain for six months, my young Mormon housemate is breaking the lease and leaving months early to go live with three lovely young women. Hormones over honor. I get it, but I'm pissed and stuck with rent I can't pay. Well, all for another day. Today there is a puzzle, a tiny remaining piece of chocolate, and a good mystery to help avoid reality.

~~~

For those accustomed to the orderly process of travel in what we call the First World, there is no touchstone for the angst and uncertainty associated with bus travel in Uganda, and much of it

starts before climbing aboard, at which point half the battle is won. Even the possession of a ticket means nothing. With any journey, there is always the very real possibility that one will arrive at the bus park to discover that the bus has been canceled (*it is finished*), or is delayed due to some mechanical malfunction or wreck (*it is spoiled*), or that it is just late (*it is not there*).

## 22    Gulu Loves Dolly Parton and The Man in Blue

On any given day, I was guaranteed to hear Dolly Parton belting out *Stand By Your Man* or Whitney Houston proclaiming, *I Will Always Love You*. Every once in a while, Kenny Rogers would tell someone, *Don't Take Your Love to Town*. But Whitney and Dolly were favorites... with Michael Bolton and Celine Dion running a close second. Ugandans love music, but oddly enough they didn't play their music; it was always Munu music I heard exploding out of the bars.

Diana Garden was a bit more respectful, because they were in a neighborhood and had been *cautioned*. They were even pretty good the night they held the Miss Uganda Contest that went on into the wee hours.

But it was a wedding reception that nearly blew the windows out, and I say that literally. Everything in the house rattled: cookware, stove, windows, doors, even the toilet tank lid. I wondered if the house would reach its resonant frequency and simply implode. I tucked toilet paper and cotton balls around every window to offset the very real probability of the glass breaking, not to mention my eardrums.

At around 2:00 AM, I screwed up my courage to go over and ask if they could turn it down a notch. I didn't want to be viewed as "an uppity Munu," and certainly didn't want to cause friction with the management, because I may need their help again.

All that said, I really like country-western music—maybe not at full tilt, but it was endearing to walk around town and hear a bit of home. I'm from Texas after all; sometimes I practically two-stepped to work.

And speaking of Texas, something I didn't expect was the dozen or so burnt-orange camp chairs carefully displayed in front of a furniture store. As a University of Texas grad, I knew that color all-to-well, and NOBODY makes or buys furniture that color unless they are Texas football fans (or got a Goodwill shipment). So I had

to investigate, and sure-enough there were the Longhorns emblazoned on the back of the seats. Damn! I was home...

## Which Brings Us to Sunday...

Sundays were a different matter music-wise, with churches controlling the first half of the day. The Muslim call-to-prayer was always somewhere in the mix, but there were many churches and that meant hymns, Amens and Hallelujahs everywhere. *How Great Thou Art* was favored, and while Ugandans are powerful and joyful singers, the churches—leaving nothing to chance in their crusade to save as many souls as possible—broadcast the music as loud as the wattage of their loud-speakers would allow.

My house was at the epicenter of four churches and sometimes, the vibrations of all that music piled up in a huge standing wave of noise that could sink a ship, and I would escape to the Acholi Inn, a popular hotel with outdoor dining at the other end of town.

It offered great fish dredged in curry and cumin, and a release from the grip of churches all around and the likelihood I would run into a churchgoer who would want to greet me and ask me where I pray.

One's congregation or religious affiliation was important in Uganda, and unlike Americans who are likely to consider religion, along with politics and sex, private matters, Ugandans have no such qualms. In fact, after the briefest of introductions, the next question upon meeting a Ugandan was likely to be about church affiliation.

This was a little tricky for me, because my quarrel with churches started young. My mother tried her best to instill some religion by taking us to a Baptist church and Sunday school, where a gray-haired battle-ax demanded memorization of scripture and other performance arts. On the day she required us to sing our favorite church song, mine was taken by the time it became my turn, so I sang the only thing I knew by memory: *the Jax Beer jingle.*

When I belted out "Hello mellow Jax, little darlin', you're the beer for me," she was not amused and dragged me out by my ear to my mother, labeling me the black sheep of the class and banning me from Sunday school. *Oh darn...*

By the age of five, I knew the three rules that—if broken— could win you a one-way ticket to hell. *No work on the Sabbath* topped the list, followed by no dancing, and no swimming with boys. At five, I had no use for rules two and three, but when we stopped in front of our Catholic neighbor's house on the way to church the

next Sunday and I saw him mowing his grass, I rolled down the window of our 1953 Oldsmobile and yelled in that voice that belongs only to small children: *"Yur gunna go ta hell!"* My dad, whom we'd called Dick since military days when it was "cute," just grinned and suggested it might be time to find another church. We did.

So my answer to that question about worship required some subtlety and became, *"In my home."* I had to offer something. I haven't been a church-goer since high school and I've never shared my spiritual life with anyone but close friends and some clients, and then only because my work as a Feng Shui consultant and intuition trainer kind of let the cat out of the bag.

Therefore, in answer to the next question, "Alone? You pray alone? But you must pray with others!" I was stymied. Uganda is so communal it was simply unfathomable that a person would choose to pray alone and neither my Acholi nor their English would support a conversation about meditation or a God I considered to be an expression of love/energy, not form.

Furthermore, the Ugandans I met were very literal and concrete, as evidenced by a conversation I had with Peter, who, as a savvy sixteen-year-old street-kid, fluent in English, had gleaned a lot from American movies and culture. Therefore, it took me by surprise when we fell into this exchange:

"Madam Nancy! I hear that in your country there is a man who can blow out a fire in a single breath!"

Taken off-guard, but trying not to show my disbelief at this pronouncement, I stumbled over some rocks as we rounded a bunch of bleating baby goats for sale. Over the din, I ask Peter who told him about this man.

Peter couldn't believe my ignorance of such a hero from my own country, "No one! I have seen him!"

This really is the twilight zone... He continued, "In the pictures! I saw him! He was dressed in blue, with a—how do you say—a cloth on his shoulders!"

Now I got it, "Did he have a big red "S" in kind of a diamond on his front?" *I* air-trace the shape with my fingers.

"Yes! That is the very one!"

"Oooooh," I try to explain that he's a movie character, called Superman, and that he was *pretending*.

"What is *pretending*?"

"It's like *imagining* something," I explained, and then he asks, "What is *imagining*?" so I explain that it's *acting,* to which Peter—his confusion and dis-belief mounting—asks, *"What ACTING?"*

Oh boy, wondering how to explain this, I tell him: "it's when this man kisses his wife and family 'goodbye' in the morning, goes to work dressed like everyone else, then puts on different clothes, like the blue suit you saw, and does lots of amazing things—maybe even dies—while other people take pictures of him. Then he gets out of the blue suit, dresses in his own clothes, and drives back home to his wife and kids, has dinner, and goes to bed. He wakes up the next morning and does the same thing. But he may be somebody different the next day. "

"Surely? You are certain about this?"

"Yes, Peter. I'm sorry… a man like that would be very helpful."

Nothing in their basic education or daily lives prepares them for the world of symbolism, or a God who is not corporeal. Life is concrete—it's what you see, and they have seen pictures of God, or at least *"his only begotten son, Jesus."*

So, I just left it at my praying alone and accepted that I would be labeled as a little strange. The thing that saved me was the fact that I came to Uganda to live and volunteer, and that was apparently enough to prove that I wasn't a heathen. But I wouldn't push the issue.

## 23　What Fresh Hell Is This?

**Trickles — Blog Post: February 20, In Service**

There was a good omen this morning... the sound of water having found the pipes again. At about 3:30 AM I awoke sweating and heard an unusual sound—not the Call to Prayer, not a rooster (that's at 4:30 AM), not booming bass, a mouse, or mosquito. Water? A leak? Naaaah, nothin' in the pipes. Wait! I recognize that sound from long ago... Yes! It IS water! Up to find the source—a little trickle coming into the toilet tank. I turn on the tap—no, not enough pressure. But I am hopeful and go back to bed. My jury-rigged fix to the inlet valve has held. God bless dental floss.

Around 6:15 I awoke for good to the staccato sounds of "who-who-who-who" sounding for all the world like monkeys, but there are no monkeys here, maybe doves.

Ah! There it was again... water for real—in the pipes! Issuing forth in a beautiful clear stream from the faucet no less! *Quick! Fill the jerrycans! No! coffee first, then jerrycans! Coffee—jerrycans—coffee—jerrycans.* Both were critical. Coffee won. *Wash something—clothes.* One never knows how long the water will last. My nightgown, which was clean a few days ago, looked like I'd wrestled with a pig and the pig won.

~~~

All that thrill in no way made me feel better about the impending solo trip to Kampala, but when I got to the bus, there were friends and while the ride was better than usual, as first-timers, we got off too early, and had to hike forty-five minutes to the hotel, after being redirected every half-mile or so.

The City Annex: Home Away — Blog Post: March 2, In Service

I have survived dental so far. I arrived and booked into the Annex—a hostel type hotel with single, double and triple rooms that share a bathroom and a shower down the hall. The good news is that the bathrooms are cleanish, the showers are pretty good and there is

HOT water. The downside is noise, and that derives from the fact that the housekeeping staff work all night, getting especially busy around 3:30 AM, banging trash cans, mop buckets, etc.

I have finished trying to work out the logic of this. Or more correctly, "Logic is finished." They are making an effort to be quiet, but it's a big concrete building with no carpet or sound-deadening niceties. You pee or shower? They'll hear in the next hall. Same with conversations. Forget privacy.

My room is sandwiched between hallways—no windows to the outside, but high windows into each hall where it's high-noon-bright 24/7, making sleep impossible. I finally convinced someone to put a piece of cardboard over the big window so I could get some sleep. Staying at the Annex is not for cowards or anyone accustomed to the vast creature comforts of a Motel Six. The Four Seasons is a distant memory—another lifetime, in a galaxy far, far away.

Upside Down

Tuesday morning was spent nearly upside down in a 1950s era dental chair, enduring three hours of drilling with something like a jackhammer. The dentist kept saying "relax your tongue." Now how the hell do you do that? I tried to remember my Lamaze class.

It wasn't so different from dental work in the States 15 years ago, and Dr. Julie was competent and professional, but that was poor compensation for the jackhammer. After all that, I got a temporary crown to await the permanent one, to be made in Hong Kong. I spent the afternoon in a post dental-work stupor and drool, a fine justification for going to a movie. Yes—a real theater.

We went to see *This Is War* and were three of the five people in the theater. About 2/3 of the way through, the film stopped, lights came on, and speakers began to crackle. Ten minutes later it started again and apparently this is normal. We got a coupon for a free drink—no fountain drinks or ice because of unsafe water. I avoided the popcorn.

Madam Nancy, You've Been Robbed

Before the tooth debacle, my reason for being in Kampala was a Budget Training workshop with my organization, which means I had a ride home in The *Daughter of Japan*. I was dreading arriving home in time to encounter my housemate's exit, but he'd agreed to wait until I got back to move out, to avoid making it obvious that the house was empty.

Blog Post: March 5, In Service

I've had to check out of the room and have numerous parcels to corral. I wait for a bootlegged copy of *The Iron Lady* to be burned at the hotel video store. It's not happening because the rain has delayed the clerk's arrival. While I wait, Caroline calls to tell me that my house has been robbed. My heart is pounding. My housemate moved out (early) and someone has watched, seeing that I am not there either.

The connection is bad, and the maelstrom of rain on the plastic roof obliterates chunks of the conversation, but what I *do* hear, *"window broken, master bedroom, didn't get inside, pulled.... window, clothes, front yard, police,"* is plenty. Lost connection. That about sums it up.

The Daughter of Japan finally leaves at 2:30, *five* hours late. But wait, it gets better. Two and some-odd hours after leaving Kampala, a warning sound is coming from *The Daughter/Shrew of Japan*, who is having a breakdown in the middle of nowhere. I am beginning to wonder if I will be spending the night in the cab of the truck, but gather my resources, shift gears, and mentally suggest to the heavens that the next vehicle down the road is a nice white NGO vehicle (they're all white...) and I can flag it down to hitch a ride into Gulu.

I turn to my right to check and there it is, appearing over the rise—a beautiful white *ActionAid* vehicle. It pulls over and stops. Really? Why didn't I conjure this sooner....

There's white smoke coming from the *Shrew* and they are giving her a drink. I'm thinking, *Don't they know if you pour cold water down the throat of a hot radiator the engine block can crack?* I mention this to no avail. I'm just a woman. The *Shrew* finally starts (water pouring from underneath), and is able to lurch to a gas station as I wave goodbye from the back seat of *ActionAid*.

I arrive home at 8:30 PM.

My Underwear? Seriously?

The good news is that the thieves have not been able to break *into* the house! Instead, they artfully cut the glass in a bedroom window and used a series of long sticks with hooks on the end to pull things—in this case a basket of dirty clothes hiding electronics—out the window through the burglar bars, still intact. My clothes—mostly underwear—that were strewn over the front yard have been

thrown back in the room courtesy of the police and my compound mates who thought to report the crime.

Seems the thief has no use for my panties. That's a relief. My happiness at this gem of good news was disproportionate, not just because I'm glad someone else is not traipsing around Gulu in my undies, but it's mighty hard to find a good pair of thongs around here.

They have, however, managed to take my iPhone that Brett spent DAYS loading with music, movies, books and even a Luganda language program; along with all of my computer adaptors, chargers for the camera and Kindle, a hard drive with movies, and a bag full of CDs and DVDs consisting of family videos, pictures and movies. I can ultimately replace most of it and thankfully, the kids have their copies.

This morning was spent at the Police Station—another learning experience—where they were extremely courteous and took a detailed report, but had no record of the previous report, or the fingerprints taken on scene, not that anyone could tell me where they might be processed.

In the meantime, I am somewhat philosophical and considering this a lesson in non-attachment to either things or outcome. Had they stolen my computer or clothes I can't replace here, I might be less resigned—murderous in fact. It's pretty creepy knowing that all my comings and goings are watched—obvious, because the shithead housemate had just moved out and they clearly knew *which* room to target, and when to do it.

The pint-size handprints left on the garage door in a failed attempt to squeeze under in the gap at the base imply it was neighborhood kids, so I'm probably safe when I am here. It's just stuff they want. I'm headed out to buy a steel locker, masonry nails to nail the damn thing to the cement floor, and a good padlock.

In answer to a question from a friend, "Is there ever a day without some adventure—good, bad, or otherwise?" I would say very few.

In the Mandarin language the symbol for Crisis and Opportunity are the same. Plenty of both here.

~~~

The fallout from the break-in continued for months. I had thought ahead to get traveler's insurance and was able to file a claim to cover replacement costs, but filing a claim required I submit a police report.

## Blog Post: April 27, In Service

Last week held a small victory. I have finally, after two months, been able to extract a report of sorts from Gulu Town Police Department. I can now submit this to my travel insurance, which would seem a straightforward matter, except that it took a total of nine trips and pleading with six different people to get this done.

It started reasonably enough, with my going in and respectfully asking for a copy of the report for insurance purposes, but devolved into extremely polite, intransigent replies: "Oh no madam, we must first investigate. (It's been 6 weeks, the trail is cold). And then we must type the report, and then we must... and it must be *stamped*. It is not valid until it is stamped. You first wait and we will come make some diagrams." (Never happens.) A month later, after all appropriate greetings in triplicate, "Hello, remember me? I MUST get a copy... No, no, a *stamped* report is not necessary, just the original statement on your letterhead will do."

"Oh no madam. That is not possible. We must..."

Office mates suggested I talk to the DPC: District Police Commander. He's lovely, they all are... But they are very regimented and yes, I must pay for the report. I suggest charging me 60,000 shillings is like robbing me again. Truly, everyone has been sympathetic, but this Mzungu just cannot understand about Official Stamps.

All of the Ugandans I met waiting there were kind, smiled and shook hands. And NO ONE ever questions or gets impatient. This is an amazing trait and is, at once, both ingratiating and infuriating.

## "You Come Back Later and..."

I met Komaketch, a name meaning *unlucky* in Acholi, and this doesn't bode well. I know the name because someone has suggested, I be named *Komaketch Nancy*, because of my many mishaps in Gulu. I decline, but here's that name again. Komaketch is very nice and assures me he will deal with it.

Since I am now returning to the Police Station multiple times a day, they realize I'm serious. Now the OC (Officer in Charge of Crimes) "requires to talk with you." He explains, again, why this is "not done," and is quite exasperated, but finally relents and lets me know there is a middle ground that is FREE.

I'm sent *back* to the DPC." Here we go again. I'm caught in a game of Chutes and Ladders and keep getting dumped down the chute.

This goes on. I go to the REGIONAL Police Commander, who says politely, "Madam let me explain... Blah, blah, blah... for the official report with a *stamp* you must first pay the *bank* 60,000 shillings and bring the STAMPED RECEIPT. It is written. There are no exceptions."

I return to the Police Station, feeling fully defeated, but, in fact, someone has finally written a "To WHOM..." letter as it is called, saying that I have reported the crime to the police and the reference number is... and the best part is: *it is STAMPED!*

~~~

I'd had enough: the ants, the burned foot, the lease-breaker, the burglary. It was time to bring out the big guns. I had skills... The whole town was a war zone and held the memory of murder, abuse, and despair, there was no way my house didn't hold some of that vibration. In Feng Shui it's called Predecessor Energy. I knew how to move energy and clear spaces, but hadn't bothered to do it here because there was such a barrage of happenings.

One night, locked in my room, which was standard, I was awakened by a loud *wham* against the door. It sounded like a body-slam. Naturally, the power was finished. I literally shook with fear and refused to open the door 'till daylight, when I found all the doors and windows still locked. I have no explanation. These houses didn't "settle," and it was the only time it happened.

As if to compensate, I had the most exquisite experience on another rare, quiet night when I was awakened by skin-tingling, ethereal vocal music—angelic, I would say. It sounded like the Mormon Tabernacle choir, though I couldn't make out words, only voices. *This must be Matins, the early morning prayers sung in a convent.* I sat up and listened; it seemed to have no direction—it just *was*: both *in me* and *around me.* I listened for a long time and finally drifted back to sleep. I thought maybe it was the girls' school a few streets over, but it wasn't a residential school.

A month or so later, it happened again. I was on the brink of putting on my headlamp to go search, but it was the wee-hours of the morning and a really bad idea.

A few days later, I asked Joy, who had grown up in Gulu and knew every church and school in the area. There was no convent, no church with such a choir, no girls' school, no choirs. It didn't come from Gulu.

A metaphysical friend suggested *The Music of the Spheres*, typically heard only in near death or Out-of-Body travels. When I

moved my bed to the opposite side of the room, to avoid being eaten by creatures slipping through the window crack, I never heard it again. Had I been sleeping in a portal of sorts?

In any case, it was again time to treat myself like the client and do an energy clearing and blessing on the house. Naturally, power was finished and as luck would have it was a dark and stormy night. I lined the hall with tea lights, opened the door into the spooky garage, got out my brass singing bowl and performed a very thorough space clearing and blessing, the same ritual I'd performed for clients during twenty years of Feng Shui consultations, clearing spaces and spirits. Then I fell soundly asleep.

The next day, a friend came by and immediately asked what happened. It felt so different, lighter. She knew nothing about the clearing I'd done. From that point forward, nothing weird, scary or unexplained happened in the house.

24 A Loko Leb Acholi ma Nok Nok

Blog Post: March 17, In Service

A loko leb Acholi ma nok nok, meaning, *"I speak Acholi a little,"* is relevant now only because I have *proof* of passing the LPI. My rating was low-medium: good enough for me and made even more important because all forty of us can now let go of the angst and paranoia of being sent home.

The travel itself was significant because after three days of getting there, it became apparent why people talk about "the north" being the abandoned step-child of the country.

Traveling to Masaka, President Museveni's stomping grounds, was like walking into a fairytale, starting with the road. It's hard to think you can get excited about a road, but there it was: beautiful, with painted lines; even passing lanes. Smooth as silk, there was nothing like it in the north. It cut through hills of green grass, fat cows, geese, and goats; past roadside craft markets with baskets, three-legged stools, drums, gourds, etc. Tall columns of carefully stacked yams and cassava were for sale in front of the homesteads lining the road. The difference between the impoverished, war ravaged north and the South-Southwest is staggering to the point of it feeling like two distinct countries.

~~~

Although we were the last group to be trained the way we had been, the remnants of our previous debacle showed up again for the Acholi group during the second testing. Tensions were high, but we moved through it and passed, having had much private tutoring at our sites.

Going forward, language groups would be sent to their respective regions early in training to live with families who spoke the assigned language. The reduction in tension with future groups was noticeable, and they seemed to be actually enjoying it, which is as it should be.

With the language and training drama behind us we were now mentally and emotionally free to do the work we came to do, settle in and make a life for the next almost two years. We were still assimilating and dealing with big emotional swings, but we were learning how to "do life," and make a difference.

Regardless of why we *thought* we were coming, the lessons we take away and the footprints we leave behind won't be fully apparent until we are long gone.

When I was a "we" and "we" were sailing, a more experienced sailor said, "If you can add up all of your best days and worst days and get a sum of zero, you've had an excellent adventure!" Still tallying... and hoping for a "zero."

## 25 The Six-Month Trough

It's actually difficult reading this blog in retrospect, but it does show the reality of what we'd been warned about. It was all they said it would be and more. That said, I am seldom so black-hearted.

Peace Corps explained it like this: "The euphoria has worn off, the Pollyanna goal of changing the world has been replaced by 'what the hell was I thinking—I can't even make a dent,' and we have discovered that 'these people/jobs/places are not nearly as interesting as I thought.' "

Here's part of what I wrote in response to a friend asking how I actually *feel*:

### Blog Post: March 24, In Service

The euphoria and newness have worn off and here we are. Actually, even with the foot calamity, the fire, the tree falling almost on the house, the burglary, and the reclusive housemate turned jerk, I've been pretty philosophical. But the fricken' heat has taken its toll.

Uganda is not fun duty, unless you're traveling to wild game parks or the Nile. It is work. And it is difficult work, day in and day out. Not the work itself, but the living: it is work to carry water; get to work; be at work; wash clothes; shop daily, have no respite from the heat and filth; and figure out how to communicate. There is no pure relaxation. There is the momentary horizontal escape, but I have not been fully relaxed since I got here. And I would not have slept were it not for a little blue pill every night. We are always in the fish bowl, always at some level of alert.

### But I Also Wrote

What it IS, is an adventure, an exploration into self via another culture. Every time you look around or have a conversation, something is reflected back in a way you hadn't expected. New skills are called for every moment of every day. There are moments of connection; some of the deepest friendships I've experienced;

moments of insight; the thrill of seeing an elephant and the Nile; the grief of looking into a child's eyes and seeing despair you know has no hope of abating; the joy of looking into a child's eyes and seeing laughter in spite of everything.

I've not had a day where I seriously thought about going home, but I have many days where I wonder how the hell am I going to do this for 19 more months.

Yet, I know I will stay, because there is something here that is important for me to do, to discover, to feel, and I won't know what that is unless I let the full process run its course. I don't even know if what I'm supposed to be doing is for them, or for me, but I *know* that being here is relevant, and may never be logically understood. What I do know is, I have been indelibly touched by the spirit of hope and gentleness of the Acholi people even after they have suffered such extreme cruelty and loss, or maybe because of it.

It is *that* that binds me to this place and to these people.

~~~

A lifetime ago, the sailing adventure aboard *Legacy* had been undertaken, in part, to confront my fears of dark water and being abandoned at sea. If I were ever to explore those fears, I suspected great adventure, love, sex, newness, and the promise of warm blue waters would sweeten the deal. They did, and the promise of a grand adventure and all that portends did not disappoint, but it scared the hell out of me more than once. When I say, *we looked death in the teeth once every ten days,* it wasn't an exaggeration.

We made some bad novice decisions, and accepted questionable help, but lived to tell the tale, were better sailors and stronger people for it.

The trial-by-fire of the first six months of Peace Corps had the same effect. We were a stronger, more resilient group, and each of us matured into people who could make a difference for ourselves and others. Adversity is a great teacher, and the storms test us and reveal strengths never encountered in the normal flow of life.

26 The United Nations Comes to Town

Dry season dragged on and on and on, just as I'd been told. Water was finished for a long time and some boreholes were running dry. There was even a run on bottled water, producing a modicum of panic. Water reuse was ever more critical. Some locals were filling water bottles from mud puddles and waiting hours in line to fill jerrycans at free boreholes.

A little girl of about four-years-old waited with others and proudly carried her two-liter jug on her head. It starts young, this ability to walk miles balancing a load on your head, with such dignity. It's a skill born of necessity and they gradually graduate to huge trays of food, bundles of wood, or sesame, or anything else that needs carrying.

I'd become somewhat accustomed to this rationing while living on a sailboat, but that was a level of privilege that embarrassed me in these circumstances.

There were other reminders of the precariousness of life: one, in the form of a waif-like boy, who paused in front of me as I was sipping coffee at Coffee Hut. He was offering me something and rubbing his fingers together in the universal gesture of asking for money. It took a minute to realize he was cradling three baby owlets and trying to sell them. My eyes met those of another aid worker, a man about my age, his eyes filled with tears. There were no words for these moments, or for the circumstances that created them.

At the other end of the continuum of reminders were the peace-keeping vehicles that barreled through town as I walked back to work.

Blog Post: March 31, In Service

Some of the extraordinary has become so much a part of life that the unusual is no longer surprising. But some things still produce a jolt. Within the last week, no fewer than about thirty behemoth white, UN transport vehicles, i.e. 18-wheelers, transporting

Herculean earth-moving equipment and supplies, convoyed through town on their way to South Sudan, our neighbor to the north. It was a dramatic reminder of the peace we enjoy in the States, even the newfound peace in Northern Uganda, which was beginning to flood with refugees, tipping the scales of an already unstable economy.

President Museveni was also evidently present, hinted at by the brandishing of heavy artillery; squadrons of military police; fancy black SUVs; open trucks filled with turret guns and soldiers with assault weapons; new fighter jets flying threateningly low as if strafing. Lots of drama, posturing, and overt demonstrations of power for a region otherwise abandoned by Museveni. For an area so recently embroiled in a protracted war, this show of military might was not welcome.

~~~

As fragile as life was there—it's a bit ludicrous and telling to admit how easily we could be thrown off track when one of our coping mechanisms was threatened. I intend no diminishment of *real problems* in sharing the following, which really was a first-world one, but realistically our lifeline to family, friends, work, escape, information and all of those things that kept us moving forward and allowed us to withstand the black holes we sometimes encountered. Witness the *near death experience* of my computer and the life-saving heroics that gave it new life.

### Apple Tarts and Apple Parts — Blog Post April 10, In Service

It finally happened... After a pretty decent day yesterday which started with a hike across town for a Cappuccino and an apple tart—or a reasonable facsimile thereof, my trusty Mac was put on life support today and has rallied with a cable transplant and a lot of hard drive repair.

**Good Friday**, a misnomer in this case: with fear in my heart and panic in my soul I had no choice; I found the Apple computer place that only sells hardware. Being Good Friday, Kampala was closed.

**Saturday:** "Oh you need the support center." *OMG there's a SUPPORT CENTER in Kampala? Are they Authorized?* Well, let's not go there. Suffice it to say that they are an Authorized Reseller.

**Monday** still closed: Easter Monday? Uganda takes its holidays seriously.

**Tuesday** dawns: Time is running out and like the burned foot, I have to trust someone.

I enter the *computer emergency room* with my baby cradled in my arms. This act is only slightly less stressful than taking your child to the emergency room. I know, I've done both. I find George, a nice Ugandan tech who speaks impeccable English.

I am relieved and finally allow myself to breathe. I tell him the issues: the *wheel*, the pulsating black sign emanating Darth Vader vibes and a robotic voice saying in FIVE languages YOU MUST SHUT DOWN YOUR COMPUTER... NOOOOOOOOW. I do! No one messes with Darth Vader. This morning, there was only a thready pulse. Programs would not open. It wasn't even whimpering; it was deathly quiet, registering not so much as the battery indicator.

George is one of those low-key, high-tech types that make those of us who are neither want to do homage. He speaks in comforting tones, smiles, nods knowingly when I make references to this being my child, gets me to step away from the computer saying things like "don't worry," (comforting) followed by "It's backed up, right? (Not so comforting.) I admit to not having the back-up drive with me and he says he'll back it up to one of his.... OK, another deep breath now.

Prior to this total act of trust and desperation, I have purged files, removed pictures, prayed, made deals with the devil, etc.—all to no avail. I have contacted PCVs with more computer savvy than I have and acted on recommendations. So, going to an unknown Computer hospital in Uganda could be life threatening and is a last resort. Remember, we are warned not to seek random medical care and this almost certainly qualifies as emergency care in life-or-death circumstances. No, I'm not being over-dramatic. Computers are the life-blood of a volunteer!

When he says it will take hours, I agree not to hover. Instead, I leave and go suck my thumb. Some three hours later he tells me he has hit a snag. I made more deals with the devil and went in search of both chocolate and money. I am at the bottom of my account inasmuch as I have paid for this trip of five days in the garden spot known as Kampala over EASTER when *others* of my kind are frisking around on the Nile probably eating fine food... I have not been reimbursed. Time to beg.

The computer will take it all. See what mothers will do to save their children? When I return to the emergency-room, George is out for lunch. I decide this is a good sign because he wouldn't leave if it were dying, right? He returns, says there is a cable that seems iffy. I

translate this to open-heart surgery, hearing transplant in my mind. And there it is: a cable. One microscopic thread of a wire—one of many in this tiny bundle—has broken. Beast! Saboteur! No amount of cleaning, purging, downloading, praying, etc. would have worked. We need parts: Apple parts. Lucky for me there is a donor in the very next room. I will wait...

I find yet another whodunit to read on my Kindle and spend another two hours in the *waiting room* with other expectant Apple parents. Finally the doctor emerges, beaming proudly, and announces, "It will live."

~~~

BabyMac continued to thrive for the remainder of my time there, and although her umbilical/power cord self-destructed and also had to be replaced, I didn't have to replace her for nearly two more years, and even then it felt like abandoning a family member.

27 Critters

Shortly after returning from saving BabyMac's cyber-life, I was visited by a scene reminiscent of one in Barbara Kingsolver's book, *The Poisonwood Bible,* when a river of ants moves through an African village devouring every organic thing—cows, goats, plants—in its path. It has come to haunt me more than once in Uganda, where there are any number of creatures that made for a sleepless night.

Nope, it's not the safari-animals: elephants, hippos, rhinos, baboons, or gorillas—none of which occupied Gulu, where most of the forests had been destroyed to eliminate hiding places for rebel soldiers.

It wasn't the large exotic creatures that gave me the willies; it was the *smaller beasties*.

Ants - Blog Post: April 27, Year One

Raining. *Again*. At some point I will tire of it, but it harkens back the bristling anticipation of hurricanes in Louisiana and the quickening of my pulse when the wind kicked up on *Legacy*.

With the start of the rains, creatures head inside. A few nights ago, when I woke up again at 4:30 AM and walked to the bathroom, something caught my attention: a wide, undulating ribbon of something was wending its way through the gap under the closed window and down the wall *next to my bed*. I scrambled to find my glasses to identify this moving mass. ANTS! Ants on the move, giant ants—an inch long with visible mandibles. There is, of course, no insecticide; so I spent the next 10 minutes whacking ants with my shoes.

All I could think of in the midst of the slaughter, was that scene. Certainly a person would be as tasty as those cows and goats. After I pulled my bed away from the wall, I tried to get back to sleep, but spent the next hour ruminating on what I could set the legs of my bed in to keep ants from marching up to the mattress. There has not

been a return, but I spent the next day further terrorizing myself researching *giant ants in Uganda*. When I got to the part about the mandible being so big they can't actually feed themselves and have to depend on the colony for shredding the victim, I stopped. This is too much to think about. Got a can of repellent the next day, hoping it does what it says and sprayed the window, the wall—you name it. I'm obviously still alive and able to tell the tale. I finally poured paraffin along the windowsill, having been told that even snakes won't cross that.

~~~

I'm not the squeamish sort particularly, but as I sat on my front porch during a rainstorm, watching the lake form in my front yard, an oddly shimmering, lacy pattern formed on the water's surface. Looking more closely, I realized the lace was moving and had some depth: a massive flotilla of ants had blanketed the yard. In Austin, I'd seen enormous, writhing mounds of fire ants floating on floodwaters and didn't want to tempt fate. I went inside.

There are roughly 500 species of ants in Uganda, another of which was unearthed during our Perma-Gardening (child of Perma-culture) training just outside of Gulu. We were learning to double dig: down two feet in stages, to bring the deep soil up. Even the men in our group were struggling, when one of our Ugandan trainers, a thirty-something mother, picked up the shovel and plunged through the impacted soil like Wonder Woman, making us all feel like wimps. In the process of all this digging we invaded a colony of angry *hissing ants*, which also emitted an odd odor.

Fortunately there were no fire ants, but the Army Ants do just fine in killing whatever is in their way. The fact that I'd brought my Adolph's Meat Tenderizer in my own first-aid kit was not comforting against the sheer number of these creatures. The papain in Adolph's dissolves the protein in the venom of stings from bees, fire ants and jelly-fish, but I had a feeling if Army Ants started in on me Adolph's might have just tenderized me for the feast.

And then there were *mice*, with whom I would have been relatively content to share the house until one of them went after my chocolate granola bars sent from home. I'd purchased a four-foot tall, rough-wood shelving unit to use as a dresser and carefully placed my hermetically-sealed delicacy on the top shelf away from any other food items.

In the night, I was awakened with the sound of crinkling, like foil. I found my flashlight and stealthily tiptoed over to the source of

the sound to find the scoundrel's tiny tail waving out of the top of the box, as he munched on a treasure even more precious than Oreos. Snapping the top closed, I captured the little beast, unlocked a series of doors with one hand and threw him unceremoniously out the front door into the dark. That act was the only thing that would have made me unlock my door at night and the little rodent ran back inside before I could get it closed. By the time I got back to my bedroom, he'd already flattened himself in the mouse-sized hole-in-the-wall just inside my bedroom door.

And *dogs*... not that I'm bothered by dogs, I usually like them, but things that would be innocuous in a place where I felt safe could and did scare the pants off me in Gulu. On an uncharacteristically quiet night, I was awakened by the sound of movement right outside my window, followed by loud crackling—like someone opening a fresh bag of chips. *Oh crap! Is someone at my window? Watching me? EATING CHIPS? What balls!* I yelled at it/them to go away. Not working. Crunching continued. My heart was pounding; I managed to quell my shaking long enough to find my flashlight and sweep the beam around the yard. It landed on a dog under my window—contentedly snacking on chicken bones. As I said, a lot of life was lived on high alert.

### Blog Post: June 23, In Service

You might recall the tale of the little mouse that likes dark chocolate granola bars. It's been replaced by a full-fledged rat, and I have now purchased Uchumi's entire stock of plastic containers and stored everything that is even remotely edible. This is the Fort Knox of food. But yesterday, having come home from a frustrating day of my landlady—known to locals as a *hard woman*—haranguing me over LABE's failure to pay my rent, I wanted to unwind with a nice cup of dark-roast decaf. Reaching for the sugar, I gagged at the discovery of a putrefied glop of spilled milk and rat urine mixed with droppings and maggots.

God deliver me.... An hour or so later, having poured several gallons of boiling water over everything, having ruined several rags and sponges with the mess, having used all the bleach and splashed some on one of my three t-shirts, I surrendered to the notion that the wildlife is winning. The water lasted just long enough for me to accomplish this task before giving a final sputter, and is still finished. Not content to set out bait and let the beast die in the walls and stink for the next few months—therefore continuing its winning

streak—in the absence of mouse traps, I've opted for the glue trap, a horrible but necessary alternative.

I set out two: one in its hideout under the bookcase and another in the bedroom. A little more history: I've been awakened twice in the last week by a rat near my pillow. Although I sleep under a net with the edges tucked in except at the foot where it fits snugly to the frame, last week I was awakened by a squeak as I rolled sideways. I catapulted out of bed, but found nothing. Later, there was a rattle on the basket by the bed and the soft *plopping* sound of a smallish creature landing on the floor. Again, no mouse, but signs of something larger. Rest assured, I plan on winning this particular war with this rat as visions of Orwellian rodents gnawing on my face march through my mind.

And now I have him! Best 6500 shillings ever spent if I can just get it out of the house. It's rather grim, but he is stuck in the glue and has dragged the damn trap deeper under the bookcase. I'll have to wait until he tires, to *somehow* drag him out. With Uganda being the ground-zero for diseases, I'm taking no chances with this *Disney-Ratatouille* wannabe. Usually I would opt for something more humane, but it's him or me. I choose me.

## Blog Post: June 24, In Service

I am sad to say that the animal rights people will be celebrating the unsuccessful termination of one rat, said to have met its demise at the time of the last post. I celebrated prematurely. I left the house to shop and allow the rat time to stop its thrashing before I tried to collect it. Call me cruel. When I came back to perform the last rites, it had managed to save itself.

After several more attempts, I managed to get the rat out of the house realizing I'd been too lenient in sharing my real estate. At least he wasn't snuggled up next to me, as happened to a nurse friend also living in the north. She awoke feeling something warm snuggled against her back and found that she'd been sharing the bed with two very large rats who had slipped under her mosquito net—confirming the wisdom of firmly tucking the nets under the mattress.

## Termites

Had I not seen these termite mounds with my own eyes, I'd have a hard time believing their size; some were fifteen feet tall, with about the same diameter. Marvels of engineering, built to keep the internal

temperature at a precise 30° Centigrade (86° F), via a complex system of tunnels and ventilation chambers, they can also be home to snakes.

Parts of the mound are used to mix with other soil to create the perfect clay used in building earthen ovens. The fact that termites had already processed the soil made it ideal in the heat tolerant composition required for these amazingly efficient and durable stoves.

During training, one young woman woke up to find her mosquito net blanketed by termites, white ants as they are called. We learned they are revered in Uganda. On the walk to training the next day, we found school kids eating them and collecting them to take home as tasty high protein snacks in a region where protein is hard to come by. For that reason, school is often released during the swarm so students can capture the insects, pull their white wings off and chow down. They are eaten raw or sautéed in oil and sold by the scoop from huge glass jars by street vendors.

Voracious eaters, they will happily eat your clothes as experienced by a male friend who came home after a storm and found only a few inches of sleeve on the grass, termites still feasting.

In addition, they can weaken a mud-brick house in short order, which brings me to my own close-encounter. When I rented the garage of my Gulu house to LABE as a way to offset the high rent, they decided to store documents there, stacking tall piles on the floor and up the walls. It seemed to be a win-win solution, until termites began slipping under the connecting door to the living room a few weeks later, by which time half the documents had been consumed and a mound was climbing up the brick wall.

Neither Caroline, whose house they were devouring, nor LABE, whose documents were on the menu, wanted to pay an exterminator. As the debate stalled, I was left to deal with the swarm as it continued to feast. By the dessert course, a truce had been called and someone came to spray.

*Moving on to bats*, a small colony hung out in the mango tree canopy over the tables at a nearby Indian-food eatery. They weren't a real problem for me, but it's why we were required to have houses with ceilings and not just a thatched roof, where bats and snakes like to snuggle in. One male volunteer, who boasted about never using his mosquito net, awoke one morning with a bat nestled on his chest.

But it was the crazed bull trapped in my yard that really got my attention.

## Blog Post: In Service (earlier)

My first step out the door should have been a "heads up" to expect the unexpected. Walking outside to guide a friend new to the house, I encountered a bull—a young one with shorter horns than the mature, mean-tempered Ankole cattle, but a bull nonetheless. Seems he had taken off at a trot, escaping his herdsman, hooked it down the alley and threaded the eye of the needle—the small door opening built into our gate. He was looking pretty wild-eyed, so I stepped back inside and watched as he circumnavigated the yard. Finding no exit and looking more crazed than ever, he dodged the herdsman who finally tracked him down, but failed to rope him. As I walked into town to find my friend, the herdsman was still chasing him, rope in hand. Where's a good cowboy when you need one?

Thinking my tale was unique, I shared it with a group of other PCVs at lunch. A more seasoned volunteer told one better—and there is always one better here—truth really is stranger than fiction. Waking up from a nice afternoon nap, she had heard some rustling in her house. As she rolled over, the warm, moist snout of a bull hovered inches above her face. Instinctively, she smacked him on the nose with a book she'd been reading before she dozed off, and he ambled out, no doubt put off by this unwarranted rebuff.

*Snakes, although I saw only one,* did influence my movements. My compound neighbors warned me about a nocturnal snake, having a lure with a bioluminescent bulb cantilevered out in front of its head, like a deep water fish. While a bit mythical sounding, I still didn't prowl around my yard in sandals, much less at night, because there were deadly enough snakes like Green Mambas and Black Mambas, without worrying about this more prehistoric-sounding serpent.

I didn't believe my yard was prime territory for these Mambas, but I knew they inhabited the grasslands along our seven-hour bus-route to Kampala. It was one of the reasons I anticipated those trips with the same dread as prepping for surgery: NPO midnight, but more extreme. Unlike *Greyhound*, there was no bathroom on the Post Bus and there was only one pit-latrine stop at the halfway mark. If nature called in between stops, the driver would oblige and let folks traipse into the bush to relieve themselves, but no way was I going to leave as my legacy: she died going to pee.

With that in mind, I neither ate nor drank so much as a drop between 7:00 PM the night preceding the trip and the half-way mark to Kampala the next day. Each departure meant a 4:00 AM wake up, no coffee, a mile-plus walk past the bars that were just closing and the half-mile through the long, dark wetlands-stretch. It was spooky as hell. A year in, I was able to get a refrigerator and I could occasionally freeze a coke to take with me—if there was power. By the first latrine stop, it had defrosted enough to deliver my caffeine infusion and propel me to the Annex. I did the same on the return trip.

Snakes and insects are the reason all good Ugandans scrape a five foot wide no-grow zone around their homes.

*And there were bees:* I used to be allergic to bee and wasp stings, so when other PCVs regaled me with their bee stories, an involuntary shiver rippled over me. George, a friend who also lived in the north, came home from work one day to be greeted by the sound of loud humming. Had that happened elsewhere, one might think fluorescent lights, but this hum came from the hive, literally hanging out in the bedroom closet. George slept in another room that night and they vacated in a few days.

Evidently, these African bees like to move around, if the swarm circling the intersection at the end of my ally was any indication, leaving me no way to get anywhere without going through that swarm.

That was the day I asked PC Medical for an Epi-Pen.

# 28    But What Are You *Doing* There?

Recently, a friend asked, "besides smacking mosquitoes and chasing mice, what do you *do* there?" The answer to that is long and varied, but whatever and wherever we did, it was *slowly-by-slowly,* A purely Ugandan expression, *slowly-by-slowly* encapsulates both reality and a philosophy of patience, acceptance, and endurance so ingrained in Ugandan culture, but not easily embraced by most volunteers—at least not in the beginning.

It helped to remember that, of Peace Corps' mission of *promoting world peace and friendship via its three goals,* only the first involved the classic concept of work: *meet the host country's need for trained men and women.* That one was/is easier to quantify than the other two of *promoting a better understanding of Americans abroad* and promoting *a better understanding of other people and cultures on the part of Americans.*

The last two might seem straightforward and easy, because it's just living, right? Nothing could be farther from the truth, because as we were learning about *each other, we were also learning about ourselves.* Living in difficult circumstances pushed every button, revealing who we were at our best and worst.

The best often showed up as resourcefulness, compassion, creativity, joy, acceptance, curiosity, and the ability to turn straw into gold, as in the fairytale *Rumpelstiltskin.*

Looking back, the PC application process asked for an in-depth history of any-and-all work we had done professionally, as a hobby, as a volunteer, related or not to our primary expertise or academics. I remember thinking *this is really excessive,* but it all ended up being relevant and it was seldom the academic background that mattered. What mattered was the body of work and the gestalt of who we were—the composite of intellect, spirit and emotion—that we were able to bring to the most random situations. The opportunity to bring everything you've got, and put a new twist on it, abounds in Peace Corps.

I used it all; every single thing I've ever done found an application in Uganda. Even so, as I look back on those 27 months, what I remember is not the work, but the relationships, the place, and the adventures. It took reviewing my Description of Service written at Close of Service, to remind me of how much was actually accomplished, in part because my assignment to LABE was such a good fit and the work was a natural progression of my skill set applied to a different "client."

Our assignments didn't define our tasks; we had to figure that out on our own and it was my skill set that helped me define mine. Having been a Professional Organizer served me well in the realm of Organizational Development, leading to a complete overhaul of LABE's document management and security, data collection and reporting protocols, and processes for delivering services aimed at better funds utilization. It also came into play while organizing and arranging the new Director's office, the Peace Corps library, and files at their new headquarters.

My experience as a writer/author came into play as I contributed content for LABE's website and programs, authored articles for an international Human Rights publication, and created courses for Peace Corps' Volunteer Training. The numerous PowerPoint-driven workshops I'd crafted in my past, as well as creating my own marketing, enabled me to do the same for both LABE, and Peace Corps, as a Marketing Course for new trainees was requested.

No experience was left untapped, including growing up in libraries, which resulted in the creation of The Children's Library in Gulu, and adding book sharing and read aloud programs to LABE's early childhood program. The consulting I did for an Outplacement agency was put to use in helping staff revamp their resumes.

Some things were more obvious: my fire department training saved my backyard and helped me train Ugandans in life-saving tools; and my work in Victim Support was unfortunately needed during a critical incident involving three of our volunteers.

Other projects were just a natural outgrowth of responding to needs in the community: i.e., The Pillowcase Dress Project (Chapter 36), and the RUMPS project (Chapter 44). Even Peter's story stemmed from my love for my own sons and seeing potential in another young man who had never had the benefit of such love.

There were tremendous opportunities there to contribute. In thinking back, the work almost seemed secondary to learning how to live and maintain oneself in such altered circumstances. The work

wasn't less important; it was just easier because *just growing up in the US gave us so many usable skills,* which we take for granted, but are so valued in an underdeveloped world. Almost any experience we had could be parlayed into a project with Peace Corps itself, our organizations, or helping people one-on-one. The only limiting factors were time, logistics, and our own creativity and staying-power, and yet, none of those are small things.

With all that I/we accomplished there, it still really doesn't describe what I consider our most important work: the mutually transformative power of caring about another, the inner shift in ourselves, and the opportunity to give without expectation of return.

Every Returned Peace Corps Volunteer (RPCV) I know says: Peace Corps changes you.

I wouldn't know the full extent of that change until much later. In many regards, that experience is the gift that keeps on giving.

# Part Three -
# Settling In

# 29    Eleven Months in Country: Sober Thoughts

Almost a year in country, it felt like we should be getting close to something that might feel like the downhill slope. But eleven months in country, wasn't eleven months at site, so we weren't really at the halfway mark, though it still felt significant. We were beginning to fully integrate and feel the real weight of any work we were trying to do.

### Blog Post: June 29, In Service

For many of us, or maybe just me, it feels like it's taken this amount of time to get fully assimilated into our organizations. And that assimilation means getting into the nitty-gritty of daily work, which in this case is collecting data and putting it into a format that will convince our donors to continue their involvement.

Data collection can be challenging in the best of worlds, but here, we have to find a way to translate essentially qualitative data into quantitative data, a problem in itself. And there are strategic issues: Community Mobilizers (CMs), the people with boots on-the-ground, work with hundreds of Parent Educators (PEs) scattered in small villages miles away in the distant bush—some unreachable in the rainy season due to lack of access, and in dry-season because of planting or harvesting. The CM has to make physical contact with each PE, interview them, document a vast range of discrete perform-ance measures and then physically deliver the data to our office, when they can arrange transport. Some CMs ride bicycles 100 miles round-trip each day.

The information is detailed, changes weekly, and has an extreme number of measurables not clearly defined in training. Honestly, the effort involved in delivering these services and collecting the data is daunting. Participants are incredibly conscientious and hardwork-ing; committed to improving their lives, not through hand-outs, but through solid work and education.

We know how much rests on our organizations succeeding at their missions, so tension and frustration are high. Another volunteer called me the other day, admitting he'd not been this stressed in his high power corporate job back home. The good news is: I am not alone in these feelings. The bad news is: I am not alone in these feelings.

Tension and frustration aside, it's pure joy to work with people who are so motivated, kind, and filled with hope.

Any illusions I had of leaving First World stress behind were pure fantasy, though in some ways I guess I did, or I exchanged it for a different kind of stress, one that puts much into perspective.

As I was walking to work the other day, a nicely-dressed, forty-something man crawled across the road with shoe-soles on his hands and knees. We said hello and he proceeded across with dignity, autonomy and an apparent inclusiveness that took my breath away. There were no pitying glances, nothing to indicate that his disability reduced him as it so often does in the States, and the fact that there are so many with missing limbs has resulted in interesting solutions.

I am humbled by what I see on a daily basis, and as much as I complain about the inconveniences, I still consider it a privilege to be able to take time from my First World life to come here and have this experience. The daily roller-coaster of emotions continues.

On a comic note, I was lured out of my office away from data-entering by the presence of another marching band in the parking area. I love marching bands, the big-time announcement for everything here. This one was the Military, practicing before setting out on its route around the city being led by a dozen brightly clad motorcyclists, wearing bright paper cones on their heads.

The occasion: Celebrating male circumcision.

~~~

Even when I felt a little flat, or mired in a swamp of things not getting done as quickly as I'd hoped, there was some gem that brought a flash of gratitude, or a smile. As a result of entering all this data into Excel, training was revised and CMs were eager to learn better methods of standardizing the process because it reduced unnecessary returns to the field. On our end, it helped the data tell us where the program worked or needed improving.

In the process, I learned about interesting cultural details, including the tradition of naming children according to the conditions surrounding their birth. Here are a few I've run across:

Komaketch: Unlucky
Adong/Odong: the child born after twins
Akot/Okot: born in the rainy-season
Arac: I am ugly, or one of the parents was told they are bad person
Ojok: born with an unusual mark
Owino: the umbilical cord almost strangled the baby
Opiyo: elder of twins
Ocen: younger of twins
Otim/Atim: born away from the ancestral home
Ladwar: born during a time of hunting
Oceng: born facing the sunshine
Lalam: they have cursed my children
Akwero: she intends to divorce and go home
Abwoto: I was abandoned
Langwen: born when white ants were swarming
Nono: worthless

Although this process of naming is a way of preserving history, for some, it can be a cross to bear for a lifetime. During my time there, at least a few churches were beginning to address this, reminding their congregation that a name stays with its bearer for a lifetime and can become a self-fulfilling prophecy.

30 Going and Coming: It Came from Where?

Going Home

My nearest PC friend of my rough age group has been relocated to a different site, too far away to visit. It was a terrible loss.

"Kate," assigned to a school about ten miles out of town, had the classic pit latrine, outdoor shower facilities, and access to one road-side stand selling only onions and the occasional tomato. Getting a whiff of financial malfeasance placed her in the crosshairs of a mother-son team of administrators, and it got extremely nasty and threatening.

Graft, bribery and financial double-dealing are ubiquitous in Uganda and when PCVs came across it in their organizations, we were advised to avoid confrontation. But sometimes it was so entrenched it was hard not to step on somebody's toes, as happened with Kate. There's no contest on who will win: we are temporary; they live here and are fighting for their livelihood.

When, at her second site, she stumbled into money mismanagement again, and was warned, "people get poisoned here for less," she decided not to stick around and find out. She made the hard decision to leave after one year of diligent work.

Coming Home

Following Kate's departure, I'd gone to Kampala to spend a few days training newcomers. While there, I was a little shocked to discover I'd finally made friends with the city or as much as one could, while being on high alert for open manholes, chaotic inter-sections, and the occasional purse or phone snatcher. Phones were routinely snatched from people in mid-conversation, as were purses grabbed from a shoulder by boda and piki-piki drivers on the prowl, but we got "used," as Ugandans would say, and got smart.

Even bus travel had become more tolerable, at least from Kampala to Gulu. In Kampala, tickets could be bought ahead, a ham-and-cheese croissant grabbed en route to the Post Office, and a

decent seat snagged with early boarding, if I told the conductor I'd throw-up unless I got a window seat, largely true.

One did whatever was necessary to manage these transits, because they were always filled with some misadventure. More than one PCV told the tale of being breast-slapped by a long, pendulous breast swinging in wide arcs as a mother took time out from nursing to work her way down the narrow aisle.

Another young woman, seated by a man who had avoided availing himself of the toilet facilities (called a short call), proceeded to relieve himself in a coke bottle, which he then emptied out the window, splattering people behind him. All this entertainment, for the price of a ticket.

As time passed, arriving back in Gulu, a town I'd previously considered unremittingly ugly, brought a deep sigh. I was home and my house with its trees and lovely Ugandan compound mates beckoned.

It Came from Where?

Although I was always a little disoriented on the first night back home, I typically slept like the dead, but on one such night was awakened by a sense of presence.

Blog Post: July 17, In Service

I awoke at 5:30 AM in full darkness, to something different. I opened my eyes and was surprised at the appearance of little sparkles that looked for all-the-world like I was outside looking up at the night sky. For a minute I thought it was just an ocular trick, like seeing sparkles when you bend over and come back up quickly. Or maybe it was what we used to call lightning-bugs in the South, but no fireflies here, and besides my windows were closed. It was neither of those things.

I closed my eyes, in case I was imagining, waited a minute and opened them again to the same sight, but with the addition of a faint, yet perfectly clear image of a UFO. For old *Star Trek* fans that would include "partial cloaking." Large, no fancy lights. No beaming me up. Just hanging out. I continued to study this for about 10 minutes and it never varied: huge, still, and quiet.

Scanning the boundary of this transparent opening in my ceiling, I found a distinct outline, like a kid had cut it with scissors.

Shirly McClain, in her book *Out On A Limb*, talked about a similar experience in Machu Picchu. While staying in a tiny shed,

the ceiling became transparent and she could see a very clear UFO through the ceiling. One of my sons had the same experience when he was about 5 years old and too young to even know about UFOs. His included orbs of light floating down.

~~~

Years ago, when the kids were young and we were living on a hillside surrounded by acres of a dedicated wilderness preserve in Austin's Hill Country, we went through a period of intense *visitor* activity and strange happenings. We were visited by spirits, blue beings, and others, whose energy and communications indicated they were there as helpers. The verdict is still out on whether these beings are from elsewhere, or merely multi-dimensional aspects of ourselves. In any case, my contact started in childhood, but didn't become recognizable as such until my forties.

Early in my childhood, I began seeing things others didn't, though my sister also saw granddaddy's ghost. Other experiences had to do with out-of-body travel, and still others with receiving visual downloads of information, presented as unfurling scrolls of hieroglyphic symbols. I've never been able to translate their meaning, but when I was receiving them in a daydream/trance-like state, I always felt I was being given the answer to some important problem. When I came out of the trance, I had no idea what the question/problem was and felt this great sadness that I couldn't remember. Today, in the metaphysical community, these symbols might be considered *light-language*.

With that long history, instead of feeling fear when I saw the craft in Gulu, I felt a deep sense of peace that my friends were near.

# 31    Peace Camp

Every year, a group of Peace Corps Volunteers coordinates *Peace Camp*, one of several camps sponsored by Peace Corps throughout the year. The goal is to work with young people who have been impacted by the war. Young men and women from four different tribes, among which animosities still exist, come together to learn skills they can take back to their communities and contribute to "peace building."

No one talks about the war here. No one complains over their losses, their grief, their wounds. They simply move forward. When asked, people tell their stories in a very matter of fact manner as though they were saying "and yesterday I went to the store..." belying the depth of their torture and sorrow.

One of the questions applicants must answer is: "How has the war in Northern Uganda affected your life?" Their answers say it all. In their words:

### Blog Post: July 26, In Service

**Girl, age 18:** "I lost some of my relatives in the war and I had to move from our home to the town areas like the bus park for safety. And also lost most of the people of my area were also killed and others were boiled in the pot. This affected my life a lot in the war."

**Girl age 17:** "The war has made me to become an orphan by lacking both of my parents and other relatives—in addition to that it also delay my study which I am not happy about it. This war has made some people in the community to lose of their body parts like ear, arm, leg, lips and breasts which is so painful."

**Boy, age 15:** "The war affected my health of which it led to disability (i.e., I am not able to work and use wheelchair since I am also disable.) I also lost one of my parents hence am too frustrated with no one to help."

**Girl, age 22:** "The war brought me down into a shameful life that led me to a painful life i.e., I lose my study. I became homeless,

disable, too frustrated and too confused and the greatest of this is me being shot by the gun and I became lame and sad in my heart."

**Boy age 17:** "The war has brought poor standard of living in our family i.e., it destroyed most of our properties and they even captured two brothers of mine and taken them in the bush and now as I talk they are not yet back."

**Girl, age 17:** "I was captured and my mother and my father were also killed. The war has made me totally an orphan. War has made me confuse in my mine. Killing of many people still make me to remember."

**Girl, age 18:** "I loss both my parents. I started my study late. Paying my school fees is also another problem. I loss all my relatives that would help me to pay my school fees in time."

**Girl, age 17:** "The war interrupted my education when I was abducted by the rebels. It has also made me an orphan since both of my parent were disturbed in that my mother was killed (murdered) in this very time of war."

**Girl, age 17:** "The war has affected me in such way that my grandfather's one side of ear and toe was cut off and it was making me not sleep in the house through running to the bush looking for a place for hiding."

**Girl, age 21:** "It affected me in the following ways: 1) Led to a delay in my education because during the period of studying, rebels came to schools with the intention of killing the teachers, head teachers and grabbing pupils to be trained to become rebels. Due to that process, my head teacher and the Ministry of Education decided to close the school... until the schools around our village were free from wars and conflict. Hence, it left me for two years without studying. 2) It spread diseases like malaria 3) led to loss of life due to the burning of houses. One day rebels got me and my family members at home. They put us in one house and set it on fire. With God's mercy, we managed to get out. When my father got out, they killed him... they were waiting behind the house to kill anyone who escaped."

**Male, age 24:** "My mother was raped by a soldier and... was infected by him with HIV/AIDS. After one year, she died of AIDS in 1997. My grandfather, who used to pay our school fees, was also killed by the rebels. That caused me to stay at home for nearly four years, after which my brother started helping me with his meager earnings. Furthermore, I was slapped on the ears by a rebel when I

was crying for my mother. She had escaped into the bush to avoid being captured. And hence, my ears are damaged. Now I cannot hear well due to the permanent damage (chronic pus discharge from both ears). It has proved to be the worse experiences in the war because it left me a disabled person."

**Boy, age 22:** "The war affected me in the following ways: I lost my father, who was killed. Secondly, all our properties were vandalized. All our animals were taken. I myself was burned in a grass thatch house and set fire, but I survived. I have only one sister and one brother. The rest of my brothers were killed. I have an injury from bayonet. My mother was paralyzed. This made me head of household."

**Girl, age 17:** states that she was not really "affected" by the war in that her parents were already dead and she had no parents to lose. Living alone in a hut from the age of six, until she was found at the age of 11, in her words: "This war did not really affect me that much because I have no family so I did not lose anyone because I am an orphan who stays alone, but still I got so traumatized by how human beings were killed and boiled in the pot and then the young ones were taken for training to become soldiers leading to total displacement of people... mothers were taken as a wife to Kony and a husband as a soldier, leaving total suffering."

~~~

The stories you have read here are a mere ripple on the water of a storm tossed sea. These are shared as a way of letting you know about the people with whom we work and share space on a daily basis.

Rest assured that, contrary to the YouTube hype, these events are not going on in our midst, and to the best of anyone's knowledge, Kony is not camped out in the backyard! I know this because I have four lovely Ugandans living in my backyard.

That said, the aftermath of what ceased only a few years ago will live forever in the soil, in the collective, and in their hearts.

32 And Then There Was Ebola

It was Ebola the first time and Marburg later during my stay there, but both are hemorrhagic fevers, spread through contact with bodily fluids, including sweat. We did our best to avoid public transportation, where we are wedged together arm to arm, sweating profusely, but there was always the unanticipated exposure that came in through the back door, or came rushing toward you with open arms, like the intoxicated man who threw both arms around me, proclaiming, "I want to fuck you!" Although I managed to escape his grip, that degree of contact might have been sufficient exposure, not that I ever felt truly threatened by any of this. For better or worse, the combination of having been blessed with a formidable immune system, being an energy worker, and good self-care made me feel somewhat invincible, and it wasn't a source of worry.

Blog Post: July 29, In Service

There have been twelve reported cases of the Ebola Virus in the West Nile region, and the continued presence of Nodding Disease in the north. Nodding Disease, a neurological disease that includes seizures and weakening of the neck muscles causing the head to fall forward affects only children, has no known cure, and is almost always fatal. Although a clinic to house Nodding patients has been built in Northern Uganda, progressive cognitive dysfunction requires constant containment of those affected, resulting in parents often tying their children to a tree to keep them from wandering into a fire or drowning.

Training and life go on and as people here became aware of the diseases, certain greeting rituals were shifted. Handshakes and/or hugs were replaced with the *wrist-bump,* so that very little skin touched. The Center for Disease Control (CDC) is one of the things that works really well here and although there were several out-

breaks during my tenure, each was brought under control in a matter of weeks.

The next threat was Marburg, a little closer to home. With its presence vaguely in the background, we proceeded with planned training and daily life in Gulu continued with gusto.

The Revival Comes to Town

Despite the risk of Marburg, the morning was quiet as Gulu awaited dusk and the first night of a revival boasting a gathering of 10,000.

Growing up in Louisiana, I have a lot of philosophical and historical baggage around revivals and religion in general; Baton Rouge was ground zero for evangelists of all ilks.

Tent revivals, working some people into ecstatic frenzies of swooning and speaking in tongues, could last a week, leaving followers in a euphoric stupor. One of those was "LillyMae," a neighbor and mother of two of our schoolmates. After a revival, LillyMae would come home and lock herself in the closet for days in her desire to continue her conversation with the Holy Ghost, rejecting all food and drink. Her family, fearful for her health and sanity, called for help, but *help* came in white-coats, took LillyMae away, and locked her in a sanitarium for months.

There was always a lot of drama in the wake of these revivals, but this local one troubled me for another reason: the asking for money from a population mired in such poverty, and the suggestion of giving as a condition for salvation.

Field visits also continued as LABE trained its Parent Educators (PEs) to create Home Learning Centers (HLCs) in their villages. It's a cram course on what children need physically, emotionally and mentally to be ready to learn. In the span of a week, PEs learn how to teach numbers, reading, and vocabulary and *make their own teaching aids* using leaves, twigs, bottle caps, old cardboard boxes, pull-tabs, and other found objects, while LABE provided construction paper, glue, markers, and number and alphabet reference pages and ideas.

The commitment is daunting. Twenty-seven or so adults rode bicycles many miles every day for a week to the training, held in a spare school room, with an old green board, wooden benches, and no lights.

As we drove into the school compound, small signs appeared, posted on trees, by class room doors, and in random places around the school.

- Say no for gifts for sex
- Say no to sugar mummies and daddies
- Be obedient
- Be faithful
- Avoid being near strangers
- Keep away from alcohol
- Be punctual
- Defiling pupil is a crime
- Virginity is healthy
- Dress decently
- Clean up baby's feces

Kids, barefoot and dressed in tattered school uniforms, were busy sweeping the school grounds with brooms made from brush collected from around the school and home. Everyone is expected to bring one; or to pick up rubbish by hand.

When they saw our truck—meaning someone important is coming—they all stopped sweeping and knelt, a sign of respect. I couldn't get used to the kneeling ritual, but it is expected of children and women.

After a bit, the school-gong, a discarded wheel rim, sounded. The first gong resulted in all children kneeling again, a sign that they heard it and were getting ready for assembly under a mango tree, where they were to sing the school song and pray, before filing to their classrooms. Uniforms were the only way to tell girls and boys apart at this age: all had their heads shaved to prevent lice and scabies.

This is a poor country, but this school is better kept than most, has some new buildings, a rainwater collection system, a water tank, and teachers' quarters.

The new-looking buildings in the rear of the property are in a state of partial collapse, the previous contractor having pocketed the money for cement he replaced with sand and mud, a fraud discovered during final inspection. The buildings were fortunately condemned before their collapse after the first heavy rain, but the money had been spent. Replacements were funded by an NGO.

~~~

## Rewiring

In revisiting the memory of Ebola and the revival it prompted me to examine my responses to those things and the past that informed them.

LillyMae's fate had become a cautionary tale for me. Because I was also seeing ghosts, and had been threatened with being sent away for arguing with my mother, I learned to keep large aspects of myself hidden, in fear of dire repercussions. (One of the gifts of a quest is to deliver experiences that help identify the neural networks that are firing, and dismantle them.) While I didn't feel threatened by Ebola, my response to the revival was visceral and judgmental, so it was important to me to be able to bring a different kind of energy and emotion to bear.

In learning more about recovery from the war-generated PTSD, I found a different perspective: research shows, *faith that life will improve* is a strong contributor to the resilience required for healing. How a person comes by that faith is not mine to judge.

# 33   Sometimes it Works, Sometimes it Doesn't

When things work here it's nothing short of euphoric; the synchronicity makes the skin tingle. I've had a lot of synchronicity in my life, but when it happens here amid the day-to-day exhaustion of getting things done, it's a cause to celebrate. In looking back over my entire experience here, mid-service really is more significant than I could have anticipated going into it.

It wasn't just a time thing. In the linear world where time takes one inexorable step and then another toward some imagined destination, we had reached an emotional benchmark. And while it was exciting, there was the discontinuity of the end point seeming that much farther away. Perceptively, time began to seriously slow down afterward, every minute becoming two minutes. A week felt like a month

The first half of service was filled with new sights, sounds, adjustments, realizations and a few epiphanies. By the second half, the unusual had become incorporated into life and *we* were becoming incorporated into the community and were afforded a level of respect for our commitment to stay.

Things both big and small began to work. Connections with community began to pay off, the hassling had mostly stopped, trust developed, and the contributions that felt really significant happened in the second year. We were building momentum, just when COS was in our sights.

### Blog Post: October 16, In Service (one year in)

Last week, I met a young man, Dean, in Coffee Hut and discovered he has been working with a charity focused on creating equal access for people with disabilities.

Although the Uganda Education Initiative claims it provides equal access and education for all, schools are not required to provide ramps, bathroom facilities or transportation for any level of disability. There is no American Disabilities Act or the like in

Uganda. Imagine someone on crutches or a makeshift wheelchair traveling the hours required to get to school, navigating mud, ruts, nonexistent pathways, and potholes, and watch the concept of equal opportunity evaporate.

Dean has befriended a young disabled mother of two. She manages to support herself and care for her children through her activities as a seamstress, but has nothing to spare. She does not read or write in any language and desperately wants to do both, in both Acholi and English. In Uganda, a man who fathers a child with a disabled woman does not have to acknowledge the relationship, and therefore does not have to claim the children.

When Dean found out I work with a literacy group that offers localized literacy training for free (i.e., she doesn't have to walk 30 K to get there, and it's free), we started trying to figure out a way this mother could access the program. It turns out that LABE has a program in her village and she can take part in all of the training, along with her children.

Since she is also a seamstress, she'll be able to help with the upcoming Pillowcase Dress project, and possible work toward generating some income. That scenario could not have been planned, but it bloomed when people wanting to make a difference pooled resources. Her success will foster others. And so it goes.

~~~

One reason the ease and synchronicity of Dean's case was so significant was that it bookended an experience with my NGO that typified the challenge of making things happen. In this case, it was the commitment to put technology in the hands of people who live in a world without access to the *electricity* needed to keep the technology functioning.

Blog Post, Same Day

Today presented an interesting scenario and I'm mentioning it because it is so completely typical of what occurs here every day for every person trying to get something done. As I've mentioned before, LABE does really fine work in spite of obstacles that are unfathomable from a first world perspective.

The goal of one of our four programs is to introduce child and adult learners to technology. To accomplish this, there is an Information and Communications Technology (ICT) box: a giant yellow indestructible gear box loaded with a laptop, camera and camcorder. Children are introduced to the use of a camera as a way

to connect pictures to stories, which they write and submit to be published in the project's newspaper that goes to every village involved in the program. Kids get to read their story, and see their pictures and drawings in print. It's a proven incentive.

The computers are used to train teachers to generate computerized lesson plans, improve their technology literacy, and share information.

It's a great program and the results are encouraging, but the strategic planning required to make it work often results in total havoc.

First, there is one box for thousands of users. That means a number of things: transferring the ICT Box from one center to another requires several trips on a boda or bicycle, since the driver can take either the box or a helper, but not both. Trips are often sixty km one-way. All batteries must be charged, the memory card must be downloaded, and cleared, and all devices must be in the box.

As would be the case with my tax documents and the POA for the sale of my Texas home, the probability of all of the elements coming together at one time is in the single digit range as evidenced by Ojok's attempt to transfer the box today. Parts were missing, fuel and time were wasted, training did not happen, and beneficiaries were left waiting and disheartened.

This is the way life unfolds on a daily basis when there is any need to coordinate access, transportation, power, equipment and people. Each of these variables impacts all of the others, all of the time.

It's like herding cats. They are lovely cats, but still cats.

34 Fits and Starts

We were warned. They said it might take a year to get projects off the ground. I said, "Naaah, I'm organized! Motivated! You'll see!" And there we were, mid-service and things were just getting off the ground. Friends from home had been so generous, sending books, puzzles, so many things to help our projects along, not to mention the soul-saving care packages of treasures. Much groundwork had been done, books cataloged and repaired, older programs were winding down with a frenzy of audits, as new programs were being launched.

Things always happened in fits and starts: great momentum followed by whiplash stops, for the most ordinary reasons. We were ready to go, having spent days making learning materials, including games of *Chutes and Ladders* recreated using cardboard and bottle-cap tokens. As we packed up, we got the word, "Fuel is *finished.*" And just like that, all forward momentum ceased. We would have to wait until funds were sent from Kampala to get fuel. The same screeching halt occurred when someone ran out of modem time, also purchased with Kampala funds.

Funds transfer within Uganda usually happens by mobile money. Mobile phones run life and phone time can be purchased in minutes with a trip to the sim-card duka, where for a few shillings, you can buy a few minutes of airtime. It was far cheaper for me to call the kids from Uganda and speak for half-an-hour than for them to call me. All that being the case, if your phone is down, life is down—no juice, no airtime, no money, no fuel.

Fuel money always arrived, but it might have been days, as it was in this case.

Blog Post: November 1, In Service

Friday we loaded up *The Daughter of Japan* and headed to Home Learning Centers (HLCs) in the bush. After dropping off supplies and a few homemade blackboards, picking up teachers and Parent

146

Educators, we arrived at Palenga Pre-School and were greeted by thirty-five preschoolers dressed in lilac uniforms and singing their welcome song. Later, the drums came out and the boys drummed as the girls danced. Muzungus are a novelty and I had nothin' in my bag of tricks but bubbles, which elicited wild excitement, shrieking, jumping, and bubble chasing. When I tried these at another site with older children, they shrank back in horror... New things could be a risk.

After this great introduction, we threaded our way through back roads and trails, engulfed in towering grasses, as we caught glimpses of *tukuls* tucked into neatly swept compounds and papaya groves approachable only by footpath. Finally we arrived at Adak HLC, and were ushered past a man hacking his way through an 8-foot tall termite mound, the dirt from which was intended for bricks for more huts, and a larger learning center.

We were guided to the current center that seems fairly new from the look of the thatched roof. In this small dark space sat thirty or so children ranging from about 3 - 6 years old. After a few minutes and some introductions in Acholi, the kids were divided into small groups and introduced to puzzles. Because village children have never seen puzzles, we used very basic wooden puzzles we would give toddlers. Some "got it" immediately, but others were still struggling to match apples to apples.

One understands in a heartbeat that what seems intuitive is really a learned skill, which in developed cultures occurs so gradually through "play" it's easy to forget it's taught. The older group was really challenged by a twelve-piece puzzle, but totally engaged.

After we'd burned off a little energy, books were handed out to small groups. Even though they didn't know what to do with the book, and pictures were mostly upside down, they were fascinated. They were stunningly well behaved and stayed engaged until every-one had a turn with every book.

We headed back to one of the villages we hadn't had time for last week, to find their large group under the Mango tree, as adults worked to build a thatched shelter on just-cleared land, so classes could be held throughout the months of the rainy season.

~~~

One of the things that really moved me about this center was the almost sacred nature of the tukul storing learning materials. Constructed of mud and thatch with a dirt floor, it was meticulous, with lace curtains lining the walls. They took greater care with this

center than their own homes—a testimony to the reverence they accorded to the opportunity to learn.

~~~

One important aspect of the Early Childhood Learning Program was the introduction of parents into the classroom. Unlike American schools, the Ugandan system doesn't include parents in any school activity other than parents' visitation day.

In fact, parents typically never meet their child's teachers, and there is no opportunity to share information. The Early Childhood Program required one parent per child to spend at least a portion of one day going about school activities with their children to introduce them to what they were learning and what was required of them in school and after school.

In this way, the parents also learned the value of caring for school materials, why their child needed a pencil, why school papers shouldn't be used to start a fire or for toilet paper, why homework was important and how they might support their child's learning. It was definitely a game-changer.

In one scenario, a mother met her child's teacher for the first time in second grade. Berating the child, the teacher complained, "Your daughter has *never* answered a *single* question I've asked her in class! Why is that?"

The mother: "You know she's deaf."

35 Looking Back at Mid-service

Mid-service—the date we'd been anticipating for well over a year, came and went without much fanfare. It was oddly anticlimactic and there were mixed emotions, but we migrated to Kampala, and relished the world of warm showers, softer beds, good food, and the telling of tales.

By Mid-Service, a few more of our group had departed for reasons ranging from debauchery and boda riding to poor site selection on the part of Peace Corps, and Induction into Foreign Service. It was somewhat sobering to realize that, of our original group of 46, only 34 remained.

Blog Post: November 16, In Service

We were reminded by a couple of ex-PCVs who presented at Mid-Service that "much of your impact is on the one-to-one personal level, and while Congress may not think so or be able to measure it, there is huge value in people learning to see the light in another and that will contribute to change."

~~~

It was "seeing that light in others," that helped move me through the plateau of mid-service and beyond. By then, people were beginning to accept our presence and embrace us and I'd developed some sweet friendships with a few local people who truly sparkled, and whose joy and kindness always buoyed my spirits.

### Leonard, the Tailor

One of my best memories was the friendship that developed with Leonard, a tailor who would appear in different locations all over Gulu. I first met him outside a corner duka that sold Ugandan crafts. I don't know how Leonard moved his old Singer treadle sewing machine around town, up and down steps, but he always seemed to manage. An enormous duffle bag always accompanied him and I began to understand, everything of value to Leonard lived in this

bag. He was a big man, always wore a baseball cap and had a great, grizzled salt-and-pepper beard. His big, beefy hands seemed at odds with the delicate work he was doing, turning out everything from trousers to traditional satin Gomez dresses.

One day, Leonard had set up shop on the sidewalk across the road from the Homeland Bus office, where I waited for friends to arrive. He sat across the sidewalk from me in companionable silence as his foot rhythmically operated the treadle as though the appendage was a part of the machine itself, unattached to him. The whirring sound created by the wheel and the methodical click-click of the needle was putting me to sleep, so I took out the paperback mystery-du-jour and started reading as Leonard expertly assembled a school uniform.

Without missing a stitch, Leonard looked up and commented that he also liked reading mysteries, then stopped his sewing to rummage through his duffle, and pulled out a handful of books! In that moment, we became friends and every time I went into town, I looked for Leonard and we chatted about books and different authors. Turns out, Leonard had quite a library, and we started our own book exchange, introducing each other to authors we liked.

I discovered Leonard had a grown daughter he'd put through school with his tailoring business, and of course he was a well-known fixture in town. Sometimes, Leonard would leave a book for me with the ticket takers at the Homeland Office, expanding my circle of friends. That's when I really knew I'd become an accepted member of the community.

Leonard was one of the people I was really sad to leave, but I was able to leave him all of my mysteries when I left Gulu.

### Sameer, the Grocer

Sameer ran an Indian, family-owned grocery store near my home and was a constant in my life, offering smiles and support from the beginning. We first met when I took in a kerosene lantern needing a wick. Since I had neither the language to scour the *cuk madit*, nor any knowledge of Gulu and its dukas, Sameer sent one of his employees to another duka to buy the wick and install it for me.

Each time I came in there led to friendly conversation, and Sameer began to share information about his family, a wife still in India and pregnant with their first child. He was saving money to bring them over and to live with him in an apartment behind the store.

Sameer understood our cravings for tastes from home and let us know when he was about to place an order. We brought him our lists and goodies would appear. Sameer's store was the only place I trusted for meat, and from time to time I could get hamburger meat, called minced beef. I'd get some from the freezer, and more than a few times, Sameer would say, "Oh no, you cannot buy that. The power was finished last night and the meat I don't trust." The same was true of ice cream. If it had refrozen, Sameer wouldn't sell it to me. He always had my back.

After I burned my foot and was able to hobble around Gulu, I brought Sameer the remains of the offending kettle and he was visibly shaken at what had happened. He studied his stock carefully and chose a kettle with a different design and traded me, unlike the store owner who kept selling me breaking fans.

When Uchumi, the large grocery chain, moved to Gulu, it could have been a real threat to his small grocery, but Sameer had a loyal following. He asked if I would be a spy for him and get prices from Uchumi, then priced his goods a few shillings less. And word got around that Sameer would get Muzungus whatever they needed to make their stay in Gulu happier.

When I left, I had an award printed and framed: "Voted by Peace Corps Volunteers: BEST friend and grocery in Gulu." He hung it proudly behind the cash register for everyone to see. I came to say goodbye at closing and Sameer and his family had gone to great effort, and I think significant expense, to gift me with the most beautiful pair of delicate gold earrings from India. His wife and beautiful baby daughter had arrived and the last time I heard, Sameer was opening a second store!

## Florence, the Seamstress

Florence owned a fabric and sewing accessories shop whose walls displayed a dazzling array of cottons, satins, brocades, and yards of trim, thread, and lace for making everything from fancy Gomez dresses to school uniforms and bags. She had a good eye for design and an eclectic knowledge of the world, in part evidenced by the naming her cat *Cleopatra*. I can't remember what first brought me into her shop, because I never had a dress made, but we became friends. She made me a couple of cross-body style purses that were a hit with PCVs, and when friends needed dresses or skirts made, I brought them to Florence.

I stopped in at least once a week to say hello, and always met someone there who enriched my life, including a woman who was working to provide better access to education for the deaf.

## The Bookshop Owner

Bookstores were an anomaly in Uganda. That said, there was a school-supply duka in town, run by a lovely young Ugandan woman who had the good sense and business smarts to get discarded books from random sources and display and sell them in her shop. It was essentially a used-bookstore, which carried school supplies for the local kids, and the occasional craft item.

I went there often to browse, partially because the first time I'd gone into the store I found a book with an interesting title, *The Zin Zin Road,* by Fletcher Knebel. I just grabbed it based on the title, and because it was a book I hadn't read. To my great surprise, it was a work of political fiction, but—as I would realize later—an incredibly accurate story of Peace Corp in a fictional West African country. It was so well researched, I wondered if it were just a veiled account of an actual experience. In fact, it felt like Uganda. Later, I read it was based on Libya, where it was banned.

I was hooked, and in the process got to know the owner. Over time, we worked out some trades: I'd bring in a stack of books and leave with ONE book. The first time I brought her some books, she assumed I was trying to sell them to her. She'd never had anyone come in and try to give her books, and broke into a megawatt grin.

# 36   Pillowcase Dresses: Literacy in a New Light

The Pillowcase-Dress Project was yet another study in synchronicity pulling together so many divergent people, locations and interests, I still marvel when thinking about it.

It started as a spark of inspiration after I learned I'd be working in Economic Development in Uganda. Researching projects that might be suitable for an IGA at site, I came across Pillowcase Dresses for orphaned girls, of which there were about a million in Uganda.

Once I arrived in Gulu, care packages from home began to arrive, stuffed with goodies and some disposable filler. I casually suggested that folks replace filler with old pillowcases for a project, and they arrived in ones and twos.

When Christmas rolled around, I sent home pictures featuring lots of schoolkids, and the pictures made it to a second-grade teacher, who shared them with her class. The kids had a million questions, wanted to know what they could do to help, and the pillow-case project was born.

As the kids and their parents came up with 150 pillowcases of every color and design, the project morphed into a study of Uganda and a contest to guess when the pillowcases would arrive in Uganda, with the winner and the runner up winning their choice of a trip to Dairy Queen, or a pass to the school's game room.

When the box arrived, it was filed with pillowcases, thread, and other sewing supplies; other friends sent ribbons and fun buttons and scissors. There was an explosion of color and among the designs, was one of a quilt festival against a backdrop of three snowcapped mountains. I thought, *this has to be Oregon*! Then I found the words: *Sisters Annual Quilt Festival*. Curious to see if it was an actual event, I naturally Googled it, then found a contact name.

I dashed off an email to the event's organizer: "I thought you'd like to know, a Sisters Quilt Festival pillowcase made its way to Africa and is now part of a Pillowcase-Dress Literacy project in

153

Gulu, Uganda." Almost immediately, a reply came back saying that one of their quilters made a yearly trip to Uganda, returning with quilts to sell at the festival, and sending the proceeds back to Uganda.

This just kept getting better and better! I zipped off another email to my friend whose teacher-friend had gotten the project going, excitedly telling her about what happened. Our emails crossed in the ethers; hers apologizing for being so absent because she'd *just returned* from the Sisters Quilt festival. She hadn't received my email. Amazing coincidence, yes?

This thing had gone full circle!

My organization in the meantime thought the project could go way beyond a simple project to make dresses; it would be an expanded literacy project, supporting reading, numeracy, following directions, the skill of sewing, and the ability to work in groups toward a common goal. I wrote directions, Ojok translated them into Acholi, and they were distributed at training.

Here's how it unfolded:

### Blog Post: November 28, In Service

Tuesday we set out for our first Pillowcase Dress training with the men and women of Pawel Lalem, a village deep in the bush about 86 km (53 miles or so) north-ish of Gulu. With supplies in tow, we bounced and tilted over one lane roads for a heart-stopping hour-plus, arriving at the school where the Women's Pressure Group meets. The name is just what it implies: women group together to discuss things the community needs and put pressure on the community to see that it's done. In this case it was literacy. As we arrived mid-morning, as scheduled, the playground was a riot of recess activity, but only a handful of the 60 people expected at the meeting had gathered under the mahogany tree, where the training would occur.

Another hour passed and we began to make noises about starting with thirty people: mostly women. (When we left many hours later, people were still arriving). Geoffrey, my counterpart, began by reading the Acholi version of instructions I'd written.

We broke people up into smaller groups by village, so scissors, thread, and instructions could be shared, though each participant received a needle, some pins, a pillowcase and elastic for the top of the dress. We demonstrated the cutting process and they all took turns with the few pairs of scissors, which, like needles, are a luxury

since the only pair was a 12" industrial set that resided at the school. After all the demonstration projects were through, the good fabric scissors will be given to the groups.

Although the focus of the project was literacy, the long term impact is far greater. The activity keeps the group together, has the potential of income generation and can move forward to support the RUMPS (Reusable Menstrual Pads) project later. Equally important is the strengthening of the Pressure Group's influence in supporting women and girl-children in their villages, a primary focus on nearly every NGO in Uganda.

These projects will continue until I leave and I believe will be self-sustaining in my absence, because we're teaching them *skills* that make it possible to improve life in ways that matter. To us it's an old pillowcase or a book. For the people in the village, it's an opportunity for a better life.

# 37   Ugly Americans?

It's a sobering experience to realize how your own culture is viewed from the outside, especially if you're on the hotseat to explain or defend it, warts and all. Sometimes, it felt more like a justification and at times it was tricky, because I had to keep my politics and personal views in check.

The opportunity came up when I was invited to help with training the first time HomeStay hosts in Gulu in preparation for the new group of Education Volunteers. Here are some of the insights.

### Blog Post: December 9, In Service

Toward the end of the meeting, the group of about thirty broke into two groups tasked with writing down:

- what they think they *know* about Americans and
- what they have *heard* about Americans.

They were told not to "hold back," and they didn't. It was both interesting and a bit disheartening. God, I'm glad I came dressed properly for the occasion; that was one of the "bad things" listed by both groups.

My job was to respond to each characterization without gasping, to reply in a politically correct fashion, and offer information that makes our integration into the community easier. Once again, this experience provides a constant mirror.

Here are some of the not so flattering characteristics:

- War mongers, invade countries for profit
- Selfish, territorial, greedy
- Harsh (meaning direct)
- Not God-fearing
- Condone Homosexuality
- Dress inappropriately
- Loud

- Arrogant
- HUGE
- Eat a LOT!
- Drink and smoke a lot
- Rich

I found it surprising that this came from people who volunteered to host us. Imagine what those who *don't like us* might have to say. Actually, I'd already heard a few things that make us sound really scary:

- Munus eat the ears of small children
- Blue eyed people are the devil

Some other observations made me feel a bit more hopeful:

- Punctual
- Curious
- Know about a lot of things
- Helpful
- Like exercising and playing sports
- Organized and methodical
- Proud in a good way
- Generous
- Have gray hair (can't argue with that one)
- Some are friendly
- Responsible

The most emotional interactions had to do with homosexuality and religion. With the Ugandan Anti-Homosexuality Bill about to pass, that particular issue was delicate to address, but well-handled by the Ugandan organizer. The religion issue was almost as difficult, but the relief was palpable when it was explained that just because we don't attend church (all day Sunday), it doesn't automatically mean we don't have a spiritual or religious path, we just consider religious preference a personal matter. We're not all just a bunch of heathens after all.

When the Ugandan organizer of this session brought up the fact that one of the cornerstones of the American system was religious freedom and freedom from persecution on the basis of race, color or belief, there was an ah-ha moment, and not just for the Ugandans in

the room. It was always surprising to learn how much Ugandans knew about our history and politics.

~~~

The session pointed out how easy it is to get caught in our own assumptions and how those guide actions we don't even think about. We were often having our noses rubbed in our own assumptions and adherence to paradigms that worked for us in the States and against us in Uganda. One of those nose-rubbings came at the hands of another Biblical rain, just as friends and I were leaving to catch the Post Bus.

Packed and ready to leave, the deluge required us to do some re-thinking and repacking before leaving the house. Out came the rain parkas, computers were sleeved in gallon zip-loc bags, different shoes were required.

Assuming the bus would leave at its appointed time, as it always had, we arrived in plenty of time to get our seats after slogging through ankle-deep water mixed with feces, as latrines overflowed

We trudged on, refusing to stop for shelter, convinced others would be making the same pre-dawn trek in the quest for seating. On the final stretch to the Post Office, we saw no lights, no open doors, no tease of activity. We questioned our reality. Had the schedule changed? Did we jump time-lines to a parallel universe? Damn! We had walked through the swamplands right into the Twilight Zone.

Thirty minutes passed. Another couple of people floated in. The gates remained locked. We waited. A guard arrived out of the darkness and unlocked the gate, but not the bus. We were still getting drenched, waiting under the awning.

Another thirty minutes passed before the bus was unlocked and we were allowed to board and... to continue waiting. At last, the bus, less than half-full, slid down the driveway into a river of mud and through the wetland zone, now completely flooded.

To our chagrin, other soon-to-be riders had had the good sense to wait along the road in town, *knowing* the bus would *pick-them*, as is the Ugandan expression. Fully half the bus was filled on the way out of town. Only the Muzungus had been stupid enough to walk through the river of filth and wait in the rain. The Ugandans knew things happen slowly-by-slowly and trusted they would be *picked...* or not. And there would always be tomorrow.

Each time the bus stopped, water that had leaked into the rear of the bus, sloshed forward, wetting everything in our backpacks

sitting on the floor between our feet. The plastic sleeves for our computers had not been overkill, nor the second pair of shoes.

Part Four
The Final Stretch

38 Peter

Peter, who contributed so profoundly to my understanding of Uganda, deserves his own chapter for many reasons. My decision to help Peter started in a deceptively simple way: I wanted to help a young man with his passion to help street kids. That was it.

As it turned out, it gradually became clear that Peter himself was living rough. The desire to help him developed a life of its own, and became a complicated story, neither easy to tell, nor to read. However, it's an essential story, because of what it conveys about both the giving and the receiving of help, of love, and of compassion in a unique context.

I had a hard time deciding where to place his story in the chronology, because the ever-increasing demands involved in helping him hovered in the background of and competed with everything that came after getting him in school a few months after our first meeting—roughly three months into my second year. Furthermore, my experience with Peter colored and gave definition to my entire journey when viewed in retrospect.

Regardless of what else was happening, Peter was always in the wings. His story became all-consuming for the remainder of my service. I include the details, because it's nearly impossible for someone who had not lived it to imagine the perils and challenges and heartbreak involved with a "simple" act of giving. We get attached to the outcome and can't help but form a vision of a future we want for someone. But that is not in our purview.

Just as there are untranslatable words from one culture to another, there are untranslatable events as well. There is simply no reference in this culture for the events that are commonplace and have become normalized in Peter's world.

While this is a story about Peter, it is also a story about millions of kids like Peter, kids we want to help, and kids for whom the well of need is so deep, it is simply unfillable. But in the process of sharing our humanity, we communicate a worthiness to be loved, nurtured, and cared for—healing the spirit, if not the circumstances.

And it actually IS a success story, but not in the way Americans have come to expect.

~~~

Matters are never straightforward when deciding to sponsor a child for school in the Ugandas of the world, especially when that child is functionally an orphan, but caught between the physical and emotional dependency of childhood and the autonomy and street-savvy of an adult, as was the case with Peter. I had no real concept of what I'd taken on; neither could I have predicted the emotional highs and lows this would entail. And while I will never know the entire truth of Peter's history, I do know he has lived on the street for many years and has no dependable support system of any kind. Peter had initially represented himself as an orphan, but later revealed he had an estranged father; other details came in bits and pieces.

That business of details coming in bits and pieces formed an underpinning of all things Peter. The first details offered were like a litmus test for whether the receiver of the details could be trusted with the truth, with his heart. Would they cut-and-run, or stay to hear the rest? Peter is wily, charming, good looking and both innocent and seductive beyond his years, possessing an uncanny ability to apply the traits needed for survival. He has learned the slippery art of half-truths, not born of maliciousness, but as a mechanism to distract from his own vulnerability. On the street, it serves him. In other circles, it is his undoing. This made working with Peter a study in trusting my intuition.

The impetus to help with Peter's schooling came with my meeting Peter's friend, a soft, round Ugandan mama who was also the Assistant Regional District Commissioner (ARDC), the second high-est political appointee in the region—who insisted on being called Emily. I met her at Peter's request to discuss his project: street kids. Peter was convinced that even being *seen* with a Munu would lend credence to his efforts and garner support. Sadly, this belief is held by many.

Our first meeting is burned into my memory. Peter had told Emily about me and set up a time for us to meet. I went alone and waited my turn as she completed her business with others—all in public view of everyone else waiting in the assembly of chairs lining the walls of a large, bare room.

When I entered, Emily motioned me to the chair nearest her. I waited and watched as she bent over and spoke, in the softest of

tones, to a wee-slip of a girl in a pink dress; she couldn't have been more than three. The little girl scampered away to get something from an *Auntie* waiting for her; Auntie being a term of endearment for any older woman, and one of affection and respect, whether or not family.

That something was a tightly wound roll of bills, which she presented to Emily. Emily hugged her and thanked her, but returned the money. Before we began our conversation about Peter, Emily explained that—responding to a frantic call—she had literally rescued the toddler from being sacrificed, grabbing her off the table moments before she would have been killed. The Auntie had come to thank Emily and pay for the service, but Emily explained she was just doing her job. In that moment, I knew Emily's work came from the heart and that I could trust her with advice about Peter.

Peter arrived and we finally got to the business of the street kids. I explained I couldn't contribute funds. Emily looked unflinchingly into my eyes and said the best thing for Peter would be for him to get back in school, and that would require some groveling with the Head Teacher (HT). I knew she was right about school, but also felt I'd been caught in a snare of my own making. I knew I was "in," but didn't know how I would make it happen on my PC stipend.

In the eyes of Ugandans, my helping Peter made me his de facto parent, and that distinction included my going with Peter for an interview with the HT, a cruel man who disliked women, whites, and Peter. To be fair, there had been some prior history around Peter's inability to stay in that school. Although it included lack of funding, his age, street smarts, penchant for leadership, and the desire to be a *big man* didn't serve him well in a residential school where subservience is the rule. The meeting was tense and reeked of animosity. Peter was forced to kneel during the interview—a demonstration of obedience, if not servitude—and was spoken to in a manner designed to humiliate him in front of *his Muzungu*. It's painful even now, to remember it.

Peter was admitted, and the situation became abusive in short order, not uncommon in Ugandan schools, where caning is outwardly condemned, but routinely tolerated. Verbal abuse abounds.

Peter didn't help matters by stopping in to see his old street-friends when he got passes to get school supplies, go to the doctor, or get a school uniform and shoes (required for exam taking). In addition to his tuition, all of these—plus soap, another friggin' lock

for his steel chest, etc. ad infinitum—became my expense, extracted from my PC stipend, with an occasional dip into savings.

## Blog Post: April 19, In Service

The last time I visited with Peter on school matters, the HT, a large man, and I were in "conversation" when he simply turned his back on me and walked away. The teachers say "he is mental," still boxes kids on the ears hard enough to have damaged one kid's vestibular system badly enough that the boy couldn't walk straight for a week after. He still canes students, often taking them out at night, so teachers don't see it.

## Storm Clouds

The HT's wrath was boundless. After Peter's attendance at a Peace Corps sponsored leadership camp, where the kids were taught how to build tippy-taps for hand washing, Peter was so energized when he returned to school that he formed a group, taught them about hygiene, and built six tippy-taps around the school. He was even invited to represent the street-children at a conference.

Peter's success so enraged the HT, he called Peter out in front of his classmates and labeled him a "piece of human waste, garbage..." He continued with the abuse, finishing with, "How dare you affiliate with Muzungus!"

## Blog Post: June 27, In Service

*Aaaah*, the Roller Coaster Ride of Emotions is always right at the back door waiting for—no—grabbing—passengers. Just about the time you think you've acclimated to a new way of doing things, of living, of thinking the weird has become normal and you've become *somewhat* inured to heartbreaking sights and stories, something throws you on the ride again. This week's torment came again at the courtesy of the Sociopathic Head Teacher (we'll call him SH-T for short) at Peter's School.

In town with friends, I ran into Peter—out of school when he shouldn't have been—looking like he'd just lost his best friend, or afraid he might.

Near tears, he struggled to tell me that the SH-T had *suspended* him for a week. He knows Peter has no home, has no way to get food and is in the midst of reviewing for the exams that determine

whether high school is possible. He refused to release Peter's belongings.

We were both blindsided. Students trying to curry favor with the HT told him a lie about Peter. Meeting with the HT proved futile, as they hold all the power. Teachers will not report abuse, for fear of retaliation.

When I took a complaint from the teachers to the Director of Education in Gulu, he recommended I simply find another school. This HT had been fired before, but refused to leave, and for some reason, they kept paying him!

## Continuing...

One of Peter's strengths was his ability to form friendships with powerful people: among them Emily (the ARDC) and the Regional District Commissioner (RDC) who worked together to place him in a government funded school for Vulnerable Children. When the day came to move Peter, we learned that SH-T had called the Head Mistress at the new school, resulting in her rescinding Peter's acceptance.

Days passed with no forward motion. As a last resort, I pulled the Muzungu-card, because I was scheduled to leave the next day for two weeks and couldn't leave Peter homeless again. Passing thirty Ugandans ahead of me—all waiting for their turn, pleading *time kitca,* (please forgive me) to each, I found the ARDC who loves Peter and loves this Muzungu who is fast becoming a pest.

She grabbed me by the hand like a first grader, dragged me past the thirty people again, and affectionately shoved me through the door and up to the desk of a somewhat bewildered RDC, interrupted his meeting with ten village elders, and said "fix this."

In a spontaneous act of pure theater, when I told the RDC I was leaving the country tomorrow, the ten elders echoed in chorus, "She's leaving the country!"

Their support was evident, and the RDC did *fix it,* but I would have to depend on others to actually get Peter physically to the school tomorrow with his belongings, which have finally been retrieved.

Patience only works for so long, then pushiness is required. Ugandans won't do it, you need a Muzungu for that.

## Flowers

In the few days Peter was between schools, friends at another NGO provided a bed in exchange for which Peter offered to clean up around the grounds. In the process, he collected a handful of Coreopsis seeds and planted them around my front porch.

In record time, my porch was skirted with bright yellow flowers. In all of Peter's trials, he maintained a sweet spirit and generous nature, often feeding other street kids, then having no money for himself.

## No Teachers

Returning from a blissful trip to Zanzibar with best friends, I went to see Peter in his new school and was informed classes were rarely held, because—as a government school, the teachers had not been paid. The school had basically become day-care, and often ran out of food.

With little time remaining before his PLEs, I placed Peter in the only school left, an expensive private school so far out of town, Peter's only option would be to study.

## Time for Me to Leave

My anticipated Close of Service date came and went, as I got permission to stay an additional month until Peter finished his exams. I knew my leaving would derail him and I needed to establish a safety net for him once I left.

A group of his trusted adult friends came together, shared phone numbers, and agreed to coordinate with each other, but that's not something that comes naturally. My deal with Peter was twofold. I would continue paying for his education as long as he 1.) stayed on campus and focused on school and 2.) took care of his health (used his mosquito net).

He passed his PLEs with a high enough score to get into a decent secondary school and at the last minute, an American friend, in charge of an educational program to fund and place qualifying students with schools and pair them with a mentor, offered to take Peter into the program. I was ecstatic.

Peter had also reconnected with his father in a positive way.

## Things Fall Apart

When I left, everything was set for Peter to succeed, but… he failed to show up for the meeting with the sponsor and when he did stop by the next day, he was nonchalant about missing the appointment and less than truthful during the interview. He was cut from the program.

I was already home and helpless to find him another placement.

I pleaded with my friend and she agreed to honor the placement with the school, but he would be on his own, with no mentor, and I would need to foot the tuition—again. I was grateful; placement required a parent or a mentor, and in my absence, Peter had neither. No one in his support group stepped up to help. It was just a massive system failure.

Friends and I paid for the first semester, but Peter started leaving campus and got sucked into some nefarious activity that landed him in jail, for his own protection, since the locals were out for blood. While none of it was Peter's fault per se, it was evidence of continued bad judgment and I couldn't compete with the gravitational pull of Peter's street connections. Other funding appeared, but that, too, was withdrawn, when Peter continued to spiral.

From the beginning, Peter's adherence to the requirements of living in a residential school, and my requirement that he not allow himself to be drawn into any outside schemes had been a struggle. The need to connect with the street kids was like a drug for Peter. The degree to which it fed Peter's self-esteem was equaled by the negative impact it had on his schooling.

Peter had set himself up for some hard lessons. He was a train wreck, having alienated everyone who was trying to help. In some ways, I felt that my being constantly available for funds had inhibited Peter's ability to learn responsibility for his actions, belongings and choices. Peter looked and acted the part of an adult, in every way but in his emotional underpinning.

Everything in Peter's world was sending the message that his ability to move forward was on his shoulders. He was a man-child and his desires for a better life were requiring him to step into adulthood.

Over the next few years, Peter reconnected with other mentors to fund a fairly consistent attendance at a public, non-residential school, with less support, but fewer constraints. It was the middle ground. He made it to Secondary 5, a huge achievement.

Peter has gone on to create a Community Based Organization (CBO), EDU Power Uganda, and worked with community members to get vocational training as hair stylists and mechanics for *his kids* and part-time work for himself. It's touch and go, but none of this would have been possible had he not been able to move beyond P7.

Peter still struggles, but he has found a life partner, a woman with shared history, and they have a daughter they have named *Wesson*. Periodically, her family abducts her and the baby, saying they have to be paid a dowry before letting her return. There are frequent requests for funds, but by necessity, my private funding of him has ceased, though my friendship and mentorship continues.

Still, this is a success story, the real face of it, not a Hollywood version. And, it is still difficult. *Life* is difficult and the difficulties in the north are compounded many times over by the aftermath of war. Peter continues to mentor and re-home the street children in his care.

Peter's story is not finished. It has a long way to go. He is now in his early twenties and despite his educational lapses, his family or lack thereof, he is a warrior of the spirit and we can all take a page from Peter's book.

I've often felt that I'd failed Peter in not giving him everything he needs for a warm-fuzzy close to this tale. But Peter now knows he is worthy of relationship, love and respect. Further, Peter has the soul of resilience, the ability to love even after abandonment, and the ability to forgive.

As always, I feel I have taken more from the experience than I gave.

# 39   A Library for Children

Many of my strongest and most consistent memories of childhood involve libraries. My mother was a career librarian, who went back to school for her Master's Degree in Library Science when I was in grade school. It wasn't done in those days. Women didn't leave their children at home to work or go to school; it was the day of the perfectly coiffed Donna Reed, dressed in heels and pearls while vacuuming her perfectly clean house.

Not mom. Life had disappointed her and she struggled to earn the tuition to go back to LSU. Consequently, I was raised in libraries, witnessing mom matriculate through Reference Librarian to the Children's Room Director. Words were her religion; a thesaurus, her bible.

When my kids were born, boxes of discards from the library arrived on a regular basis and books became friends: bed-buddies along with stuffed animals, cars and trucks.

I took it as a sign when I was assigned to a literacy organization, but the seed planted for a children's library took a long time to germinate and resulted in three miracles, not just the library.

### Blog Post: March 5, In Service

At long last, the library project is afoot. Among the causes for delay was a truculent Ugandan volunteer, Pamela (not her real name) who dug in her heels and played the role of a power-mongering bureaucrat. There aren't many opportunities for women to have power in Uganda. Our time and expertise ignored, her first question had been, "What will you give us?"

When we started, we thought books were the answer, but the real issue had to do with a fact shared by many Ugandans, "Ours is not a reading culture."

After working with LABE, it became clear: developing a reading culture would have to start with children, who in general never hold a book until well into primary school, if then.

After some false starts, we were granted permission to transform a storage room adjacent to the adult library into a children's room on the condition that we clear the existing chaos, much of which was covered in rat droppings, mold, and ten years of other detritus. Another prerequisite required that I reshelve the adult collection onto new shelving, to liberate the old shelves for the children's room.

~~~

Pamela wasn't happy. She insisted the books be reshelved using the Dewey Decimal System, even though the books had never been cataloged, there was no means to do that, and there was no card catalogue. I suggested the Bookstore Model, so books could be easily found by topic, increasing usage. Absolutely not, she was digging in.

At one point, I said, "I apologize, but you know I can be very *stubborn* and I really feel the category model will work the best for your library, since no one can catalog the books."

She laughed, giving me the first smile I'd seen from her, and said, "Ah! You are stubborn! That is good!" Then, "Yes, we will do it your way." Our frosty relationship began to thaw.

The real stinger came, after I'd been gone for a while on Peace Corps business, and returned to find all of the books in disarray, a Kampala team having visited during the interim, emptied the shelves and demanded the Decimal system approach. She was helpless to intervene.

~~~

The library, the first miracle, was a true labor of love. But Pamela's shift was equally miraculous. Other PCVs offered their time, and one day when Pamela begrudgingly unlocked the room for us and watched us work, she proclaimed, "You Muzungus... You really work!"

From that point on she was a fierce ally. Her total buy-in became evident when, of her own volition, she lobbied city-officials for allocation of staff to man the children's room.

But the real denouement came when, liberating back storage rooms, we hauled out hundreds of pounds of filthy, duplicate newspapers we'd been unable to recycle and she had refused to discard.

Watching the process, she conspiratorially approached me, and whispered, "You know, there is a burn pile behind the library," and

produced a book of matches. Raising her eyebrows, in the way that denotes approval, she said, "You first burn these."

I insisted she do the honor of lighting the fire, which she did, giggling all the way.

In that way the universe works, just as we started burning the first stack, a young man showed up and asked if he could have the papers to line the inside of new mud huts, like wallpaper. Within a few minutes, carts arrived and an hour or so later, the papers were gone.

Finally, we moved the shelves and the small children's collection into our new room. A local carpenter offered to shorten the legs on the adult tables for free, to make children's activity tables. I produced a floor mat for story time, and another PCV's organization donated paint. We had ourselves a Children's Room!

The third miracle came in the talent of an eleven-year-old artist who offered to reproduce anti-malaria cartoons on the walls and freehand a *Children's Library* sign for the door in exchange for a set of acrylic paints and brushes, sent in a care package from my friends. The next week, he was seen on his front porch, painting a beautiful portrait of his mother...

The project was the first public children's library in Uganda and as such, would require a lot of what indigenous NGOs call "mobilization," or engaging schools, parents and children to actually use the room.

Many lives were impacted by the library project—by its very existence, by the relationships forged during its creation, by encouraging a young man's talent, and facilitating the shift of a culture.

Aside from all that, perhaps the biggest surprise for me personally was finding myself continuing my mother's work in Africa, at very near the age she was when she visited Kenya. Africa was the only time I'd felt my mother's presence since her death three years prior, and it became the first step on a path of reconciliation in our relationship.

# 40   Hearing Aids Déjà Vu

Of all of the things I could have imagined encountering in Uganda, mass hearing aid fittings never entered my mind. But there I was witnessing something that, from my western audiologist's perspective, I would not have thought possible. Another lesson was about to be delivered.

### Blog Post: March 12, In Service

My work mates are off in Kampala this week and I'm in Gulu trying to get other projects moving forward. Somehow, that has not proved fruitful, but the week is young.

The day was salvaged by hearing from a friend that Starkey, the world's largest manufacturer of hearing aids, would be in town fitting free hearing aids.

I'm ashamed to admit that as an audiologist with prior experience in fitting hearing aids, my thoughts were pure arrogance: *How in the world are they going to fit hearing aids in Africa? This I have to see.*

I did. It was humbling and informative.

We walked along the dusty road, past the *cuk-madit*, numerous boda stands and a slew of Ugandans amused to see a couple of Munus walking that road. Arriving at the grounds of Saint Monica's orphanage, we found hundreds of men, women and children lined up or sitting in staging areas waiting for the next phase of what proved to be an orderly, well-orchestrated process.

Making all this happen were about 30 Americans and at least as many Ugandan volunteers.

The next image that came into focus was a long, skirted table with piles of something I mistook for mounds of raw shrimp—same color, size and shape, but lacking odor. That took some processing, but it turned out to be hearing aids divided into "power groups," from weak to mega-strong, and then body-aids for the profoundly deaf.

*173*

I introduced myself as a Peace Corps Volunteer and former audiologist and was warmly welcomed and invited to observe and be part of a process that was a brilliant adaptation to the realities of the developing world.

Here, the mere opportunity to hear something overrides the first-world concern of "is it perfect?" While we were there, one child labeled retarded immediately started mimicking the fitter's vowel sounds when the hearing aid was turned on. Instead of being an outcast, with little hope of developing speech or integrating with his community, he'll have a chance at a more normal and safer life.

I watched the process unfold as a med-tech examined ears and invited me to watch; not for the squeamish. Many folks here sleep on the ground, and critters find a home in their hair and ears. Some were referred for medical follow-up, others went to the next station.

Although earmolds had been fitted in a prior session and manufactured elsewhere, new beneficiaries who showed up without were fitted with stock molds.

What was most amazing was the fitting process, all based on behavioral feedback, circumventing the diagnostic approach. Even in the best of circumstances, the fitting of hearing aids isn't an exact science and the final tweaking is based on how the device feels and sounds to the wearer. In this process, it starts with the behavioral response and it seems to work.

The last step was group counseling on care, where each wearer received a supply of batteries and a bag of rice to store the batteries in, because rice absorbs moisture and prolongs battery life.

As my publisher once told me: "Perfection is often the enemy of good enough."

# 41    Tragedy Strikes

None of us could have been prepared for this. We entered with dreams of making a difference, adventure, friendships, maybe just building a resume. Parents released their fresh college grads into the bright light of youthful enthusiasm and sometimes bravado, onward to the next chapter of their lives. I've released my own sons into theirs, encased in a bubble of love and blessings for their safety and well-being, as they released me for my own adventure.

Everyone here accepted the risks we knew about, but there are other dangers in faraway places we could not have anticipated. The annals of tragedies that have befallen those involved in humanitarian efforts are usually related to politics, war, disease, or some social encounter gone wrong. Not this one.

Three young Education Volunteers, women in their twenties, set out in the wee hours of the morning to catch the bus en route to their first In Service Training. None would arrive.

## Blog Post, May 3, In Service

Saturday, as three young friends (names omitted for privacy) left to go to Kampala, they walked along the same route I've taken many times and dreaded every step, to catch the 7 AM Post Bus. Pre-dawn we walk along a stretch of road that wends its way through town skirting the bars, just closing and spilling out inebriated patrons. Next comes the long stretch flanked on one side by a Papyrus swamp and a tangle of trees on the other. The swamp is spooky in its own right—the salient sound being the croaking of frogs, but we tend to walk on the swamp side because it's safer and has a wide shoulder.

Because roads are pretty deserted at that time of the morning, we are alert to vehicles, likely to be piloted by someone "under the influence," as was the case as the girls headed to the first benchmark of their service. Without warning: no lights, engine noise, squealing

of brakes, a drunk ploughed into them in mid-sentence, killing one instantly, and injuring the other two, one seriously.

The aftermath is too grim to describe, but suffice it to say there's no 911 to deliver a sparkling clean and efficient team of paramedics and medical equipment to your rescue. I received a call at about 6:15 AM from our Country Director saying the ambulance had not arrived and asking if I could help. It took a bit to determine who was involved and as the details came out, I knew which route they would have been taking. Knowing a taxi would take too long to arrive, I left on foot to find help.

The two survivors were taken to the nearest of the two better hospitals in Gulu, only to be transferred to the other, LaCor, and then airlifted to Kampala via private plane sent by Peace Corps.

From Kampala, the worst injured (broken femur) was taken by AmRef air-ambulance at 10:30 that same night to South Africa for surgery. Seeing AmRef operate was like being back in the States: fast, respectful, efficient, state-of-the art.

The community of Gulu rallied and has been very supportive. Ugandans and Muzungus alike, having heard the news, made their way to the hospital in vigil. I've received calls from the post-office folks who know us all, the man who fixed my windows, the tailor with whom I share books, the Ugandan volunteers at the library, and so many others. I've even received a call from Sameer, my dear Indian grocer who, having missed me for the week, feared the worst.

When it happened, locals appeared from everywhere and apprehended the driver. No doubt mob justice would have ensued had the police barracks not been so near. The court-date for the case against the driver is scheduled for next week.

A grief counselor sent by Peace Corp D.C. has been working with the group, and a beautiful memorial service was held at the IST training site. Another is being planned at the school where the deceased young woman had taught.

I know for most of her group, this is their first brush with death of a friend and this magnitude of loss. It's a cruel initiation into adulthood. I hope her family can take comfort in knowing how well loved their daughter was, that the way she lived her life has already changed lives, and will be a beacon for others. As a mother, my deepest grief is for her parents and sisters.

~~~

The court proceedings stalled and a final resolution wasn't reached until two years later. Along the way it was beginning to

176

appear that the judge would be or had been bribed, at which point the Embassy intervened and issued a warning about the possibility of Peace Corps' withdrawal from Gulu, if not Uganda, if it was found that the trial had been compromised.

Ultimately neither the death, nor the injuries resulting from the hit-and-run were addressed and the driver got off with a mere slap on the wrist—a small fine for drunk driving.

Peace Corps remains in Uganda and in Gulu.

42 Texas in the Rearview Mirror

I knew this time would come, but had put it on the backburner of denial, until the owner-finance loan became due. I'd bought and sold roughly thirteen houses, lived in some of them, renovated and sold others and had always been able to finance via what's known as a low-doc loan (high down payment, low documentation) popular among the self-employed. Literally, a month or so into our deal, that loan capability was eliminated and the sellers were as committed to selling their home as I was to buying it and renovating it. A deal was forged, and they carried the loan, then extended it when I couldn't sell prior to Peace Corps.

A year in, when it was time to sell, I was 9,000 miles away.

June 6, Year Two

What to do? My friend who held my POA suggested a realtor friend of hers take the listing, and while I've always had house-luck in terms of finding just the right house at the right time, selling them was another matter. In looking back over my history, the ones I really struggled to sell were those to which I had an extreme emotional attachment—not to the house per se, but to the life that happened in the house, and to the dreams both realized and lost.

Leaving California to return to Texas after the birth of my first son: the house sold in one day! We were going *home*. On the other hand, the post-divorce sale of the home where the kids had grown up was emotionally devastating and took forever. Selling the last house before moving to West Virginia wasn't as devastating, but I was in the grips of empty nest grief and even though the kids were adults and on their paths, I had the horrible feeling I'd snatched their history and home away from them once again. That one took a while too, but the West Virginia house sold on the first offer. Once more, I was moving *back to Texas*.

The house I sold in Peace Corps represented the last tie to my spiritual home and a life that had defined me: college, kids,

businesses, marriage and my evolution as a woman. The double whammy before Peace Corps was my *fear that if I couldn't sell it, I couldn't move forward, couldn't leave for Peace Corps.* It was the perfect storm of emotions to disrupt any transaction. I'd learned long ago that worry and fear only serve to stall plans and conspire to draw in the thing most feared. It's all about resonance and energy, but knowing it and managing it are different. Still, I'm getting better at it.

I couldn't bear the thought of another emotional roller-coaster, of it languishing on the market another time. The difference now was that after more than a year away, there had been a sea-change and I'd released my attachment.

Literally, the moment the realtor pushed the *For Sale* sign into the ground, the buyer showed up to make an offer. He made a show of being an investor, but claimed to be buying my house for his sister. He'd read and accepted the disclosures, and accepted the house "As Is." No inspections; it had been beautifully renovated.

We haggled about the offer, and a deal was made, but the Title Company refused to accept the POA I'd executed before leaving. Crap! We'd delayed getting to the airport prior to departure to sign the POA prepared by an attorney, just for this eventuality!

In the States, executing the new document would have taken five minutes; here it took five days to get all the elements lined up, another day to get to Kampala, and another two days to get the Embassy to waive its Thursdays-only rule for notary public business. By that time, I had two days left to get it to Austin by the closing date.

Serendipity intervened when the Education Director, scheduled to fly to the States the next day, took the documents with him, overnighted them from the airport, and they arrived within an hour of the deadline. It was another fire drill, and that should have been it, but the buyer had other ideas.

Thinking I was desperate to close the deal, he pulled a fast one when he came to sign his papers and threatened to walk unless I reduced the price by $15,000. It was a jackass move—he was playing a game of chicken that was probably part of his strategy from the beginning.

My realtor made the difficult call, and explained the situation. The real test for me was, *could I say no and risk the house going back on the market?* I had a moment of panic, but also knew he

could be sued for breach of contract and I was just mad enough to do it.

I called his bluff and refused. His gamble had failed, and I had my money by the end of the business day, thanks to a great realtor.

I was liberated. No house, loan paid, equity in the bank! At long last, I had the free rein to design life on my own terms after COS.

I'd finally cut the umbilical. It was the first time since arriving in Austin fifty years ago that I had neither a home there, nor a desire to return to live there, though I will always love my friends and Texas history.

The unique pride-of-place held by all true Texans never leaves you.

43　We've Been Sleeping Around

With my house finally sold, I felt the freedom I'd hoped for when leaving Austin over a year ago. The synergy of the sale and COS being in our sights made our last trip even more of a celebration. Ethiopia, with its rock-hewn churches was mystical; Uganda—primal, but Zanzibar! Even the name feels exotic when it floats off the tongue.

In Ugandan terms, I was going to be *sleeping around,* meaning I would be traveling, i.e., moving around and sleeping somewhere other than my home. Glad we got that straightened out.

Although many in our group had elaborate plans to travel after COS, I knew this was my exit trip. I'd had a lifetime of wonderful travel: Tunisia, Morocco, Europe in my youth, China and a few other near-east countries as a Feng Shui speaker, and now Uganda, Ethiopia, and Zanzibar. I was ready for home, family, and putting down roots, again.

With this as our last trip, six women and one brave husband set off to enjoy warm blue waters, exotic Stone Town, spice plantations, and revelry before the final stretch and our COS Conference.

Close of Service Conference

Although our COS conference was next, it wasn't the crowning end of our two years. *Superlative awards,* named by and voted on by our fellow inmates were handed out and I proudly accepted mine:

> *The Best F'ing Guru in PC!*
> *(most likely to funtuate shit)*

Though some volunteers had chosen the earliest possible dates for leaving and had little more than a month remaining, a few chose to extend to complete projects. In any case we were ready, but were filled with mixed emotions. Arriving back in Gulu, the rainy-season once more upon us, a friend and I slogged through the ankle-deep

mud yet another time—the slop nearly sucking the shoes off our feet. But as we rounded the corner into the alley leading to my house and were greeted by a small herd of Ankole cattle, I was again in love with Uganda.

The Last Minute Sillies: The Egg and I – August 26, In Service

We were all beginning to say our goodbyes and my friends Holly and Bill came for a last visit. We were growing tired of constraints, itchy to return to our lives, and silliness was taking over.

It's going on two weeks without eggs in Gulu and it will be another week before egg delivery. Somewhere I suppose there were eggs hiding out in small clutches. There are certainly chickens. Perhaps they are on strike.

But Holy and Bill, my great friends from Kolongo, are visiting and staying at Casita Nancy for their 39th wedding anniversary. In celebration, they brought along a bag of sacred brownie mix mailed from the States, a mix that requires one egg. I'm not in the mood to substitute a banana or applesauce (not that there is applesauce in Gulu...).

On the way back from a breakfast of EGGS, we stopped by Uchumi, the biggest grocery in Gulu, in the hope that a big chain would have eggs. No eggs.... at least no eggs for sale. But wait!

Just about the time we were consoling ourselves over this announcement, sighted in my peripheral vision was a tray of beautiful eggs held high in the air by the hand of an Uchumi employee headed to the bakery. *Ah HA! Follow that man! Certainly we can talk him into selling ONE egg.* I am not above groveling for something that will ultimately emerge in chocolate gooeyness.

I laid on the charm and explained I really need just one egg and could he let me buy just *one* from the bakery stash. It's a good day; he agreed after talking to the bakery folks. Who in the world would want just one egg anyway, but she's a Muzungu and there's no tellin'.

Somewhat bemused, he handed me the solitary egg, which I clutched to my bosom like a mother hen. After all it's the golden egg from which brownies will be born. After collecting a few more items, I went to pay and put my treasures, including the egg, on the counter. The checker looked at the egg—looks at me. *One egg?*

This is the conversation which ensued—delivered in the stilted (but always p-o-l-i-t-e) Uganglish we use here:

Checker: "You *cannot* buy one egg."

Me: "One egg is all I was able to get."

Checker: "But we do not *sell* just one egg."

Me: Smiling, "Well, your man in the bakery gave me that egg to buy, because the eggs are finished."

Checker: Bored refrain, "We do not sell just one egg."

Me: Still smiling, "I know that is usually true, but I need an egg and you do not have eggs. I talked to your employee in the bakery where you DO have eggs and he was nice enough to get this one for me."

Checker "But we do NOT SELL just one egg; we sell eggs by the tray of one dozen."

Me: Matter of factly, "You do not have a dozen. In fact your eggs are finished, but the bakery gave me this ONE egg to buy. It is OK."

Checker: Disgusted, "Madam, we-do-not-sell-just-one-egg! (Note: everywhere *else* you can buy one egg, 20 eggs, 200 eggs...)

Me: Getting a little more direct, "I've been here for two years and I *have* purchased three eggs, six eggs... now I am buying ONE egg, because that is what the bakery would sell me and that is what I'm leaving with."

Checker Gave me the *look*... and now several others are in on the conversation trying to explain to this obviously deaf or stupid white woman that WE DO NOT SELL ONE EGG!

Me: Raising my eyebrows, "I'm leaving with this egg..."

Checker: whose look has escalated to, "Over my dead body." A crowd is gathering.

Me: "You sell boiled eggs in the bakery, right?

Checker "Yes?"

Me: "I could buy just one boiled egg?"

Checker: "Yes, but this egg is not boiled..."

Me: "Pretend it is boiled and I will pay you for one boiled egg. I AM leaving with this egg..."

Checker "But that egg is NOT boiled and they *count* the eggs."

Me: "In all due respect, I'm leavin' with this egg—so let's find a way to make that happen. Count it as boiled."

Checker: silent and glaring.

Me again: "How much is a boiled egg? 400 schillings? I will pay you 400—no—make that 500—even a 1000 shillings! I'M NOT LEAVING WITHOUT THAT EGG!"

Checker Exasperated, puts the egg in a bag. I tell Holly to grab the bag to establish possession.

Checker: Sends a messenger to the bakery to get the code for a boiled egg.

Me: My heart quickens. Success is near and we're fantasizing about the possibility of brownies cooked in series in the small toaster oven, if the power comes back.

Checker: Snatches the printed sticker with code from the clerk and stabs the number into the cash register.

Holly: Clutching the egg—she is moving toward the door...

Me: "Apwoyo matek," to the gathered crowd, I dash for the door before she changes her mind.

We STILL don't have the brownies; "power is finished," but we have the prized egg, brownie mix and spoons.

44 Keeping Girls in School

Even though my departure date was a couple of months away, it was practically tomorrow in the scheme of my overall service, and considering the time it took to get things done, it seemed impossibly close. The kids' visit would consume a few of those weeks, and acutely aware of the timing, I was desperately trying to work in the things I still wanted to accomplish. From the beginning, projects to support the *girl child* were high priority.

Blog Post: September 1, In Service

This is not a blog I would have thought of writing earlier, but a lot of topics we would consider taboo in the States are just part of the fabric of life here.

In a country where education is so dramatically impacted by HIV/AIDS (both teachers and children), the forced marriage of barely pubescent girls, and a 50% school dropout rate for girls who don't have the money to buy menstrual products, the rules change.

Working with LABE has given me an inside view of the sorry state of education and school facilities here. One of the most startling statistics is the 50% to 75% dropout rate for girls once they hit puberty, due to lack of feminine hygiene products and private changing rooms or latrines at school.

This exposes them to even more serious issues; with no skills to earn survival money except to sell their bodies, many fall victim to early marriage.

So, last week, Joy and I drove out to one of the schools to teach the girls how to make reusable menstrual pads or RUMPS, as they're called. Reusable? Huh? Something you never thought of in the States, right? Although there are commercially made kits (*AfriPads*, factory near Kampala) that sell wholesale, for about $5US and will last a girl about a year, they are only recently reaching the north, but even that cost is prohibitive for most.

At some schools, supplies are given to the girls on an emergency basis, but that's rare. We are teaching them how to make the pads from old clothing, towels and sheets, but often, in the village, there are no sheets, because there are no beds—people sleep on papyrus mats on the floor.

Sitting under the mango tree, we've taught about 150 girls and some parents, using kits I made from supplies you all have sent, old materials I had on hand, and discarded sheets from a few hotels. I doubt if American girls have ever given this much thought, but these girls and their families acted like they'd won the lottery, because this ONE thing can keep them in school.

It was a fine wrap-up to the week before I head to Kampala to train some staff and meet the kids on Wednesday in Entebbe! Can hardly contain myself, I'm so excited to see them. It will be a kick to experience Uganda through their eyes! What an amazing opportunity and a blessing to be able to do this together.

45 The Broken Digit

Finally! The day arrived and I met the kids—both sons and one girlfriend—at the Entebbe Airport, one of the best moments of my life and certainly the high point of the last two years. After a comfortable night in Entebbe, the kids were introduced to the luxuries of The Annex. They had requested an experience as close to mine as possible, which was a good thing, because we were all operating on a budget and you can spend a lot of shillings filling the gap between The Annex and en-suite baths. Our time was too precious to spend a day getting back to Gulu, so we started our tour from Kampala, and hit the Rhino Sanctuary first, followed by Chimp Trekking, and a slippery trek to the top of Murchison Falls, where the Nile squeezes its way through a six-foot gap in the rocks and plunges 141 feet into Lake Albert on its trip west.

Exhausted, our arrival at a lodge on the banks of the Nile was a bit raw. Apparently, I wasn't going to be able to gentle the kids into adjustment to my world. I knew our safari guide and had requested something with at least a modicum of luxury: working fans, an indoor toilet, and running water.

Instead, when we arrived after dark and were deposited at our dark cabin, what we noticed first were the skittering sounds. Flicking on the single light bulb dangling from a cord—good so far, *power was there*—a prehistoric cockroach dropped into a half-full beer bottle and the rest of the swarm disappeared through cracks into the cavities between the walls, where they skittered through the night. I knew these cockroaches from Louisiana. Brett strode matter-of-factly into the kitchen and covered the largest crack with a book, in a futile attempt to imprison the roach-clan.

There were fans, but they didn't work.

Toilets and showers called. Good, sort of, on the toilet: sit-down, not latrine. The shower? Water was "there," but produced only cold drips from a hand-held wand. Thankfully, there were mosquito nets.

After a fashion, we found the outdoor, communal dining and having arrived so late, were treated to the dregs of spaghetti. But there was beer.

Between a hippo's guttural garumphing as it consumed its eighty-eight pounds of greens outside our windows and the kids' bad-stomachs, we spent an uncomfortable night, but when morning came we were ready for the wild wonders of the park.

And that afternoon, the *finger happened*. While a broken finger is not, in its own right, terribly significant, it ushered in a sequence of events that was pure theater and black comedy. It's bizarre, I know, but I wouldn't trade the experience for anything. It was horrible but entertaining.

In the Beginning

It was the second day of Safari when it happened. We were all unfolding from the 4X4; wild animals called and we answered. My hand was in the door frame as I pulled myself forward from the rear seat when the driver shouted: "Shut the door!" And someone did. It was a bit before anyone else realized what had happened and my hand remained stuck. In the perversity of luck, only my shooting-the-bird finger was well and truly damaged.

Well, nothin' to do after the scream, but get out and see animals, although I have no memory of what they were. This is the Ugandan outback, no ice for swelling, no Minor Emergency Clinic, but both sons having been EMTs, pulled out their first aid kits, and in short order the digit was splinted and wrapped. It was three days before we made it back to Gulu and the possibility of help. As a good friend told his wife some years ago (and lived to regret it) after she'd stepped on hot coals, "Just wrap it and go." And so we did.

To make matters worse, I had a ring on that finger, causing the finger to swell and look like a purple sausage.

Returning to Gulu, the kids went on a futile search for a pair of wire-cutting dikes to cut the ring off while I waited and had X-rays in a walk-in clinic with a 1950s X-Ray machine and no protective shielding. A few minutes and $10US later, the film revealed a bifurcated break. Now, how to get that ring off?

PC Medical made some calls. Since the only ring-cutter in Uganda is in Kampala, they suggested I go to the Italian hospital where a metal worker could cut the ring off with a rotary saw under medical supervision. None of those words belonged in the same sentence.

We got a private hire to the hospital and the day was getting toward afternoon. We piled out of the car and headed for the Casualty Department to find that the doctor Medical had called was in surgery, leaving me to find the metal worker and negotiate the removal of the ring. And this is where the comedy began. You can't make this stuff up. The sign outside the hospital waiting area said:

If you have nothing to do, DON'T DO IT HERE

Frankly, I wasn't looking forward to doing anything here.

The Blade Master

I told my story to the nurse who intercepted us and she sent for the ring-cutter soon to be known as *The Blade Master*.

A few minutes later, a middle-aged Italian man wearing several days of white stubble, and a dirty shirt with one button holding in his massive belly, arrived. His eyes twinkled with mischief. Through fuzzy yellow teeth, he spoke: "You have ring to cut off?"

I showed him the hand. Grinning, he tells me, "I haf dooone eeet... using saw—don't woorrrry!" I WAS worried so asked how many times he had done this and he said "at least four or fiffe times."

With what I considered a wantonly sadistic gleam in his eye, he offered, "I haf cut riiinggs not just frrrom feenger...!" Asking what else had he cut rings from he said, with a deep chortle, "from peenises."

I'm sure I heard several men behind me passing out.

He left to get his equipment and returned holding a 12" long electric rotary saw over his head like the torch on the Statue of Liberty. A six-foot-long cord trailed—no plug, just naked wires to stick into the outlet, meaning it could stop in mid cut. Closer examination revealed a rusty 6" circular blade, with lots of big nicks. I thought I might faint.

My innards were beginning to roil as we were ushered to a treatment room where the Blade Master happily stuck the wires into a socket and turned the saw on—full squeal—and moved toward me, still with a twinkle in his eye, and grabbed my arm. This man is jolly and obviously loves his work. Me, not so much.

A group was beginning to form as all of us gasped and I began to pull away from the saw, protesting loudly. This was pretty much the conversation:

189

Blade Master (BM): "Don't worry. You not move—no problem."

Me: "It's not YOUR hand."

BM: "You too anxious. Someone hold her down."

Travis and Brett: "You have to protect the knuckles."

BM: "If she not move, no worry." I sense that this man is very good at cutting all things metal, but my finger is not metal.

Me again: "What if it slips?"

BM, Beaming with cheer: "No worries! If it slips, we in hospital!" Hahahaha "Give her drugs maybe... xanax," but I'm thinking they're gonna have to chloroform me to get any closer with that blade...

Brett: "The safer you make this, the less you have to worry about her moving."

BM: Forces my arm on the table: "You just hold her." *whirrrrrrr*

Travis: "Alright everyone quiet! Conference! Outside. You—step away from that saw!"

There are now six people in the room, including two Ugandan staff frantically trying to make this safe. Molly, the girlfriend, looking pale, has left the room.

Me: "You have a metal shop, right? You cut wires? Yes? Go get some metal dikes—now-now. This ring is silver—soft," gesturing with my hand giving everyone an involuntary obscene gesture. "Metal dikes will work."

BM: crestfallen: "Saw will work, you too anxious! That ring stainless—dikes not work, but we try." He left muttering, but returned with two pairs of shiny dikes and a hacksaw.

The smallest pair of dikes and a strong hand did the trick. *The Blade Master* left shaking his head over this bunch of weenies.

Next Day

No setting of the finger yesterday. By the time we got the ring off everyone had left and the doctor was still in surgery, so we met the next day.

We all traipsed to the exam room; a party atmosphere developed out of pure nervousness. Cameras were snapping... FaceBook accounts were shared (at the doctor's request while pain shots were taking effect.)

190

Every effort was made to realign the bones, but they had already fused in place. I was going to have a crooked finger as a souvenir. (The tip still dips down like it's embarrassed.)

The entire bill from "soup-to-nuts" was less than $100 US dollars.

The experience with *The Blade Master*—priceless.

46 Fixin' to Get Ready

So many of my memories of Uganda have to do with sitting in candlelight. We all groused about power being *finished,* and it was damn inconvenient much of the time, but lack of power at night meant candlelight and there's a certain magic that comes with that. The darkness wraps around you and the light of a candle is its own cocoon, slowing down all else. With light, ideas fling about, noise bumps into itself, bugs buzz, there are things to do, or worry about not doing. But darkness, like a rainstorm, seems to grant permission to sit, and ultimately thoughts go inward; we become softer and more reflective.

It took me back to when the kids were little, and there were strict limits on TV time, but at some point not far into elementary school, TV became king. As an experiment, we unplugged the beast and put it in a closet.

Nighttime TV was replaced with reading aloud by the light of a kerosene lamp. We were all happier, slept better, and looked forward to the evenings, instead of dreading the bedtime scuffle. The kids still record it as one of the best summers ever, right up there with living on a boat. And of all the memories of Uganda, candlelight remains one of the sweetest.

Blog Post: October 25, In Service

As I began writing this, the power was off and I sat in an almost empty house in the soft glow of candlelight. It's a memory I'll have forever. To keep it from getting spooky, I spaced tea-candles in the hall, offering little puddles of light from living room to bedroom. The scene has repeated itself so often over the week that I ran out of the tapers I thought would last forever, then tea lights, then batteries...

As time comes to a close here in Gulu, it's a bit surreal. The house feels like a shell and is essentially empty except for the basic pieces of furniture. All the artwork is down, crafts packed. Knowing

me as many of you do, I packed the arts-and-crafts and mementos first, along with those things the kids gave me to make life more comfy here: solar chargers, Life Saver Water Bottle, Steri-pen, Leatherman, French Press.

Naively, I thought I had only one suitcase of treasures. Two 40lb bags later, I realized that packing to leave is actually more complicated than packing to get here, for one simple reason: things I forgot from home could be (and were) mailed to me, and I knew I would return to my family and friends.

Leaving here, it's probable I won't return; I want to take every morsel of memory back with me. It appears I'm doing just that.

Mentally, I'm somewhere else. Physically, I'm here doing what I need to do to leave. Part of that equation is Peter. What to do about Peter in the long term?

LABE has just this week moved into the larger offices promised a year ago, but they still have no power, water, copier, internet, lights. The library project, however, seems to be in hands that will work to continue its growth and that's satisfying.

The weekend was spent saying goodbye to friends I've served with and a curious thing is happening: There have been multiple reconnections promised Stateside: with both Ugandans and PCV friends.

Today was spent delivering gifts to people who have made such an impact on my life here: a shawl to Emily, bed sheets to Peter's friends who have been so lovely, personal mementoes for my LABE friends. The list goes on; there are so many people to hug, and thank and share tears with.

It's a bagful of mixed emotions and as time draws near—twelve days left in Gulu—my emotions careen from giddy to heavyhearted and everything in between. I've been warned that this roller coaster will continue and get even worse when I'm actually back in the States. You are forewarned!

~~~

I love the way the universe conspires to support the processes of life. None of the hinted-at alliances actually came about, but the hint of them came at a time I needed to believe some of my life in Uganda could continue, that I and it would continue to be relevant. As it has happened, some of those connections came to an abrupt halt, while others took longer to unravel. And it's all OK. The teases served their purpose—to ease the grief of leaving, but once home, I didn't need them. Texas here I come! Almost... Six. More. Hours.

# 47   A Parallel Universe

**Blog Post: November 29, Texas**

After twenty hours of travel and 48 hours without sleep, I have landed in what feels like a parallel universe. It looks like a place I remember: there are people, cars, paved roads—places I recall. I'm supposed to know this place, but it feels alien. Describing this sense of disconnectedness, a friend related it to time-travel, except I've also transited cultures in the process. Having sold my house, I am "homeless," in a way that is both exhilarating and unsettling. I'm incredibly blessed to have friends who have taken me into their beautiful and extremely luxurious home, but I feel like Alice in Wonderland must have felt when she fell down the rabbit hole.

It's a strange new world: soft bed, no mosquito net, down pillows and comforter, a bath*tub*, a toilet that doesn't require a two-foot long *mingling stick* (a long wooden stick used to stir) to flush it... and fridge that works full time and is stocked with things like cheese and pickles and...

I went to wash clothes and discovered twin stainless steel monoliths adorned with a control panel rivaling that of a space shuttle, blinking blue lights with 20 possible options of how to wash. I wondered if they might also orbit. Do they speak?

Maybe sleeping on a cot in the garage for a few nights would ease the shock of reentry.

Next, there is the car and I am allowed to drive it. Ah! No key but a button that begs pushing. I like keys. They make me feel safe and grounded. When I push the button, my seat glides silently into exactly the right position and the car hums into action. Windshield wipers think for themselves and come on when it begins to sprinkle, mysteriously speeding-up and slowing-down to match both rain intensity and car speed. Said car locks with a mere swipe of the finger... I have to check the back seat door to convince myself it's locked, because if I touch the driver's door, it unlocks and we have to start the verification process all over again. So-long to my

longstanding compulsion to double check the door by pulling on it. Foiled again. Last night I discovered that the headlights also have a mind of their own—I had them on bright at one point and they dimmed when I was at a stoplight.

Jet lag and realty shock play strange games with the mind. I lose things or forget where I put them moment-to-moment. Yesterday, I was late getting somewhere because I'd lost my underwear having put it in a logical place I couldn't remember in my mental fog. Things are clearly moving themselves around in the night, waking me at 3:30 in the morning. OK. So it's jet lag.

I have eaten my way through the new world: Mexican food, BBQ, toast made in an actual toaster, eggs with yellow yolks, cheese, pickles, Torchy's tacos. There are stripes down the road, stop signs and red lights and people know what to do with them! There is a startling absence of cows, chickens and goats on the road. Where are they? No chickens hanging from bicycle handlebars.

And today, it's winter. Last week it was summer and will be again soon, if it doesn't snow. This must be Austin...

To exacerbate matters, I've suddenly become very aware of my age. In Uganda, age is revered, not so much here. I've now crossed the threshold where I can no longer pretend: I have signed up for Medicare and Social Security, but have had to retrieve marriage and divorce documents from different agencies I had a hard time even finding, much less getting to in the push-button car. And I thought thirty was a threshold!

Meltdowns are reducing in frequency. It's a new world for a stubbornly independent woman of a certain age to suddenly become dependent on friends for shelter, transportation and goodwill. And fortunately for me, I have an abundance of saints in my life who are sharing their lives, resources and especially their love and goodwill with me. This makes me even more exquisitely aware of the contrast between my life here and that of my friends back in Uganda. In Uganda, I was constantly infused with a deep sense of gratitude for "all that I have."

All it took was stepping off the plane in the States, to instantly be sucked into the awareness of "what I don't have." All this in the face of the incredible generosity of friends. Yet, it is the very absence of those *things* that affords me the liberty to create a new chapter. My goal is to once again opt for a simpler lifestyle—one consciously chosen, not just fallen into as a result of stepping into the mainstream, or should I say maelstrom.

The next chapter may not be Africa, but I hope it will stay fresh. I hope to continue to be wide-eyed with discoveries and it is my full intention to age-backward.

**Thanksgiving:** What a season to chance upon reentry: to an embarrassment of riches, of friends, opportunities and open doors. My hosts are both professional chefs and the experience would have been stunning in any case, but coming from Uganda, it was practically orgasmic. The adventure continues but in a totally different way, of rediscovering the "ordinary."

~~~

Peace Corps said there would be days like this... They tried to tell us, re-entry would be challenging. But truly, there was nothing that could have prepared me for the totality of disconnect and reverse culture shock. I was a mess. I couldn't carry on conversations about the daily concerns of friends; they seemed irrelevant in the scope of the poverty I'd witnessed in Uganda. I began to feel like we—in this country—are the impoverished ones, totally unaware of what we have and devoid of spirit.

Things felt flat, mechanical, colorless—like food with no salt or seasonings. I'd fallen into a black hole of judgment and isolation at a time people were wanting me to schedule a consultation, teach a workshop, do things. Hell, I couldn't even find my underwear, much less string the words together to teach. I did a consultation for friends and felt like I was a fraud; felt even guiltier because I had to charge them, having no operating funds. I felt guilty on every level.

Within days of being back, my affluent hosts opened their home for an annual concert. There was a scrumptious buffet, wine, champagne, an eclectic guest list of Austin's elite and regular folks. I was of course invited, dug around in storage for something marginally acceptable to wear, and mingled. I was introduced to a guest, who upon hearing where I'd been for the last two years, looked at me with total honesty and said something like, "Oh my God, this must feel so ridiculously inconsequential. How are you holding up?"

Friends who came to my homecoming party a few days after I'd landed described me as drawn-looking, shell-shocked. And I was.

Friends shook their heads, tsk-tsk: what had become of this previously strong, organized, accomplished, go-getter? What had happened to Nancy?

I was asking the same question.

Part Five ~ Intermission

Intermission: a recess between parts of a performance (a life?).

Others have defined it as a period in which the action stops for the observers, but not the actors, who are still busy off stage, changing costumes and scenery.

The audience, on the other hand, can return to reality from their suspension of disbelief, get back to real life for a few minutes, get a glass of wine, a Margarita maybe? And I'd like chips with that, *por favor.*

Mexico was that intermission for me. I may have been off-stage, and between acts, but there was plenty going on.

That said, the script was being rewritten at every turn, and there was a lot of ad-lib, but it gave me a chance to catch my breath and regroup. It definitely included costume and scenery changes, and the snacks were good. And finally, it broke the tension between the previous act and subsequent ones.

48 Reassembling

It's been a little over a month since I stepped back onto US soil, and I am just beginning to feel like a citizen, although a forever changed one. I wonder if I will ever lose my excitement over looking at a night sky, washing my hands in warm water coming from a tap, or flipping a switch for light on demand. I hope not. Interestingly, internet access and phones continue to be a mystery.

I'm on the mountain, hanging out during the day in Brett's domain. Christmas Day was spent at Timberline Lodge, encased in ice.

The contrast between the primal nature of Uganda, with its grime and poverty, and the pristine stillness of ice and snow at a luxury resort is mind-boggling. Across from me sits a woman wearing a full-length mink coat over her leopard-print pajamas and fur-lined powder-boots.

Meanwhile, in Uganda Peter, between schools, continues to struggle with shelter and food, although I have sent some funds. Even those who mentor him live on the very edge of survival.

Connections with my community in Uganda continue even as I wonder what my next chapter will be. Part of it is known: yesterday I put down my deposit for a certification course in Guadalajara for Teaching English as a Second Language (TESL), with the idea of working in Mexico to fund my goal of becoming conversant in Spanish. Right now, the only phrase I remember from high school Spanish, other than greetings, is "Caramba! Se me olvido me quaderno (OMG, I've forgotten my notebook)!" The mind is a perverse thing, though I may have an opportunity to actually use that one. I've wanted to do this for decades and now's the time.

~~~

I'd hoped time in Mexico would help me recalibrate, and it did, but not in the ways I'd expected. I knew this was a bit of a stopgap measure, hopefully a bridge between Uganda and the US, but more importantly between my former life and a new one.

Third World and indigenous cultures have always held a fascination for me, but I think a seed planted during my high-school graduation trip to Mexico held the subconscious promise of discovery.

A week into that trip, my mother was hospitalized with Ciguatera fish poisoning, a rare gastrointestinal illness. Earlier in the day, we'd met two handsome sons of a wealthy rancher. Students at University of Texas (UT), they spoke impeccable English and gave us their cards in case we needed help while in Tampico.

When Mom became so violently ill, I called for their help. Fearing the public hospital, they immediately collected us all, along with their private physician, and checked Mom into the private hospital. Over the course of the next two weeks, a member of their family stayed with her around the clock, in case she needed a translator. When she was discharged, the doctor refused to charge us, and the patriarch arrived with an enormous roll of bills (which we repaid), to help us finish our trip.

Once home, Mom saw her chance to get me out of Louisiana and a music scholarship to a small Baptist college near her relatives. She decided I would go to University of Texas, and although I hated her for it at the time, I later understood what a huge gift she had given me.

Subconsciously, maybe I was hoping Mexico would work its magic again and offer a clear solution for my next chapter. The TESL certification was just the vehicle to get me down there.

In any case, I'd decided to give it six months—the length of stay allowed by my Visa—and see where it would take me.

### I Hated it!

Not Mexico, Mexico was all of its magical self, but TESL was not for me. I hated the *process*. It felt rigid and while I liked the concept, the process was not a fit for this right-brained creative. Truth be known, the idea was a means to an end—to learn Spanish—not a passion. Since my refund would have been minuscule, the school graciously offered to apply the remainder of my tuition to do just that: learn Spanish.

And just like that, it began—the *time of wonder and synchronicity* that would characterize my sojourn in Mexico.

## Synchronicity Abounds

When the course ended, so did my reservations at the hostel. I sent half my belongings back home, headed for the Yucatan Peninsula and stepped into my own version of *The Celestine Prophecy,* where whatever I needed magically appeared.

My first stop was Merida, in the heart of Maya Country, where my interest was twofold. Merida had been the place Dick dreamed of managing a small hotel; the second had to do with its Mayan history.

Having happily survived the widely misunderstood eschatological event intimated by the Mayan Calendar for December 21, 2012, I wanted to learn more about this culture that predicated *not* the end-of-days, but a shift in human consciousness. Amazingly, I arrived on the day of the Equinox festival at Chichen Itza, when the serpent, represented by the shadow of the sun, slithers down the staircase of the temple. I ditched my backpack at the hostel and headed that way, to find much of the world had done the same. Phrases in German, Farsi, Mandarin, French, and Aussie-English drifted through the air.

The next day, I wandered around Merida to see if I could connect with what it was about the place that had held sway over my father. Following the music to the town square, I found it vibrating with dance performances, color, food, and laughter. It fed my soul and I remembered my dad's joy in Mexico.

Then I *knew*: his life in the States had been a monochrome world of repetition and struggle; but Merida was *Technicolor,* offering a kaleidoscope of possibilities.

I felt Dick's presence and joy at my understanding the allure of his dream and in my own coming home to myself. I felt content in a way that surprised me, because I was not physically home and wouldn't be for a while.

Merida was lovely, but inland, and scorchingly hot. Already, I was conjuring on how to go about finding an affordable place near the ocean to settle for a bit. On the third day, a couple of American women passed me, wondering aloud about directions, and I offered my help. The next thing I knew, we were drinking iced-Horchata, and one of the women offered me free use of her beautiful condo

near the beach in Playa del Carmen for the month of June. In parting, she said, consider it a "thank you for your service."

Instances like this continued throughout my time there.

From Merida, I went to Cozumel, en route to Isla Mujeres, a place last visited when my firstborn was just a baby. As we spilled out of the bus into a sea of tourists, I wondered, *how the hell do I get to the ferry for Isla,* when a French-Canadian man asked me if I needed help getting to the ferry! We became travel buddies and have remained in loose contact.

From there, I went to Tulum, and dragging through the heat, I found the hostel where I had a reservation. It was unsuitable, so I ended up going elsewhere and meeting some Brits there conducting sea turtle counts. Needing another hostel for the interim month before Playa, they offered me theirs in Bacalar while they were away for surveys.

Bacalar offered long, solitary walks along the Laguna de Siete Colores, trips to the Cenotes, and time to ruminate, but my desire to see more ruins had not yet been satiated. The problem was, I didn't have a car and was uncomfortable adventuring off into the jungle alone to find them.

As I sat at breakfast, another thought was answered.

### Blog Post: May 29, Mexico

I'd just finished my three mile walk and was waiting for my favorite breakfast: fresh local fruit, topped with homemade yogurt, honey and granola offered by the tiny cafe under the hostel. As conversations always happen in such places another traveler came in and we began comparing notes about the area.

The topic shifted to his eleven-year-old, twin ADD/ODD grandsons. I shared some ideas from the consulting I used to do, and before long he invited me to join him on a trip to see some Mayan ruins deep in the jungle. He'd already secured a car and a map of sorts, so we set off, having only a vague idea of where we were going.

Hours into the drive, we took a wrong turn toward an abandoned landing strip, and after realizing our mistake, backed out to the main road, thereby attracting the attention of a tank-full of military guards patrolling for drug smugglers! Bulging with guys armed with assault rifles, the tank approached us and a lot of scary men in full-camo dressed for Armageddon leapt across the road, guns at the ready, motioning for us to stop. "This can't be good..."

but considering the lack of alternatives, we stopped. Neither of us had brought our passports and the combined pulse rate in the car escalated as fear practically fogged the windows.

Once stopped, with the window obligingly rolled down, six stormtroopers surrounded us. Oh man, how did I spend all that time in Africa, only to come to Mexico and find trouble?

In fact there was no trouble. We didn't look the part of smugglers apparently, because these guys just wanted to know where we were going, pointed us down the road and wished us a good day.

What's travel without a little adventure!

~~~

June was approaching. Playa beckoned, and eased me back into First World commercialism with the presence of Walmart and Costco. I allowed my inner tourist a last fling as I swam with the sea turtles and Whale Sharks, but always in the back of my mind was, "What's next?" I'd been making lists of different options, and had seen a bit of the expat lifestyle and didn't want it. I'd been away long enough, had dropped much of the hypervigilance, eaten good food, honored some family history, and was ready.

It was time to go home, time to get back into my life, but not the life I'd left. That door had closed. I know, because I'd slammed it.

Yes, I was ready to go home, but where was it?

49　Where Is Home?

Rarely, in adult life, do you get the totally open-ended opportunity to start over in a new place—unless you're in the witness protection program, that is. Fortunately, that didn't apply here. But seriously, there are usually so many ties to family, job, community, or other constraints—real or imagined—that a large part of the decision is made for you.

Not so here. I had devised a portable life with total autonomy and it was daunting. Having infinite possibilities was both the good news and the bad news.

It's actually easier when some of the parameters have been decided for you. Where the heck did I really want to go and what did I want to do once I got there?

No longer hell-bent on a particular professional track, I focused on place. I literally had to get my life out of storage, and that meant loading up a truck one more time and unloading it *somewhere else*. I had some ideas:

- Near water, preferably an ocean
- Close to at least one of my sons
- Smallish town approximating my own philosophical bent.

I had a lot of refining to do, and doing the work I had done for so long, I knew a little about helping people make decisions about big life transitions. I even wrote a book about it, *Moving Your Aging Parents*. Apparently I'm now the *aging parent,* though I'd slap anyone who suggested it.

So I fell back on a technique I'd used for years, and turned to the ancient practice of Feng Shui and the Nine Life Domains, the nine aspects of life we all live. We may live them differently from each other, and at different stages of life, but getting clear about how I wanted those to look had always worked.

For the uninitiated, the Nine Domains are: Career, Wisdom, Family, Finances (Empowerment), Reputation, Relationships, Creativity (Future,) Helpful People (Travel), and Health.

Here's a bit of explanation and what I wrote then (in present tense, as the exercise is meant to be done), fresh from Uganda, about what I wanted to create—with a few teasers about how it evolved. Setting those intentions gave me access to an ever-evolving expansion of consciousness and a richness of life that continues to unfold in ways I could not have foreseen.

Career: This domain really speaks to what we want life to bring us in terms of opportunity, meaningful work, and how we spend our time on the planet. The one thing I was sure of professionally was that I wanted to continue to offer people the means to manage their energy, but take it to the next level. People have asked how I moved from a Master's Degree in Audiology to Feng Shui and Energy work, because they seem so unrelated. But they are just different points along the energy continuum, bracketed by the sciences of Acoustics and Quantum Physics on one end and spirituality on the other. Working as a diagnostic audiologist and living with an electrical engineer, whose hobby was calibrating devices using an oscilloscope, grounded the abstract for me, giving me an easy visual of how these concepts of frequency, sound transmission, and resonance work.

I'd offered tools that aid that process from the outside in, and as transformative as they were and are, I now want to apply the new insights and tools I've gained to help people do the work from the inside out, and bring spirituality into the real-world of everyday life.

Peace Corps gave me time to work on translating spiritual practice into daily living.

I now understand that I don't have to teach it per se, I just have to live it in whatever work I do.

Wisdom: Wisdom for me is the ability to bring knowledge and spiritual practice into the mundane: life as a prayer. That has evolved into recognizing that patterns/behaviors I see manifesting "outside" of me, aren't "outside" at all, but reflections of past hurts that I have yet to heal.

Having experienced radical transformation in my family and the world around me as I heal my own stuff, I'd like to share that process.

Family: Family doesn't have to mean biological family, but could mean your tribe, the people who love you. In Peace Corps, the need to connect with people of shared experience is so strong, in the

absence of other family, that fellow volunteers became our *"family,"* in spite of differences we may have had. And like family, they could be triggers, becoming part of the learning process.

I hope to find at least one kindred spirit wherever I land, and that place should be within easy visiting distance of one of my sons.

What ultimately transpired fulfilled all of that and life is still unfolding in ways I know to trust.

Abundance: It's unfortunate that this sector is routinely addressed in financial terms. Money, while necessary to meet basic needs, is only one aspect of abundance, at the core of which is the ability to manifest through resonance with the conditions that allow us to feel secure and happy—however we define that.

In planning for my future, having chosen a fairly minimalist lifestyle, I see empowerment as living an autonomous life, having access to healthy food, people I love and who challenge or inspire me, living in a peaceful environment, doing meaningful work, and having the means to do things are truly important to me.

Extensions (Community): Traditionally this is called Fame, but even fame is about how we form extensions into our community of choice. No longer bent on broadcasting a business, my focus has become about living in such a way that my external presence is a match for my inner life. Here, reputation is not about *what* you do, it's about the spirit, emotion, and integrity brought to the doing of it.

Relationship: I'd been divorced and living alone for twenty plus years by this time, and by necessity had developed a fierce independence, which had served me at one time, but didn't nurture reciprocity in relationships. At one time I dated a man who announced, "You are the most infuriatingly competent (said a curse word) woman I've ever known!" Like that's a bad thing? Only if it's used as a shield and masks a vulnerability born from the belief that no one will be there for help anyway, as mine had been.

I wanted to dismantle some of the barriers constructed over a lifetime and unravel the tangled networks, but I wasn't entirely sure how to go about that in a vacuum.

A few years down the road, I would be presented with the perfect crucible for that growth, one I couldn't turn down.

Creativity and Vision of the Future: Creativity is what we bring to every moment of life, and the creative endeavor of bringing our

visions into the future. That said, I'm extremely visual, connected to color and texture whether it's in decorating, food, or writing. Some of that is stimulated by surroundings, and I wanted to be able to draw from whatever surroundings I found around me.

When the kids were really little and I was a stay-at-home-mom, I began weaving and felting: beautiful colorful, textural shawls, wall hangings and exquisite felted hearts I sold in various venues.

When I got divorced and had to make real money, I no longer had the physical or mental space for weaving, so channeled my creative juices into transforming the homes and offices of clients.

Creativity is ultimately about being able to adapt to shifting terrain and create new options and new life from what we have available. It includes children, because they represent our desire to create brought into the future.

Helpful People: Throughout my life, I'd operated almost as an island, neither asking for, nor expecting help, because I'd learned it wasn't available and vulnerability was just another opportunity for rejection. Mostly, I *was the help,* always responding to other people's needs, putting mine so far down the list I didn't even know what they were. I envision a more inclusive present and future, one less defended, with the ability to trust in other people enough to invite and accept generosity, and choose a community where good deeds abound.

My mother had a similar trait installed by her own stern upbringing. When she was diagnosed with pancreatic cancer, I discovered that form of cancer is related to *an inability to taste the sweetness of life.* It totally defined mom. She was always willing to help others, but would never ask for help and was uncomfortable receiving it. The joke about her was that she wrote *thank you notes* for thank you notes written to her.

One of the gifts in her cancer was that she was able to heal that aspect as she received so much help and unconditional love from her family and community. She learned to receive with grace and recognize it as an act of love rather than a weakness. In the end, she was content.

The gift in the lesson was not lost on me.

Health: Throughout my life, I'd enjoyed excellent health and naturally wanted to continue that, so I wanted to live in a place that would be a match for the kinds of activities and opportunities I love. Such a place would have: proximity to water, a library, a creative

and intelligent community, teaching opportunities, safe places to walk and explore, trees and green landscape, and be a smallish town, with a potential for solitude.

But the physical aspects are only the top tier of this domain. Like an orchestra, if one of the sections (life domains) is out of sync, the result is noise and chaos and the whole suffers. In the physical body, disease shows up in the biofield before it becomes evident in the physical.

A few years after really settling in, I would have the opportunity to address some of those imbalances, and when they showed in my life, I knew it was because I needed to address and heal some old emotional injuries. That played out in exaggerated interactions with family members, whom I adored, and who adored me.

This domain integrates all of the others, and offers the opportunity to examine how each domain impacts the others. Balance in the different areas of life contributes to optimum health.

As life progressed and I did the deep work of healing the past, the inflammation rampant in my body began to settle down, without other interventions, although it's a work in progress.

50 Jigsaw Puzzle

Focusing on how I wanted my new life to unfold brought into high relief how much had changed for me. I was deeply aware that I had become a different amalgamation of pieces, and began to think of puzzles.

Since early childhood, I've loved jigsaw puzzles; they were the way our family connected over holidays and vacations; and one of our few shared activities, when casual conversations burbled up offering tidbits otherwise neglected.

It turns out there's a term for puzzle-people: *dissectologist*. Didn't we do that to frogs in high school biology? Seriously though, the concept is perfect for what happened in Mexico, as I dissected the puzzle of my life, analyzing the pieces to see which ones I would keep or discard, and figuring out how to put the Nancy-puzzle back together again.

Most of the puzzle remained, but lots of border pieces had been discarded, some interior pieces reshaped, new pieces found along the way, and some long lost ones reclaimed. So basically, I was a somewhat amorphous collection in need of definition.

When the kids were young, spurred on by their father, they gave me a Spilt Milk puzzle in a milk-carton for Christmas. Given as a joke, I knew it was really a dare: totally white—no shading, no interlocking pieces, no clue-pieces, no discernible border. I was honor-bound to put it together, and did.

Decades later, although my life wasn't *that* formless and it certainly wasn't colorless, like spilt-milk, it was waiting for *something* to give it definition.

That "something," would be a place to land and provide a framework from which to start over. That place would be the Oregon Coast, winning out over Florida, which had been a fit in my thirties when we were a sailing family, but had lost its appeal due to climate, crowds, and the transiency of the population.

With that in mind, and my Visa set to expire, I loaded up the puzzle that was "me," and flew back to the States on July 4th—oddly fitting.

~~~

As much as Mexico had eased re-entry, reintegrating would take a while. I had come back to myself to some degree, but I was still a person in flux. I had hoped that Teaching English as a Second Language would complete the "what to do" slot, but it hadn't. I would just have to start with "place," and let my intentions and gut guide me from there.

With all the philosophical noise operating in the background, I was acutely aware I still had to manage the practicalities of resettlement. With none of the trappings that lend *legitimacy* in the USA—i.e., car, insurance, a job, or a solid plan, I set about the impossible: relocating from Texas to Oregon and finding a place to rent, without any of the ballast landlords routinely require, and my last known landlord (and reference) living in Uganda. And I needed to do it all on a holiday weekend.

Here are some of the high points and low points—in both logistics and adjustment. Life didn't jump-start automatically. I know people who seemed to have slipped back into their former lives, but most of those had left their lives on hold, not totally boxed up, or they were young and hadn't yet defined their lives. A few extended their service in-country, went on to another country for service, or went on to work with humanitarian organizations. Regardless, re-entry usually came with some challenges.

~~~

Blog Post: July 4th, Oregon

Since I now have a US phone, I suppose that makes me a citizen again, albeit not a very active one because I don't exactly know how to use it. It turns off of its own will, not mine, and seems to have a prima-donna attitude, unlike those tough little Ugandan flip-phones that tolerate being dropped in the mud, coming apart in three pieces and still work when you put them back together. It beeps at me for reasons unknown; I don't know its beep-language yet, but it's not English, Spanish or Acholi.

I am here in a place where the beauty almost makes me weep: the pure richness and accessibility of it; picturesque little towns, bright hanging baskets, giant evergreens, and trails populated with families carefree enough to hike in the woods with the family dog, cold

water rapids. I suppose in part it's being in a culture where despite the complexity of life, we have sufficient disposable income and time and feel safe enough to go climb a mountain—to expend energy in ways other than finding food.

What strikes me as one of the most salient characteristics of the developed world is the presence of *choice*. It doesn't mean that those choices are easy or that we even recognize their existence, but the potential to *choose* is there in every breath, whether or not we exercise it, or live by default instead.

So, in gratitude, here's to choice and all that that entails, including the responsibility to choose wisely and often.

~~~

Just because I was back in the States—home in a global sense— and in a holding pattern, didn't mean life had slowed down for anyone else. I'd spent a month with Brett in his one-bedroom apartment, and it was beginning to wear, though he was totally gracious. His summer schedule was grueling and having a house guest made it harder. I, on the other hand, had no car, limited clothing, was sleeping on an air mattress, and had no idea where home would be, except in Oregon.

It was Brett's idea to drive up the coast, starting at the farthest point I would consider an acceptable drive to come visit. Knowing me, he said I would just *know* when we drove through the right town, and I did.

Having chosen a tentative landing spot, I flew back to Austin to get my stuff and drive it back to Oregon. It meant getting someone to rent me a truck, and paying through the nose for insurance because I didn't HAVE any... because I didn't own a car!

### Blog Post: September 1, Texas

The last week has been quite the adventure, starting last Sunday with loading the truck. What started as a plan to drive a small U-Haul grew and grew. While I'd purged about 75% of my belongings before Peace Corps, they still filled and 8X10 storage, translating to a 14 foot truck *expertly loaded*, but by departure had morphed into a 20-foot truck with granny-attic. With each additional foot in length, my anxiety level ratcheted up, and a 20-foot truck is really 30-feet with the cab.

Forget the big-girl-panties; I went for the jockstrap and channeled my "inner-trucker." It seems to have worked.

~~~

A former Peace Corps friend joined me and acted as navigator and ad hoc therapist. We named the truck Guadelupe, demurred at a friend's suggestion of taking a gun as self-defense, took a hand-rake I'd forgotten to pack instead, and climbed in. I bought a new Garmin navigator and let her speak.

Leaving Austin: Blog Post

As we were leaving Austin and waiting for the light to change, a beautiful white haired, black homeless man ensconced in the median locked eyes with us and gave us the most beatific smile and the thumbs up. From that point on the trip felt blessed.

~~~

It was a good start to our journey of roughly 2400 miles, transiting Texas, New Mexico, a corner of Colorado, Utah, Idaho and Oregon. Laughing much of the way, swigging coffee, arguing with the pushy female-voiced Garmin we named Garmina, who always spoke as though she was right, we made the trip in a state of grace, even as we drove through places named *Dismal Nitch, Dead Horse Canyon, Starvation Road, Poverty Lane, Hells Bend* and *Humbug Cove,* hoping they weren't omens of things to come.

As we neared the turnoff to Mt. Hood, I simply couldn't wait to see Brett, and in an ill-planned spark of insanity, drove Guadalupe up the mountain, forgetting that Timberline would still have snow.

## What the Hell Was I Thinking?

In any case, we survived the hair-raising trip down, only to arrive in Portland on the Friday afternoon before Labor Day weekend. I mis-understood one of Garmina's commands, took the wrong exit and ended up on a death-defying detour into the Belly-of-the-Beast known as downtown Portland, with its five-o'clock traffic snarl, narrow streets, and more chaos than I'd driven through in the last four years. Garmina wouldn't shut up until she got us out of downtown, and under the spaghetti bowl of overpasses, where I had to stay in the left lane or transit hell all over again.

My response to stress is often laughter, and we were both convulsed with it, tears blurring the overhead signs. By the time we'd transited the city and found a questionable motel, it was all we could do to park Guadalupe and crawl into bed.

The next day, a couple of good natured, hunky college guys unloaded Guadalupe into the only 8x10 storage unit available, and my friend, Karla, rented a car, because I had no car insurance, because I had NO CAR! I was giddy with excitement as we headed to Cannon Beach, but the *one* rental agent we could find laughed-out-loud at the prospect of finding an apartment on Labor Day weekend (much less in my price range), so we walked the beach and I wallowed in the swamp-of-despair for a while. Karla, undaunted, found something on Craigslist, though it would be weeks before I could even see it.

Looking back over that period, I still marvel at the way things unfolded, though at the time the logistics seemed insurmountable. But as in Mexico, things fell into place. The most unexpected was the cedar-shake cottage a couple of blocks from the ocean—the Craigslist find.

The best of it was that it matched to perfection a life-long-dream: a cedar shake cottage by the sea. The exclamation point to that synchronicity was finding a thrift-store coffee mug with a picture of a cedar-shake cottage by the sea, with the caption: "You never know how many friends you have till you have a cottage by the sea." And friends did come.

All of it happened just in time to see Brett off on his cross-country motorcycle trip, which gave me access to his car and apartment until I could move into the cottage. I finally bought a used Honda Fit, christened her Hissy-Fit, and found someone to reload a geriatric U-Haul. Things were coming together.

## 51    No Going Home

Within days of unloading the U-Haul, I was on a flight back to Austin. No time to get settled-in. I'd received a call from my friend in whose home I'd stayed after Peace Corps, asking if I would come back to help move her Mom. The only answer to that was, "of course."

While there, the idea of restarting my Real Estate Feng Shui class was presented, and although I hadn't considered that option, logic said it would be a good way to bridge the income gap while I got settled in Oregon.

A plan of sorts emerged, but in truth, the plan that had found me turned out not to be the right one.

Although the first class was a success and resulted in some lucrative consulting, it felt out-of-sync. It wasn't the way I wanted to offer the material anymore, but constrained by my contact, I had to teach it as I'd written it a decade ago and it felt like going backward.

Those were the thoughts that occupied my mind as I drove to Florida to see Travis for the first time since coming home. There, I was reminded of the fact that my children's lives had evolved independently of mine, as it should be, but the reality cut our visit short. It was a wonderful reunion, but we were both shifting gears and trying to mesh into new lives.

As Travis left for Miami, I headed for the annual UFO conference hosted by Dolores Cannon, whose work in past-life regressions had unearthed a treasure trove of information on multi-dimensional experiences. Unlike some of the glitzy, carnival-like affairs elsewhere, this was a serious gathering of leading researchers and documentarians in the field.

Because I'd had numerous beyond-normal contacts in the past and was feeling the pull to take that part of my life out of mothballs and pursue answers, I attended a second conference, where I met Mary Rodwell, another respected researcher. Both conferences were helpful, and though they didn't bring me any closer to knowing what I want to do when I grow up, connecting with other

experiencers, as we are called, reclaimed yet another piece of the puzzle. And frankly, I was itching for more experiences.

I left with my head spinning with possibilities, and returned home ready to delve back into my meditation practice with a vengeance. The hibernation-like nature of a winter beach town was conducive to meditating a couple of hours per day, and the more I meditated, the more lucid my experiences in non-meditation time became. My body vibrated at night. Not the bed, my body...

At the time, I was experiencing intense pain in my wrists and hips. I would ask for a healing in some part of my body and receive an instant physical response. Among the other experiences: a visible portal that looked like a wavy disturbance in the air opened inside my front door and a small being stepped through; a friend who visited reported experiences with orbs—describing it as being kissed on the cheek. I saw orbs zinging through the room during meditations, and had encounters with a group of beings I identified as my *Council of Seven*.

This all tied in with Dolores Cannon's findings from her research with thousands of Past Life Regressions, but mine were happening in real time. One of the possibilities that came to me during this period, because of the impact regression had had on my life, was to become certified as a Past Life Regressionist via her program. My first regression experience was the result of a trade with a client/friend: Regression for Feng Shui. Here is that first regression experience:

## Unity Consciousness

Without going into great detail, I had the single most profound experience of my life. The best way to describe it would be a merging with Unity Consciousness or Oneness.

I arrive at a place drenched in golden light; pyramidic crystalline structures "created from lateral planes of thought," glow from the inside out. The structures themselves are information.

I ask for a guide; an extremely tall, benevolent being appears and gives a bow of recognition, offering a sense of welcoming me back home. He announces himself, "I am Arcturus."

We glide to a temple filled with even more intense light and emotion, the very essence of love. I merge with a larger body of light, in which smaller points of light, of which I am one, are suspended. Although words are inadequate, I am enfolded by the

feelings of being welcomed, embraced and honored for my contributions.

I am sobbing. It is the most intense emotion I've ever felt. I know this is home and I feel complete for the first time in my life. I am told I chose to separate from the collective, the ONE, to be a part of the great shift of human-consciousness occurring on the planet and my purpose is to teach others about energy.

I weep at the idea of going back, but am told I will be able to connect via the golden cord that connects my physical body with the collective.

~~~

The feelings were indescribable. I'd felt separate and different for so long, never having felt "at home, at one," but this "place" was home. Oneness? The feeling was one of joy of being at home, mixed with the sadness of knowing I would have to return to duality when I returned to the physical.

Because that experience changed me at my core, I felt it would be a valuable process to offer clients in my consulting practice if I revived it. Although I did become certified and conducted a number of productive regressions, I chose not to pursue it further, in part because of what happened next...

No Going Back

Shortly after becoming certified, I returned to Austin a second time, and began dreading the trip even as I took my regular detour through Taos, New Mexico, one of my favorite places. I love the feel of the place, the Native American art and flute music, the scenery—all of it in stark contrast to where I was headed—Greater Austin and its two million people. As I approached Austin's traffic corridor driving in from the north, I could feel the knot forming in my stomach. The tension had been building throughout the trip, but I kept telling myself it would dissipate as I got into town and started teaching. It didn't. And I didn't teach.

In the shifting profit-emphasis brought in by the new Real Estate Board, a more profitable event took priority and my class was cancelled after I was already in town—having driven two days through a blizzard. The final blow was their attempt to withhold payment, violating our contract. I prevailed, but it left a sour taste.

Everything about that trip, including the unraveling of an old friendship, conspired to remind me I was going against instinct in my re-engaging with a life I'd left behind for valid reasons. The only

times I've been in real trouble in my life have been when I've allowed intellect to override intuition and the Universe was delivering a message. Had the events been fewer in number or less dramatic, I might have been tempted to excuse them as a one-off, but there was no denying this steady line-up of calamities.

Fees from the class and additional consulting had made the trip a marginal success financially, but not emotionally.

I got the message: there is no going back.

New Directions

After great gnashing-of-teeth and flailing, I felt totally liberated to move in a different direction, and broke free from the gravitational pull of a place that had been home most of my adult life.

Often, when making the break from a person or a place, the soul delivers an event or an argument—some distraction—to temper the real feelings, those that keep us coming back in that slingshot way, for one more effort at the job, the relationship, the life. The events in Austin were my "distraction," but rather than treat them as "outside" me, I needed to go deep inside and understand how I had contributed to that experience. Although my youngest son said about another event, "Mom, I know you like to go deep, but... sometimes people are just shits," blaming others would have been the easy way out for me. I needed clarity.

The desolation of West Texas seemed a fitting backdrop for all that, as I hauled ass back to Cannon Beach, emotionally processing as I sped across the flatlands, replaying the road trips with the family to go skiing, then with just the kids and now... by myself.

There is no quick exit from Texas or the past, literally or figuratively. And there was no going back. I was in the badlands, and the only way out was through. I cancelled my planned stop to see friends in Taos and just kept driving.

By the time I got back home, I recognized the gift in all that had happened, and was feeling relieved and grateful for such an obvious answer to the ambiguity surrounding my question *of whether I should just try to make this work.*

I recognized the vitriol hurled at me by a longtime friend as her unresolved anger with her mother, but more importantly as a mirror for my own unresolved issues with MY mother, who would fly into similar diatribes.

I also recognized the issue around being paid, a lack of integrity on the part of the agency that had hired me, as a mirror of my own

lack of integrity in returning to the exact practice I'd left behind and knew was not right for me.

Time to focus on "the now."

After some months of soul searching, I dismantled my website of twenty years, *Focus On Space*, the thread that kept me tethered to my past. I'd cut another umbilical cord and just like that, all proof of me as a professional entity was gone. As long as the website was up-and-running, I'd felt the pull to do something with it. Instead of grounding me, it felt like an anchor that prevented my moving forward.

Whatever presence I wanted to build, it wouldn't be a retrofit.

Part Six ~
Answers

52 The Thing That Started It All

Each time I attempted to re-enter a previous stage of life, using the old rules, the result was the same: I came face to face with the reality of how radically my inner life had changed. I was tuning in static, not music, not harmony.

I tried to determine when that had begun, and while there were many small shifts along the way, what I was experiencing was nothing short of a paradigm shift.

I traced it back to that summer day in Austin twenty-plus years ago.

Me, Before...

There I was living my life, paying no real attention to the chatter in the background, except that I remember finding it impossible to get a deep breath, my ribcage was so tight. Later, after all the dust settled, I found this was a symptom of deep anxiety, but at the time, I just scheduled a massage in the hope it would help. It did, but not in any of the ways I'd expected. I was mothering two small boys, managing our real estate investments and a large, complicated property with lots of moving parts, most of which leaked and rattled. I was contractor, yard man, landscaper, bill collector, mom, landlady, wife, bad-cop when needed, advisor, and fixer all wrapped into one.

Our main business was a software development company. My husband, a Phi Beta Kappa genius, was consumed by that, and by a constant need for some form of escape that would take us away for months at a time in the summer. My job was to be sure everything ran smoothly in my absence, organize everyone, and be ready to pack and/or unpack at his whim.

With all this in this background, what happened on a particular, bright summer morning precipitated a spiritual awakening that would direct the rest of my life. Any images of that process involving candles, yoga, sipping green tea, and being smooth sailing

should be jettisoned. As the saying goes, I did all that but the yoga, and still felt like smacking someone, and probably should have.

Take This Light

It was one of those incandescent summer mornings in the Texas Hill Country when I awoke in our blindingly-white, second story bedroom—the sun streaming through a clerestory window and setting the room ablaze. But something was odd; I woke up with my eyes locked onto a *spot* in the middle of my forehead and it was pulsating wildly. *Well, this is weird, what's happening?*

A spinning indigo disc came into view, the center opened up and a cloaked, monk-like figure thrust a lantern through the opening. Offering it to me, he spoke:

"Take this light for all to see…"

Ah, OK. By this time I recognized the figure as The Hermit—Number Nine in the Major Arcana Tarot deck I'd used many years ago—a spiritual guide, using his lantern to light the path for others.

Stunned, and waiting for something else to develop, I thought, *Is there something more you want to tell me?* I knew The Hermit as a way shower, but not what it meant for ME.

OK, *let my light shine. How? When?* The aperture closed, and the moment was gone, or so I thought.

When I opened my eyes in this sunlit room, a strobe-bright pinpoint of light appeared about ten feet away. *What in the world is that?* Pearlescent rays of gold, silver and violet began to stream from the center, drenching the room with luminescent color, presence, and all-enveloping love. My whole body tingled; the top of my head pulsated. I found myself weeping in complete ecstasy.

I knew I'd been touched by the hand of Divine.

And just as quickly, the spell was broken. Sounds of children squealing downstairs broke through the veil and pulled me into the present.

~~~

Such is the way epiphanies happen—in the middle of life, punctuating the mundane; exhilarating and sometimes inconvenient. I was left to figure out the *meaning of life* in the middle of scrambling eggs, kissing a husband off to work, doing housework, and picking up dog poop.

That night, a torrent of tears began, ebbing and flowing through the next day. I sobbed while cooking dinner; wept in the bathroom to avoid unsetting the children; and blubbered while driving to the

grocery store. I was a mess and didn't know why. Then it came to me: "*Oh God, I'm having a nervous breakdown and this is what it looks like!*"

By the time the Hermit popped into my forehead, I'd had many metaphysical experiences, and had read Tarot cards for years, starting in the Brittany region of France when my sister, and her friend, Kathleen, and I stayed with the village seer, Marique, who read our cards. It was between my first divorce and my dream job and I'd taken off for nine months in Africa and Europe, so I was ripe for a little intrigue.

Each afternoon we were invited in for a reading, a thimble-full of strong coffee begrudgingly added to bourbon. Kathleen had to translate from Marique's ancient Breton, as she made predictions—most of which came true—that scared the pants off us. I was hooked. My sister gave me an old deck of cards and I learned to read them for myself and friends. That said, The Hermit had never shown up in my bedroom with a lantern before.

In many dreams and encounters, I'd been gifted with a glowing ball of light by a guide; and there had been other experiences, other visions, but I'd set it all aside to pretend normalcy for the sake of marriage, kids in a mainstream school, and just to function in life.

This wake-up call set me on a path that would change my life and was central to my knowing I needed to honor the light-within. Looking back, it set in motion the sequence of events that culminated in my decision to make a break.

It was the first of many experiences that would lead to my knowing of:

*Light* as energy
*Light* as vibration
*Light* as frequency
*Light* as en*light*enment
*Light* as the frequency of love,
And *love* as the purpose of life

It became inseparable from the journey, becoming the journey itself. Peace Corps had become an integral part of the journey that deconstructed me in a way that made the rest of the journey possible, but also changed the reference points I used to determine emotional fit and true value.

## 53  Casting About

For the first year-and-a-half back, I felt an urgency to hurry up and decide what I was going to do, but it wasn't an academic decision; I knew it would have to happen intuitively, and nothing felt right.

I was back to "living the work," but this time on my own soil. At least in Uganda I had the identity of Peace Corps Volunteer. Here I was just "me," with no trappings but a rented cottage, a used car, and no f'ing rain gear! I had wanted a place near the water, and had forgotten to plug in climate preferences. There was rain. And while I truly missed the rain in Africa, this was not a substitute. What Uganda got in an hour, would take months of continually-spitting mist to reach an equivalent. In Uganda I could simply wait it out, have a cuppa tea, meditate, enjoy the interlude, then go about life.

On the north coast, life WAS rain! Waiting it out would mean literally hibernating for eight months. The year I left the coast, we'd had 162 consecutive days of rain.

Within the first month, I'd purchased three pairs of footwear for differing levels of onslaught: messy, serious slop, and walking on water. An equal level of diligence was required for outerwear: wet air, mist, spitting rain, frog-strangler, doesn't-have-sense-enough-to-get-out-of-the-rain. I bought them all, not as a fashion statement, but as survival gear. I knew I'd become an Oregonian when I went into a grocery store and was excited when I spotted rain-gear—the type a fisherman in the Bering Strait would wear—hanging right next to the elk-jerky and chocolate-covered "bear poop."

I bought a serious rain-hat with a stiff brim that wouldn't blow off in a gale. I thought of it as my Oregon Stetson. It was just as essential, but was so tight, I wondered if it could cause dementia-like symptoms from the sheer constriction of blood flow. So I drank more coffee...

Furthermore, it's the only place I've lived where, in the winter, with King Tides, I had to check a tide chart to know when it would be safe to go grocery shopping fifteen miles away. It was a love-hate relationship, but mostly love.

It was a new world, but I thrived and tried different avenues to get myself out there. There was no instant fix and I got comfortable with ambiguity.

As I cast about for ideas, I tried offering courses at the local community college—courses I'd taught via University of Texas' adult education program. Not a fit. I'd already dispensed with regressions as a plan.

An idea that *did* work had an oblique connection with the literacy work I'd done in Peace Corps, and it started with that thing I said I hated and would never do: Teach English as a Second Language. What started as my volunteering in TESL, and restarting the local classes, turned into my becoming the Literacy Coordinator for a community college program.

Over time, the classes became much more than an ESL class, as we focused on functional literacy—how to make a doctor's appointment, communicate with landlords, access services—fundamental skills. As I became part of the local Emergency Preparedness Team, I created lesson plans around Tsunami and earthquake preparedness, the threats in our area.

When the immigration crisis hit, the Hispanic community along the coast was hit hard as raids instilled fear and tore families apart. It was soul crushing. I worked with the Hispanic Council, and expanded literacy training to include relevant information on documentation, guardianship, and traffic stops.

It was an emotional time, but new community cohesiveness resulted, and the immigrant community, so vital to the area's economic survival, was embraced in a way that had heretofore been absent.

The work felt cohesive, but it wasn't so much about literacy per se. Literacy was just the vehicle for living-the-work, as were my jobs working as a docent for the Marine Sanctuary and as an Information Specialist at the Visitor's Center.

I was learning that anything and any place can be sacred work.

## More Synchronicities

There were some fun synchronicities along the way, and those have always been an indicator that I'm on the right path. This one happened in a Goodwill Store where I was searching for something specific for my classes and met a woman who told me she had "just the thing" at home and would run back and get it if I could wait; I

did. She ended up helping with the classes and became a good friend.

When my lease ended and there were no rentals anywhere on the North Coast, she was the one who convinced her neighbors to rent their seasonal cottage on the lake to me.

Life was taking its time unfolding, and I continued my inner work. Learning about my own triggers, I continued to prune away the extraneous, allowing myself to settle into self-acceptance, develop true sharing and reciprocity in relationships, and study how each of the shifts in my emotions and thoughts impacted my external world. Small towns and quiet lakes can be good that way—there's so much less noise and drama, fewer distractions, less access to familiar escapes.

I had the good fortune to meet and become friends with a woman my age, who shared some Africa background, and those unique insights gave us a springboard for other conversations. We discovered a shared interest in philosophical and spiritual matters, and spent hours "going deep." The mutuality and reciprocity of this friendship was something new to me, since so many of my other friendships had started in the context of teacher-student. Perhaps they'd been available years ago, but I wasn't a match for them.

About that time, the country fell headlong into the deepest political chasm I've personally witnessed in my lifetime.

I struggled to understand how we had come to such a deplorable state of divisiveness and duality. I had long ago known that each of us brings our own vibrational signature to bear in every interaction; had known about mass consciousness, and the hundredth-monkey principle and taught about all of it. But this new chaos was so large in scale it was terrifying.

It was that struggle that brought me to understand how the energy each of us brings to every moment contributes to the resonance of the whole, of all humanity and how that resonance becomes the out-picturing of what we witness and experience on the world stage and in our personal relationships.

That realization and my desire to be responsible for what I contributed at an energetic level would define the move that was to come next.

## 54    Heartbeat

And in a heartbeat, everything changed. Literally the beat of a heart—that of a soul having chosen his parents—very *surprised* parents—and wanting to start his next lifetime NOW, or as my Ugandan friends would say: Now-Now! *Chawa adi!*

There was no lack of chaos surrounding the events that followed, but the short version is that two families who in the ordinary flow of life would never have found each other, did, and we bonded as though we had been waiting a lifetime. And maybe we had.

I had consciously orchestrated my life to be available in whatever capacity, should there be a grandbaby. My kids had little access to their grandmothers and both grandfathers had died decades ago. Both my sons and I wanted to forge a different path, and as it turned out, this was that path, or at least the first leg of it.

Though I had planned for this eventuality, the event itself had not been planned. Two people had found each other in one of those ways that defy logic and forethought, and the third swooped in as though to say, "Well, finally! Let's get this show on the road." And so they did.

But there was a *test,* one that begged the question, "are you sure?" A miscarriage-that-*wasn't* happened, and while everyone was grieving (what we thought was a loss) but going about life, the sensation of giggles and blond curls enveloped me. I knew it was my grandchild. A few days later, the call came in: a healthy heartbeat was still there. Today, that same giggle fills our lives and belongs to my grandson, the embodiment of love, joy, and a mass of blond curls.

This announcement sped up a plan that had been in the works for a while, but in a different context. At one point or another, all of us had talked about a family compound, or at least being close enough to be more involved in each other's lives.

Brett and I had been searching for a suitable start-up and nothing clicked, until a wife and baby completed the picture, at which time

225

the house appeared, even though it had been on the market the whole time.

Conceptually, the property they found seemed perfect, including an attached efficiency apartment where I would live until building my own small house on a tract to be subdivided out. There was room for a large garden, and the commute for each of them was doable. It sounded perfect... on paper.

After driving five hours, getting lost, and arriving late due to roadwork, I was hot, sweaty, and not my most gracious self. I said something tactless like, "My god this is remote..." and they beamed, "yes, isn't it wonderful!" The die was cast.

The area truly is beautiful with rolling hills, canyons, and white-water rapids. Surrounded by a valley of wheat fields and cows, their four acres, one of which comprised the habitable zone, had been taken over by noxious weeds, yellow-jackets and ground squirrels— the functional equivalent of a band of subterranean terrorists. The thought of being alone out there with an infant in my care held all the promise of a pioneer woman in rattlesnake country.

That said, I took a deep breath, grabbed the jockstrap and the big girl panties again, and jumped in, after contributing a down payment which would ultimately secure the tract upon which I would build.

With the confidence honed in Peace Corps, I moved forward like a herd of buffaloes running blindly toward a cliff. The edge was closer than I thought.

I jettisoned another fifty percent of what remained from previous purges, loaded yet another U-Haul—lamenting not owning U-Haul stock—and drove into the wilderness of another new life. And while I was getting to the bottom of the barrel in terms of my *physical* baggage, I still had a ton of emotional baggage about to announce itself, and an excavator would be required. There should have been warning signs, like those highway markers announcing *dangerous terrain ahead*.

And there may have been, but I was moving so fast, I couldn't read them, or just plain ignored them, when people said, "Aren't you brave!"

### It Started with the Table

I unloaded the moving van into the double carport. How could I still have so much of life in so many boxes? But it had been a big life and it was comically evident that it wasn't all going to fit into 300

square feet. By the end of the next day, I reloaded and drove the now-half-full U-Haul to Goodwill, sans six small pieces of furniture and a 200-pound, 52-inch round, solid oak table from the 1800s, dripping with history and drama.

The table had serious juju and I had lugged it along on the last SIX moves. This was the table around which the entire Daniel clan had sat for Sunday dinners at Auntie's, my father's calamitously obese, diabetic Aunt. Autie's house anchored the end of a long driveway that wound through a pecan orchard draped in Spanish moss and Oriole nests. At the mouth of it was a ramshackle Church that danced on Sunday nights with black-gospel music and Amens. Auntie's place was more than a house, it was a kingdom, and Auntie was the Queen.

Dinner was always fried chicken, and dragged on for hours. No one left until Auntie had gnawed every last morsel of meat off several chicken carcasses. Captives that we were, the conversation inevitably drifted to family tales of clairvoyance and healing, on both sides of my family. The stories were never derided, because the events had all been witnessed, and acceptance of life-beyond-the-veil wove itself into the fabric of my life. Early on, I knew *just because you can't see something, doesn't mean it's not there,* and that there was an entire alternate universe that informed life.

In each place I'd lived, life arranged itself around *Auntie's table* and it was damn well staying. But it truly didn't fit anywhere, and remained parked, taking up both literal and figurative space, its presence looming like a specter that demanded recognition. I finally had to admit that along with the eccentric history, it also emitted the netherworld energy of conflict, jealousy and favoritism at the core of my father's history, a history that was at the soul of his sadness.

Those qualities, making the table a symbolic albatross around the neck of yet another generation, had no place in my current life. I called St. Vincent De Paul and told them to come get it.

Again, I felt liberated, but had I not been forced to deal with that piece of *physical* baggage, I'm not sure I would have recognized its psychic load. I felt lighter for another weight having been lifted.

### And Then We Waited

Having jettisoned that load allowed all the stuff buried beneath it to rise to the surface while we waited for a baby.

Three autonomous adults, well ensconced in their personalities and lives, had come together to live in close proximity; each of us

evolving into new roles. One of those was *MOM*, living fifteen feet away. What could possibly go wrong?

Plenty, as it turned out.

The challenges triggered ALL the unresolved emotions from my childhood, but I didn't recognize their origin. Instead, I erroneously attributed my feelings to the current situation.

The upside was, my beautiful daughter-in-law and I really liked each other, my son and I had good history, and there was enough work around the property to keep an army busy and somewhat distracted for the next year.

As is my nature when I am stressed, I cleaned and pulled weeds—and I was *very* stressed. Fortunately, there were enough weeds to go around, and if those ran out, there was the blackberry thicket encroaching on the house. Brer Rabbit couldn't be far away.

As I waged war on weeds, my son, returning from work on the mountain, prepped for war on yellow-jackets. Under the cover of darkness when it cooled down in the high-desert and the stinging-bastards returned to the nest, he suited-up in Hazmat gear for midnight sorties. The enemy was everywhere, turning even a light fixture into an enemy bunker. It was guerilla-warfare: his weapon of choice: Black Flag Wasp and Hornet Foam with a trajectory of thirty feet. He was stealth in his pursuit of the enemy as they rested up for the next day's assault on humanity.

With the yellowjacket population under some degree of control, it was time to do battle with ground-squirrels and take back the crawl space. Tools at hand, he commenced to block the tunnel under the plywood barrier. As he diligently created blockades, one of the miscreants stood sentry like a meerkat, surveying the folly from the blackberry hill thirty feet away. Within minutes of the project's completion, the marauder had re-dug his tunnel and all was well again in the squirrel-world.

So endeth the project.

The waiting continued.

# 55 Another Cottage

## Baby Made Three

Finally, the reason we were all together decided to join us and we had a beautiful baby boy. For the first month or so everyone was at home. They needed privacy (and sleep); I needed friends.

Our nearest neighbor was Crazy "Frank," known for bizarre behavior. Back on his meds, he had been in a relatively sane stage for a while, but had previously threatened a neighbor's wife with a chainsaw. I wouldn't be having coffee with Frank.

Christmas and my seventieth birthday came and went and the kids gave me the first real, honest-to-god birthday party I'd had in twenty years. I felt wrapped in love.

Christmas Day heralded in a new tradition, a leisurely float down the Deschutes River. Thankfully, the white-water version would wait till summer, but I'd stepped into another new world and sure didn't need five kinds of raingear. What I desperately needed was thermal underwear, a dry-suit, hand-warmers, and a life jacket. Feeling like the Michelin Man, wearing everything I owned, they rolled me into the raft and I embraced this new adventure with my beautiful and growing family. I loved that part. I loved all of it, but ached with the knowledge that things weren't right.

Over the next few months, we adapted to and grew into our new roles, but we all needed more room to expand, so devised a new strategy that included building my place a little ahead of schedule.

A quagmire of obstacles made that impossible. Furthermore, I realized, living so remotely would be isolating as others worked and went to school. I'd stepped into an episode of the Twilight Zone, where we just couldn't find normal again.

In the meantime, Brett had serendipitously discovered a renovated 1918 cottage in a cute town nine miles away, hatching another plan. It solved multiple problems at once: I could still care for my grandson, we would each have more space (literally and figuratively), and I would have community. There were a few

funding obstacles to overcome, but we figured it out. Though it was vastly overpriced, I made a low offer, expecting a counter. I also wrote a letter to the seller, who liked what we were doing, and generously accepted my offer.

It was a gift in every possible way.

## Wildfires

As I moved, the area was practically surrounded by wildfires. It seemed the whole of central Oregon was aflame. Cresting the hill between the kids' house and mine on an evening drive back home, the hills were silhouetted by a tangerine glow. The next day felt like a National Geographic Special as air tankers distributed swaths of orange Bentonite fire-retardant and helicopters refilled between rafters on the Deschutes. That night I alternated unpacking with status checks as the fire made its march down the hill behind my house.

I packed a go-box with critical documents, just in case fire jumped the road, then the river, and moved uphill. By midnight, it had reached the highway and the road became a twinkling necklace of emergency lights as firefighters methodically extinguished the burn before it could jump the asphalt and move toward town. I slept after all.

Wildfire crews around these parts are heroes. The next day I drove through the burn areas that extended in every direction and it was clear that the crews had had one goal, save the town. I would have to learn from the locals and let go of my fear.

In previous moves, I'd searched unsuccessfully for that small town where people support each other, where status and politics are secondary to being a community. I think I hadn't been an energetic match for such a place, so couldn't find one. But this little town of 432 people turned out to be that place, and I was ready.

As usual, I set to work transforming my place. I had lovely neighbors and an outlet for my creativity, but best of all, the kids and I had respective spaces. Things were better, but there was still a residue and guardedness that I was at a loss to know how to heal. And there were other things unfolding.

## My Own Personal Armageddon

When I entered Peace Corps, I bragged to myself that I was in perfect health... and I was. Since childhood, I've boasted an

astounding immunity; I couldn't even catch the mumps from my sister.

But since returning from Africa and Mexico, I had condensed an entire lifetime of aches, pains, injuries and maladies into a continual parade of doctor visits, physical therapy, and surgeries. What the hell was happening?

Intellectually, I knew that before an ailment shows up in the body, it's been hanging out in the energetic field long before that. Well, my field must have been crowded, because my body was in upheaval. Was it old injuries coming to roost, or evidence of my emotional state being so out of whack that it had finally had its say? In any case, my body was angry; my spirit, aching.

I got steroid shots in my thumb joints to avoid surgery; had bilateral cataract surgeries, tore my Meniscus and ACL.

The Universe was screaming at me, and other voices were added to the fray.

A part time job in town brought with it unexpected toxicity, and I quit.

Every friggin' thing was going wrong… and then, a routine mammogram revealed a possible precursor to cancer, resulting in two surgeries in a month. Spiritually, breast cancer has long been associated with refusal to nourish self. It was time to take a step back and do some serious evaluation.

During that time, my grandson was with me four days per week and absolutely the only joy in a life that felt like it was careening out-of-control. I was at a loss to know where to start to wrangle some control and then…

## There Were Bats

My Florida son had just come home for a while to reconnect with family and his presence, good heart, and sense of humor offered some light in this temporary dark-night.

From the back porch, "Mom, come see this! I think these are bats!"

Excitedly, because I like bats, I rushed out to see them whiz past, "Wow, these things are close, let's see where they're roosting!

Yes, they were close: dozens of soft, velvety bodies poured from around my chimney. After everything else, a friggin' bat colony in my attic?

Biblical. Is a swarm of locusts next?

By this time, it was pretty clear I wasn't responding quickly enough to the signals aimed at me. I was evidently ignoring something major, and was searching, but were bats really necessary? Wouldn't a note on my door have sufficed? Wasn't an entire colony overkill?

I consulted Native American lore on *bat medicine,* and read: bats often represent letting go of the old, and rebirth of a new life, transition, new starts.

Well hell, I knew that was going on.

But, if this was a rebirth, it was a helluva long labor and I'd needed to speed things along. I panicked over the thought of hundreds of breeding bats generating thousands of pounds of bat guano in my attic. Bat ejection and cleanup is costly, and as odd as this sounds, I knew this was a problem that was going to require *a metaphysical solution.* I needed those bats out of my attic, absolutely now: *chawa adi!*

I was quite happy with sharing some space with a few, but not a colony, not in my attic, and not while caring for an eighteen-month-old. I offered to build them their own little bat-condominium, but was told by a bat extrication expert, a bat-house would be like offering them a move to Motel 6, when they were happily ensconced at the Hilton.

## That's When I Remembered...

When the kids were toddlers, we lived in a cedar house with a shake roof, home to thousands of red wasps that considered the side of the house where the boys played their territory and would routinely dive-bomb intruders. We couldn't exterminate them because the products used were flammable when sprayed on a blistering roof. There had to be another way.

So one day, I pulled out my metaphysical guns and meditated. I told the wasps we could share space, but there would be rules and a no-fly-zone. I asked them to please move to the unused side of the house. Treaty violations would result in death.

The next day they swarmed and by day two, were ensconced on the other side. From that day forward, they stayed out of the house and the kids-territory.

I'd had similar success with scorpions and snakes for clients, so if all these worked, maybe it would work with bats. I meditated, thanked them for their work, asked them nicely to find a home elsewhere as their presence was problematic, and went about life.

In a week, they were gone. Bats do migrate, but that wouldn't happen until fall. Nevertheless, they had evacuated all at once, and have not returned.

Maybe I was getting my juju back, taking back my power so to speak.

*I needed to address why my life was so askew.*

I began meditating again, scanning for unresolved issues. I didn't have to go far, but I did have to go deep, so I journaled. As I zeroed-in on my past and how it might be impinging upon the present, it proved a target-rich territory.

As I wrote about my mother and our history, I was finding it harder to be angry, and in something close to an epiphany, I began to like her, and a different rationale for her criticisms and emotional distance began to coalesce.

I hadn't expected that.

And what about my father, Dick? As important as my mother's influence were the unspoken and less often addressed contributions of my dad, who—though less present in the physical—had an enormous presence from the other side of the veil, and in that way mentored me through much of my metaphysical and spiritual growth.

## Peace at Last

And then one day, my son called and asked if we could talk, *really talk*. What followed was a conversation that, in another heartbeat, healed the past that was causing us both so much sadness. And just like that, it was over. I revealed more about my history than he probably wanted to know, but it was important to me that he not carry what was not his.

## 56    Rescripting History

Could it really be that the purpose of my "cliff-jumping" into Peace Corps was to so radically shift perspective that I would end up viewing my history through an entirely different filter? I had wanted to strip away the extraneous, and that certainly happened. I knew there would be shifts in perspective, challenges that would test me, adventures that would delight me. All of that happened as well. What I didn't know was that it would precipitate an exploration into the darkest recesses of my psyche, how far that would take me, and how many "imposters" I would meet along the way.

It didn't start that way. The vast shift in external realities kept me distracted from my tendency for intellectual dialogue and what a friend calls "to-ing and fro-ing." When I periodically checked in with myself, I found I was swimming in a stew of emotions, not intellect. Gratitude and the skill of moving forward kept me—well—moving forward.

That in turn shifted my reference points, so that when I returned to the States I was a poor fit for "life as I had known it" and life as I had been programmed to live it.

By the time I moved into this new role of grandmother, retired person, newcomer to the community, I was almost unrecognizable to myself and absolutely no one but my sons knew my history, knew what I'd done in my life, knew about my accomplishments. And his lens also had filters. I was again, stripped bare.

You know those dreams where you're walking around naked? Yeah, it was like that.

In no way was I prepared for the new vision of my history that would emerge. As in Peace Corps, where few of my old approaches to dealing with life worked, that was also the case in this new life. My previous roles had been about "taking the bull by the horns" and wrestling it into submission. My intuition provided safety and guideposts, but it was sheer force of will that got me through the swamps. I'd learned to identify the issues that needed addressing, ferret out a solution, and make it happen. I didn't fully realize that

about myself until I got enough distance to look at my life in the same way one might when watching a movie. That's the distance that was afforded by stepping out of the mainstream for three years.

When I tried to slip into this very foreign, but much anticipated, new role that none of us had clearly defined, the rubber-band effect of springing back into old patterns was strong: be busy, be productive, identify the problem, fix it, and move on. The better role in this unknown territory would, again, have been, "Shut up and listen."

After a while, I did, but as my world reorganized itself, it took a lot of chaos to drive me into honest introspection. I had forgotten an important tenet when someone unpacks a problem in conversation: "Are you just venting, or do you want input?" Besides, that only works when the listener isn't part of the problem, as I was. I wasn't saying too much, but I was doing too much, in an effort to be helpful.

I'd done some pretty deep self-examination in traditional therapies, which have their place, but at some point I believe they can keep us operating in the same frequencies (hurt, blame, judgement, despair) that got us there. Wasn't it Einstein who said, "We can't solve problems by using the same kind of thinking we used when we created them?"

Knowing this, my latest look at my history was conducted through the lens of gratitude and greater neutrality. Past examinations of events had been conducted through a lens of assumed fault and injury. Viewing through this new filter offered a different view of my history.

Same history, different interpretation.

The resultant healing I have felt has produced a ripple effect that reminds me of the Native American concept: *when one heals oneself, a simultaneous healing occurs in seven generations past and seven generations forward.* I suppose it depends on your point of view, but if it's true that the concept of linear time is only a function of the physical world, and in all other dimensions and frequencies, everything exists simultaneously, the concept of healing forward and backward works. In any case, the healing of my family line was almost palpable.

It started with a conscious review of the events I remember from my life in Louisiana, and a dedication to rewiring the faulty neural programming that was installed along the way. It's been a largely successful endeavor, but with some stragglers and sleepers.

In doing that review, one of the things I noticed was a curious lack of fear for my personal safety (with the few exceptions of dark water and remote places, and that may be common sense or my feeling the predecessor energy of a place.) I wondered why. The obvious reason is that things hadn't happened to me physically. My fears were focused on things happening to people I love.

I realized that lack of fear for myself in general is based not so much on a *belief* that "I will be OK," as it is on numerous experiences where an event, which could/should have resulted in catastrophe—didn't, because of some form of beyond normal intervention or event that prevented it.

A case in point had to do with my being thrown by a horse on a trail ride hosted by a dude ranch where I'd taken the kids after my second divorce. We were assigned horses commensurate with our riding experience, of which I had little or none, and mine was supposedly an old and gentle creature, named *Apache*. I should have heeded the contradiction implied by the name.

Just before heading down a steep, boulder-strewn trail, Apache got spooked and, to add insult-to-injury, slipped and stumbled down the slope. I did all the wrong things, which resulted in my being thrown.

I flew off the saddle; time slowed down and I wondered where I would land that wouldn't kill me, because the hillside was a mass of boulders.

The kids, eleven and thirteen, witnessed the scene and reported later, "Mom! You were in a flat spin! And then, it was so weird! Your body paused in mid-air and you hung there, and then... you just dropped straight down!" I had landed flat in the only level space large enough for a body. Had I landed an inch or two off in any direction, I'd have sustained a fracture, kidney damage, or worse. Thrown objects don't fall that way, they travel in an arc. Something strange had happened and had been witnessed.

Although the muscles in my back were torn, the fact that I had no skeletal or other internal injuries was fairly miraculous. The mid-air pause was the first time I consciously realized I had helpers that could actually intervene, but I'd been aware of presences/beings long before that.

Another incident occurred while driving a Rent-a-Wreck along Austin's notoriously dangerous road, FM 2222, heading to teach a class. I made a maneuver that, in my Subaru, would have been a mere hiccup, but this car was not a Subaru. It started fishtailing and

I couldn't control it; each swerve got wider, taking me across four lanes: alternating between the hundred-foot drop on one side and the stone embankment on the other. I thought, *This is how it happens! I'm going to die or kill somebody!*

I didn't actually *decide* to take my hands off the steering wheel, they just lifted off and I heard myself say, "Take it!" I closed my eyes and felt nothing but a floating sensation. By the time it stopped, I'd spun 180-degrees and come to a soft landing—pointed in the wrong direction—between the road and the stone embankment with boulders in front and back of me. When I looked up, a dually pick-up truck was bearing down around the blind curve toward me and had I been six inches further out, he would have hit me head on.

I managed to get back on the road unscathed, arrived a couple of minutes late and taught my class. In my world, that's divine intervention.

Sometimes that help has arrived in the most comical ways and there are too many instances to share here, but I have never asked for help and been refused. I knew I was safe, but I feared for those I loved.

It was also given when I didn't consciously ask, but needed guidance. I believe this is the way the universe is supposed to, and can, work. But you have to ask and you have to listen and pay attention.

By the end of my review, I knew four things:

1. The catastrophes that had characterized my youth ceased when I left home.

2. My sense of impending doom was not based in reality, but in the neural networks that had been formed around those childhood catastrophes.

3. That fear was, in part, tied to a feeling of unworthiness and a belief that I was unlovable.

4. My personal boogeyman was the fear of being abandoned, and the phrase "abandoned at sea" kept coming up.

Hiding out in Numbers 3 and 4 was the tandem belief that if my mother couldn't love me, I was not worthy of love, ergo if the shit-hit-the-fan, I would be the one left behind.

I started with examining where this sense of being so unworthy originated, and the fractured relationship with Mom seemed obvious.

In my twenties, after my first divorce and reading, *Primal Scream,* I was ready to lay all fault at my mother's feet. Armed with the rage and arrogance of youth, I drove the ten hours to Baton Rouge and confronted her with my memories of a childhood devoid of touch, which I had ascribed to being "unlovable." She described her own childhood, equally devoid of touch, deriving from her family's strict Baptist condemnation of physicality. "Touch" was a foreign language and she had no context for it.

But that didn't reach the core of it.

## The Burn

The scars, both emotional and physical, have receded with time, but it was only when I had my own kids that the impact of a burn I received as a toddler began to niggle at me. Growing up, it had been mentioned only as an aside when I came across a picture of me in bandages. I'd grabbed a table cloth, on it a pot of boiling tea, which poured over the left side of my body, causing severe burns. Family was probably literally afraid holding me would cause more pain, but Mom never mentioned it in the context of my feeling unloved, even though the event overlapped the period toddlers are already dealing with separation anxiety.

A week or so after the *Take this Light* epiphany, I had a vision where I returned to the day of the burn and felt the wise-women of my family: Granny, Aunt Ivy and my Great-Grandmother, embracing me. In that instant, I knew that what my brain had cataloged as lack of love, was not true.

All those years, I'd operated on an erroneous assumption, kept alive by the unceasing demand for perfection, that supported the tandem belief of *not enough.*

But there was more to come.

## Abandonment

Revealing the impostor behind the feeling of being unlovable was transformative in its own right, but didn't get at the root of the business of abandonment, and certainly not the "at sea" aspect.

So I continued down the rabbit-hole. I was a teenager before I could verbalize a recurring nightmare about being abandoned on an island. Mom said, "you can come with us, if you finish... (building a house with needles tip-to tip)." I watched the boat with my family in it leave, as I placed the last needle, and the house collapsed.

238

But the one about "the sea;" past life? Growing up in Louisiana, there were plenty of tales of tragedies involving water, but that only went so far. Even the storms on *Legacy* didn't unravel it, though the one that found us on our second night out held potential. It was my midnight watch, on a moonless night and I was on *a run* (sails at right angles to the mast) as I threaded through a field of unlighted oil-rigs when we were hit by hurricane force winds and a following-sea. The shallow water in the Gulf of Mexico created what's known as a *confused sea,* which held the potential of dismasting, especially with that sail-position.

My husband, incapacitated by seasickness and below decks, left it to me to heave-to, while he issued a Position of Navigation (PON) message (if you don't hear from us in 24-hours, start the search here...) and the Coast Guard replied, "we cannot assist. The weather's too bad." That night was the first of many trials we survived, and it's a good story, but not one of abandonment.

Onward, down the rabbit hole.

## Finally, It Comes Together

A few days after my birth in the Panama Canal Zone, as part of the American evacuation, a boat-load of troops and families, mine among them, shipped out for Trinidad. As a newborn, the nurses smuggled me aboard (something to do with my not meeting quarantine requirements), but once on board, Mom was too seasick to take care of me. I was shuffled around among the nurses and Dick, who also had full care of my sister.

The deeper truth of the chasm between me and my mother found its roots in our failure to bond; what bonding occurred was with my father. The witnessing of the deep bonding that occurred with my grandson allowed me to realize my own loss in a way that had not been possible previously.

It then became clear that ALL of the events and interpretations after the events at sea, had piggybacked on the neurology and psychology of separation—abandonment, which became my chemistry, tainting future events.

Every action, criticism, failure to show up, was seen and felt through the lenses of a wound delivered in infancy, through no actual fault of anyone but the circumstances at the time.

And finally, I understood that very literally, I had been: *abandoned at sea.*

239

## Better Late Than Never

When I finally made the heart-connection between not having had a secure attachment to either parent during childhood, and having viewed the events of my life through that particular filter, I began to wonder if I could examine all of my life, using a different filter.

When I applied a different set of assumptions about our motives—my mother's and mine—it was enlightening.

The more I wrote, the more the alchemy involved in the process worked as compassion replaced judgement, and I realized I wasn't angry any more.

Recently, when a friend asked me how I found the gumption to persevere in Peace Corps, I told her I really didn't know another way. I'd learned perseverance from a master: my mother.

I was watching our relationship change and reaping the rewards as it happened.

One day, I realized I was happy.

# 57    Lessons from my Mother

Of all the rewards I might have expected from the Peace Corps experience, I had not expected it to precipitate the healing of my relationship with my mother. I was not really aware of the gradual momentum in that direction while I was immersed in it. It's true what they say, "When you're up to your ass in alligators, it's hard to remember you came to drain the swamp."

I have heard many women talk of their affection for their mothers and of their deep sense of loss on their mother's passing. I'd never identified this within myself, until recently. While I mourned her passing, I felt more of an observer than grief-stricken. I've viewed our history with something akin to an analytical dispassion that belied a deeper angst.

The new revelations stirred long-buried feelings and revealed nuances I had missed as a child, a defiant young woman, a new mother, and a divorced woman.

With a history of difficulties I thought I'd put-to-rest in the months before her passing, I'd put Mom in a metaphorical box labeled: **MOM:** *do not open.*

That brings up a scene from the time I helped my friend, Alice, relocate after her husband, John, died. As we sorted through boxes, determining which were too precious to be trusted to others and would make the trip in the car, I came across a 12"x12" box labeled in big block letters: *JOHN.*

I asked, "What's in this box labeled, JOHN?"

Not looking up, Alice said, " JOHN," to which I replied," Yeah, but what's IN it?"

Again, "John."

Another second passed, "John rides in the car."

Getting a bit frustrated by the lack of definition about what was in the box, still not knowing whether to treat the box like a priceless antique or a box of junk, I asked again, "Oh for Chrissakes, Alice, what's in the friggin' box?"

"No, really, Nancy... it's JOHN. That's JOHN's ashes.. He's riding with us."

With considerably more reverence, I put JOHN in the back seat and strapped him in.

A few minutes later, I came across another box labeled, JOHN. I looked at Alice, "Really? Also JOHN?"

Straightfaced, she replied, "JOHN was tall..." And so rests John.

After cremation, Mom, not as tall as John, arrived in a smaller, distinctly non-metaphorical box—nondescript brown cardboard—labeled simply: *Lee Ora Daniel*. The finality was dumbfounding; the idea that a life, her life or any other, could be contained in so small a box hit me as an absurdity.

My sister wrote Mom's obituary, and I learned things I'd not been privy to as the youngest daughter. I had not known, for example, that the copious number of pies she'd baked throughout my childhood had been her way of funding her escape from a life she'd hated.

The spirit that was Mom began to sift out of the box, bringing with it a memory, long since dormant. Mom had baked a batch of pies—their aroma lingering, covered them with a flour-sack dishcloth, and left them to cool. Our one-and-only cat jumped down from its perch and, as only a cat can manage, made a perfect four point landing with a paw in each pie, ruining all four. It was a scene straight out of the cartoon, *Felix the Cat*. Dick howled with laughter, and I laughed because he laughed, but Mama collapsed on the floor and wept inconsolably. The next day, the cat disappeared, probably having wasted its ninth life on a bunch of pies.

As a child I hadn't realized the incident represented the loss of her dream. As it turned out, her dream wasn't lost, only delayed, but from that day forth Mama harbored a vengeance toward cats!

In her youth, Mom's intellect had been her ticket out of an impoverished life in the Bible belt of North Louisiana. The lovely Lee Ora, her mother having seen her potential, was the only sibling of four to attend college, her tuition paid for by tomatoes her mother sold from the back of a truck. Thus began a passion and life-long devotion to reading and the power of words to transform life, ignited by her lit-professor, Robert Penn Warren, Pulitzer Prize winner for his novel, *All the King's Men*.

I had not known that detail either, until I discovered her old Shakespeare text with her professor's name written on the inner flap. Her choice of Library Science was the next iteration of her

former self, abandoned with her marriage to the movie-star handsome, charismatic Dick, and the onslaught of WWII.

After the war, her dream of using her degree stalled again, as scarcity foisted them into managing a truck-stop owned by Dick's brother. Life became a series of rough customers, midnight forays into dangerous neighborhoods to find a cook, and her daughters sleeping in the car while she had to work. I witnessed it all, but didn't know she hated it.

Dick's drinking and gambling, perfected in the Military, reemerged. A flashing neon motel-sign across the highway beckoned: *Sleep with Hanna,* and apparently Dick took the suggestion a little too literally. These were hard times for Mama, but I relished the time with my dad at work. Sundays produced fat biscuits with crispy tops, loaded with butter and apple jelly, whipped up by Ethel, the black cook. I liked those, too.

During that time, Baton Rouge's social ladder rivaled India's caste system. No one who lived on the wrong side of the tracks, as we did, dared aspire to higher realms. A down-payment was made on a residential lot in the chichi part of town, but the bank foreclosed after Dick gambled away the next payment.

On the heels of that, the "goddamn cat" was the last straw, making it imperative to do something to save herself and her daughters. She pursued her degree with a vengeance; her commitment to pulling, shoving or threatening us into opportunities she'd missed was Herculean. She was the drill-sergeant to Dick's kind-hearted Eeyore.

So mixed were my signals regarding men and women, I went to a therapist to figure out what the hell was wrong with me. I resented the hell out of her, until I realized she had been the model for the competence boyfriends and husbands found so frustrating on one hand, and needed on the other.

The pain of realizing I had been assigning to others the unhealed issues of my past forced a new view of the perfection she sought for us: she'd been trying to protect us from the life she'd lived. What I felt first was guilt, then forgiveness of her and myself, then gratitude, and finally love: hers for me and mine for her.

Loving myself would take longer, but I began to soften.

Mom's passing continued to offer insights not visible through the clouded lens of our past. We celebrated her life with friends in her Texas community where she'd lived her last two years, friends who embraced her quirkiness, fierceness, and her fearlessness.

Before her death, Mom and I spent hours taking drives into the Texas Hill Country where wildflowers are so intensely abundant and beautiful in the Spring, it literally takes your breath away. She knew them all, just as she did every bird. As a way to honor that, my sister, Evie, and I made up little pouches of wildflower seeds and gave them to friends at the memorial. Unfortunately, the seeds looked a little like ashes, so we had to assure them we weren't actually giving them a little piece of Mom.

We still had a North Louisiana burial ahead, so I found a metal box with hand-painted birds for her ashes, but there was still more of Mama and we wondered what to do with the rest of her. We settled on mixing her ashes with wildflower seeds and giving her one last journey through the Louisiana wetlands she so loved for birding. As we drove, we broadcast scoops of the Mom Mix along the roadsides, to repopulate the wildflowers recent hurricanes had destroyed and place Mom among them.

At the funeral, old-timers tsked-tsked about there being no corpse to view and the minister preached a hell-fire sermon, ignoring our request to the contrary. At graveside, Mom's box didn't fit into the hole just augered, and still miffed at the preacher, I looked at Evie, cupped my ear, and said, "Evie, I think I hear Mom's voice! She's talking to me."

Evie, taking the bait, "Oooh? What is she saying?"

Straining as if to listen, I said, "She said, 'You can't put a square peg in a round hole!" A nervous chuckle rippled through the mourners.

I spread my silk scarf on the ground, folded Mom's ashes into it, tied the four corners in a bow and lowered it into the hole.

The preacher gasped, but family laughed, saying, "It's just like Lee to tell everyone what to do, even at her funeral."

Justice had been done. Her memorial plaque read: "Gone Birding in Paradise."

Mom had been a true force of nature and now she was a part of it, as she would have wished. And at that moment, I had no idea her lessons would become even more apparent after her death, but I know beyond a doubt that what I learned at her hand, in both misery and joy, offered the grit to meet the challenges of Peace Corps and life in general with curiosity, perseverance, and humor.

Thanks, Mom.

## 58 Gifts my Father Gave Me

Writing this chapter felt a little weird, partly because my dad died so long ago, in a stage of life when I was still amassing history—not examining it, that it started out as an arms-length observation, told in those objective terms one uses to avoid disturbing the ghosts. But the closer I pulled the memory, the more real it became, finally wrapping itself around me like an old, familiar blanket pulled from storage.

The incident that took his life happened four days before I started my dream job, and within weeks of meeting husband number two. It was the perfect storm of life-markers, and to exacerbate matters I had a persistent prowler. I slept with my bedroom door locked and a loaded .38-revolver at-the-ready.

Life then did not include much introspection and now that it does, I've been surprised and humbled by what the memories and perspective of age have brought to the forefront about how my inner life was nourished as a result of my dad's influence.

While my Mother's contributions were omnipresent and identifiable, Dick's operated in the background and were so organic I didn't bring them into the foreground until I started realizing how much of the attitude I brought to Peace Corps came from him.

I watched as he fixed all things mechanical, and had his same aptitude for problem solving, fixing things. I was my dad's "son." He was kind, smart, witty, and cared about people in a way that made them feel valued. He was also the black-sheep of his family, not fitting his mother's Bostonian, descendant-of-Richard-Wadsworth-Longfellow idea of what she wanted him to be. (It probably started with the violin lessons his mother insisted on coming to an abrupt end after he broke the instrument over the head of a bully.)

We were both misfits in our families.

Dyslexic, but not diagnosed until my thirties, I lived in the shadow of my valedictorian sister. Knowing I couldn't compete in the areas my mother valued, I distinguished myself in other ways,

and I ran like the wind from any form of competition, developing my skills, and ultimately a business, around things unseen, where the only proof of my abilities defied measurement and competition. Dick became an unwitting ally in that arena, but not until after I left home. Until then, I was on my own with my mysterious world.

I may never be entirely sure about some of the things that happened in childhood, since they were never discussed, but I do know that they created an inner landscape where I never entirely accepted the physical realm as the only truth, and I trusted answers and solutions I was at a loss to explain in logical terms (a gift not appreciated by my Algebra teacher).

## The Apparition

My first awareness of our metaphysical connection, which has continued since his death, occurred when I was in Graduate school.

Married to my first husband and living in a small garage apartment tucked away in a dark, bamboo grove, black as a cave at night, I began inexplicably waking up at 4 AM, each episode punctuated by a red glow emanating from the adjacent room. Investigation revealed no source for this glow, and yet, there it was with every wake-up.

I tried everything to sleep through 4 AM, to no avail. After two weeks, determined to put an end to this nonsense, I sat up and studied the glow.

It began to pulsate, change shape and drift closer, morphing into an apparition of a dark-haired man, graying in the temples, horn-rimmed glasses, but no defined features—wearing gray slacks and a pink shirt.

I watched until the figure got to within a few feet of me, then slammed back under the covers, pulled a pillow over my head and willed it away.

The next morning, Dick called from India, where he'd been working on a ship. He had been on a 4 AM schedule and waking with terrible vertigo. He thought he might be dying.

Coincidentally, I was working as an audiologist, conducting electronystagmography (ENGs), a test for vertigo, during which rapid eye movements blur the vision. I remembered, the apparition's face was blurred—in the way that vision is blurred during vertigo.

I realized the apparition had been Dick appearing in his favorite gray slacks and the pink shirt I'd given him. He wore horn-rimmed glasses and his hair was graying in the temples, but without the

facial features, I hadn't made the connection. I knew intuitively the red was about his fear of dying, but later learned it is the color associated with the root chakra, also about survival.

After his return from India, I told him about the event and the precognitive dreams I'd been having. At that time, my dreams were innocuous, but nevertheless manifested in the exact detail. He confided that he'd had similar experiences growing up, but knew he couldn't tell anyone in his family, except a great Aunt, who also had "the gift."

## The Glow Returns

Knowing it was Dick didn't help me cope with the glow's reappearance at odd times in my life, but I began to realize, his appearances coincided with times I felt at risk. It was still unsettling.

## The Dream

After my first divorce, a healing year abroad, and just prior to starting my Welfare job, I dreamed of Dick's death. In the dream, I'd called home and Dick's friend Louis, (in real time the only other person to know of the event psychically) answered the phone and told me, "Dick's dying from sinus surgery, so if you want to see him, come now." I argued, "people don't die from sinus surgery." The scene changed to my walking down a long hallway, turning right into a hospital ward, and seeing Dick—his face bandaged except for one blue eye—surrounded by six men in white coats, wearing medical masks.

I awoke sobbing; I knew the body-feel of a precognitive dream and this was one.

I called home; nothing had happened.

The next week, as I was driving like a wild woman to see my boyfriend in Houston, I went into a trance and the car drifted off the road up a grassy embankment, shaking me awake just before I entered the trees. I corrected back onto the highway, but even with all the adrenaline coursing through me, and the promise of some hot sex in Houston, I kept being pulled back down. I could barely stay awake.

On the return trip, near the same location, I heard the words, "Dick. Dead. Shotgun."

I got home, and found a note waiting. Dick had suffered a shotgun blast and was dying in New Orleans Charity Hospital.

When I arrived, I walked down a long hall, turned right into the ward, and found him: face bandaged except for one blue eye, with six doctors around his bed.

Sinus surgery was necessary to remove the buckshot. He died two weeks later.

## From the Other Side of the Veil

Not long after we'd buried him, the glow came to sit in the corner of my room in the house where I'd had the prowler. It scared me, because at the time, Mom believed it had been suicide (it wasn't), and wracked with guilt over not being able to prevent it, I feared he might be angry with me. For the next few years I ran from everything metaphysical.

Contact was renewed in California, when after my second marriage and the birth of our first child, Dick started contacting me in other ways.

One of those was classically Dick in nature. In the dream, I am walking with family on the waterfront in New Orleans, where Dick used to ship out. Dick came up the dock ladder and tapped me on the shoulder. When I spoke to him he said, "Jesus Nancy! Don't talk to me out-loud! People will think you're crazy! Everyone knows I'm dead!

At the time, it seemed he was asking me for help with his medical records; he mentioned a review. I knew that couldn't be it, yet I didn't know what he *really* needed.

An answer of sorts came through with the next experience, when I was awakened one night to the sensation of moving at high speed through what I recognized from description as the near-death tunnel. I knew I wasn't dying, but to assure myself I wasn't dreaming, I felt for my husband, checked on my baby son, and went back to bed. The tunnel-travel resumed. When I saw the light at the end, I assumed I must be going to meet someone. I arrived at a white waystation and waited.

Dick glided in, rubbing his palms together in excitement. I mentally said, "Oh my God, where have you been, I've been trying to get in touch with you!"

"Oh I'm sorry. I've been busy with my life-review, looking at the decisions I made. Did you know that's REAL?"

He continued: "I wanted to let you know, I'm off to the next realm, and I want you to take a message to the family. Tell them, 'I

lived my life in a manner that caused my death. There should be no guilt.'"

And with that, he started to glide out the other side of the cubicle. I called out, "You can't leave! I'm not finished!"

He said over his shoulder, "Oh... you know how to get in touch," and I did, several times after that.

It has been the continued contact over decades that helped me to verify for myself that there is no death, and that it's possible to continue our connection beyond the physical body.

Those were the experiences that motivated me to delve so deeply into both scientific and anecdotal material, to help me understand how we can see into the future, influence reality, and consciously receive assistance from the other dimensions. And far beyond reading about these things, it gave me the confidence to invite more experiences, actively ask for guidance, know when I'd actually received it (as opposed to having intellectualized an answer), and then know what to do with it.

Along the way, I came to identify my own intuitive method, and learned how to help others find their intuitive voice. This ability to tune into my intuition and trust it has guided me in ways intellect alone could not and at times has directed me to information so specific, it defies logic.

One might wonder how I could fail to understand my dad's contribution to the way my life unfolded, as I have wondered myself. Part of that answer has to do with only now having entered a new paradigm that has allowed me to look back at my life with the intention of discovering how I became.

But one thing I know for sure, is that in many ways, he has never left.

# 59    The Alchemy of Shift

What was this process that brought about such a total shift in not only how I view my past, but how I live my present?

I've released huge chunks of judgment, fear, resistance, and resentment and stepped into an emerging state of grace. Whatever I'd set in motion with the decision to recalibrate by living in an altered universe for three years had started with a vague intention of "shift," and taken on a life of its own. Each step created momentum and added to the synergy of a process that honestly felt like alchemy, because while I was certainly doing my "work," I was not driving the process consciously.

The river of life simply carried me to people, places, feelings, and methodologies that were precisely what I needed, when I was ready to receive them.

The teacher in me wants to be able to describe that process for any benefit it might offer another, and it's easy for me to get all cerebral and analytical, but the real alchemy is not intellectual, it's emotional. That said, there are some concepts that guided me and facilitated an emotional shift once I allowed myself to feel.

The short version of that follows, but it's not the whole story. When the journey began long before Peace Corps, I was still externalizing a lot of cause and effect, even though, as my understanding grew, I had begun working with the concept of thought creates form, at its most simplistic level.

Working with that, I encountered the most basic tenets of quantum physics: that all matter consists of vibrating strings of energy; and we can influence the vibrational frequency of that energy, through intention and thoughts, all of which made sense to me, based on my previous background.

Gradually, I began to understand that emotions are a form of energy that vary in frequency, i.e., love, gratitude, and compassion are considered high frequency; hate, fear, judgment are low frequency. That came full circle to being able to modulate energy-frequency-emotion through intention.

Working with Attention Deficit Disorder clients, and the concepts of PTSD introduced me to the process of rewiring neural networks, and changing brain chemistry, through choosing thoughts and emotions.

In a nutshell, that's the oversimplified synthesis behind the idea that we can choose our thoughts (which influence our emotions), and in so doing, can choose the signal we send out to the rest of the world. That, in turn, influences everything around us, what we attract to us, and the potential for the way life unfolds.

While all of that is true, it's still an intellectual concept until the magic ingredient of emotion completes the formula. It was a while before I could allow myself (or was forced) to identify and feel the emotions that I'd avoided since childhood.

The real alchemy began when I moved into my heart. The long nights of impenetrable darkness, the rains, lack of usual escapes, and aloneness in Peace Corps had the effect of shrouding me in emotions, and brought them so close they became real: gratitude, love, peace, forgiveness. Applied to external relationships and to the self, the experience was catalytic in a way that mental gymnastics never were.

Once I moved beyond the fear of feeling—lest I self-destruct—the more the intellectual processes were brought into play as tools (as opposed to avoidance) that helped me examine what I'd made the feelings mean (i.e., I wasn't loved), and whether it was true, or just an assumption. When I opened the door to other possible interpretations and examined them with different emotions, it was magical.

The more I was forced to confront those emotions, the more acutely aware I became of the truth that whatever was showing up in my outer world was there to get me to deal with my inner world.

Still—and this was crucial—I had to be willing to step back from automatic, programmed responses, take a breath, remember my intentions, feel, and work with what was showing up. Sometimes, it was brutal.

Admitting what the previous paradigm of confronting, blaming, and judgment had wrought, I began to practice compassion, gratitude and love.

Having lived in the crucible of family for the last few years, I can attest to the gentle and profound magic of this approach, not only for myself, but for my family as well. My love for my family and this new little niche we had formed was so intense that I didn't want

them to carry the weight of my history any longer, didn't want them to have to reflect back my own pain for me.

With each small emotional shift, I experienced an equal or greater shift in my external world and what came back to me.

The gift of being able to love and care for my grandson in all the ways I'd not been has allowed me to reclaim my lost childhood. Loving unconditionally has amazing restorative powers.

Joy and gratitude are transcendent in their ability to heal, and both are more available that we might realize: a grandchild, seeing wild animals roam free, a walk in nature, a trip to the sea, deep meditation, food on the table, clean water, doing something for another who cannot repay you... The list is endless.

Uganda brought gratitude to the front-and-center of my life. Peace Corps, with all its chaos, disturbed my status-quo and took me out of my intellect for long enough, and enforced "stillness" for long enough that I finally just surrendered.

There's a lot to be said for surrender, which is not the same as giving up. Just as forgiveness is not "giving permission" or saying an action is OK, it's an act that changes the energy around a situation and allows us to move in a more compassionate direction for ourselves and others.

Perhaps the greatest gift of this quest, one that has eluded me all of my life, and one that allows me to live in a measure of grace is that of knowing that, finally: *I am enough. And perhaps I always was.*

# 60　What If...

Curled up in my favorite chair, sipping coffee one afternoon, I basked in the contentment of my newfound history and began to wonder how my life might have evolved differently if I'd felt from the beginning that I'd been loved. More importantly, I wondered how life could move forward from this point on, knowing that I had been loved, and this poem began to flow:

> *What if*, after all the years
> Of feeling unloved,
> Feeling "extra" and in-the-way...
>
> *What if* all those times I felt "*other*,"
> Not enough and
> On the outside looking in...
>
> *What if* those memories I had of
> Someone ignoring me or
> Putting me down...
>
> *What if* everything I saw on the outside,
> Was just a *mirror* of what I felt on the inside
> And not the *creator* of what I felt, but the *result*?
>
> *What if* it wasn't actually "real?"
> Just a reflection of my feelings.
> And *what if*—as my feelings change—
> The evidence I see outside me also changes?
>
> *What if* I was always the writer of the script,
> But I am just now realizing it?
>
> And *what if* my interpretations of the behaviors
> I witnessed outside of me
> Were all based on assumptions and

253

*Mis*interpretations of someone else's life?

Of their life being one of struggle,
Where they were giving all they had...
All they knew HOW to give?

And in their way
They loved me
And I missed it,
Because I was their mirror
And they were mine?

*What if* we were just caught in a loop
Of missed signals
And I was loved all along?
And just didn't know that love
Was a warm blanket on a cold night?
Help with my homework?
Money for a school trip?
A tub of cold water to play in
On a hot day?

*What if* I found out all those years
Of feeling unloved
Were because I didn't know someone's
Language of Love
And I have just now
Translated it
And am able to hear it,
With all its nuances?

I could rewrite my history!

Maybe now that I know I was loved
I can love myself,
And come home to myself
as a loveable person, a person of value.
And in doing that I can quit wasting time
on grief and trying to fix myself?

*What if* I am perfect, just the way I am?
And I have the freedom now to cast off chains
and step boldly into a new timeline?

Now I can get on with the business of living,
and loving others without wondering if I am loved back.
Because I know now, that I became used
To the feeling of unworthiness,
And like a drug, it feels familiar.

*What if* some of what I blamed on others, was just me
Looking back at myself through the faces of others
there to aid in my unfolding.

*What if* now I can see—and learn to feel—
the presence of love
and just assume, better yet—*know*—that it is there
In all the little ways...

Wouldn't that be grand?
I could love anyway,
Love them, love me, and in that way
Heal us both.

And so, I will.

# Apwoyo Matek: Thank You

I think it's safe to say that for every Peace Corps Volunteer, there exists behind the scenes an army of friends and family who have made it possible. Included in that are both physical friends and the spiritual presence of those passed and the Universe at large.

You have buoyed us through your physical and emotional support in disconnecting from our lives at home, in safekeeping those in our absence, through your emails, phone calls, letters, care packages, and your witnessing of our journey.

Thank you Alice Choate for your enduring friendship and your preposterous suggestion of Peace Corps, and to Chuck and Jan McCullough, Diane Land and Mayor Steve Adler, Ann Daughety and Danny Davila for your generous handling of my Austin life in my absence.

Without question, I would not have been able to embrace this opportunity were it not for the unconditional love and exuberant encouragement of my sons, Travis and Brett, who just said, "Do it, Mom!" and backed it up with gear.

Thank you Pat Barnes, Evie Lotze, Liz Gillies, David and Kay Hines, Marcia Temple, Victoria Bovard, Lori Lessner, Joan Miller, Chris Campbell, Caren Upshaw, and my sons again, for your soul-nourishing care packages, and gifts of support before and after. To Janet Houser and Candace Craw-Goldman for introducing me to the *Melchizedek Method* and Dolores Cannon's work, respectively.

The Pillowcase Dress Project would not have come to pass were it not for the inspired and generous project made possible by Molly and Merrily Simone, Jan Wels and Welches Elementary School. Thank you for supporting an excited group of second graders in their desire to help total strangers. This is the way we change the world.

To Florence Gesa Kibuuka, Nabossa and Ernest, thank you for your loving care during HomeStay, and to my Gulu LABE family—Joy, Ojok, Geoffrey, Rose and Godfrey—for your sweet spirit and care of this Muzungu, and to Peter and Patrick and so many others for enriching my life there.

For your wrangling of 175 sometimes unruly volunteers, thank you, Peace Corps staff and especially Gary Vizzo, whose smile was the first offered and who remained a bright light. To other volunteers, you know who you are, but especially Bill and Holly Copeland, whose laughs and chicanery brought light to the dark times, and Karla Deihl, Betty Lambert and Jeannie Hodaian of my northern tribe.

Judy Knight, your friendship and selfless hours of manuscript reading, and comments helped me immensely, made this a better book and me a better person.

To my new daughter-in-law Kim, and extended family Jim and Gail, and the light-of-our-lives Colton, my love is inexpressible.

To Joy Reyneke, masterful photographer, artist, and friend: thank you for the powerful and evocative cover; and to Omule Geoffry, thank you for your insights on the history of Uganda, insuring its accuracy and balanced telling.

Finally, to my publisher, Victor Volkman, for your encouragement and giving this tale a platform, and Bob Rich, my editor, for your guidance, humor and rich commentary: **apwoyo matek**!

# A Brief History of Northern Uganda: The Horrors of War

What most Westerners know of Uganda begins and ends with Idi Amin Dada, one of the world's most brutal dictators. We'll get to him, but Uganda is so much more than its political history. Let's start with a wider view, including its location in east-central Africa, bordered by South Sudan, the Democratic Republic of Congo, Rwanda, Kenya, and Tanzania. It's home to a portion of the Great Rift Valley, separating the African continent into two tectonic plates. Known as "the cradle of civilization" for its defining role in the evolution of mankind, the Rift Valley—or trench, as it is also called—is home to some of the deepest lakes in the world, and its geology contributes not only to the richness of resources, including copper, oil reserves, gold, limestone and cobalt, but also the fact that much of Uganda is on a plateau giving rise to a milder climate than much of equatorial Africa.

### Before Colonization

Human activity, supported by some of the most fertile soil in Africa, and an abundance of water, fish, and wildlife, dates back 50,000-100,000 years as evidenced by the discovery of stone tools, agriculture, animal keeping, metallurgy, and production of tools around Lake Victoria, Africa's largest lake. It occupies the southeast corner of Uganda, extends into Tanzania, and is bordered by Kenya. Prior to the mid-1800s, Uganda (then Buganda) had little interface with the outside world, and it wasn't until 1862 that the first European, British explorer John Hanning Speke, arrived. Shortly thereafter, in 1875, with the arrival of Christian missionaries, intense and bloody conflict developed among Protestants, Catholics, Muslims, and traditional practices. By 1890, Britain and Germany had signed a treaty, giving Britain rights to what was to become Uganda. Four years later, it became a British protectorate, remaining so for nearly seven decades.

Britain's brutal Divide and Rule strategies created deeper rifts, establishing the southern region as the political and economic power base of the country, manipulating locals to collect taxes, decimating

tribal systems, and introducing foreign elements as administrators, effectively barring indigenous people from learning the tools of finance and self-governance. Meanwhile, the north depended on agriculture, herding, and hunting and supplied most of the country's labor and military personnel.

Resentments developed around the relative wealth of the south, and the labor-centric north, which held a majority in the military—an imbalance that would remain, and prove problematic for those in power, in later years.

Uganda's history is incredibly complex and intricate, and the thumbnail sketch that follows is offered only as context, and not intended as an academic treatise.

## Self-Governance

Uganda became self-governing and independent in 1962, with Milton Obote, of Lango descent, from Northern Uganda, as it's Prime Minister. Four years later Obote promoted himself to the presidency, overthrowing then President Mutesa (former King of Buganda), only to be removed in a 1971 coup led by Idi Amin, once one of his military officers.

Although Idi Amin Dada declared himself president for life in 1976, his notorious reign of terror, immortalized in film, ended roughly three years later. The fact is, modern Uganda has a long and bloody history of coups, assassinations, unspeakable brutality, and mayhem. After Amin's removal in 1979, multiple coup-d'états would produce four different regimes (Yusufu Lule, Godfrey Binaisa, Milton Obote again, and Tito Okello) before the National Resistance Army (NRA) rebels prevailed and installed Yoweri Museveni as president in 1986.

Within that history, Idi Amin's record of tyranny pales in comparison to the twenty years of physical and psychological terror waged in the north by Joseph Kony and his Lord's Resistance Army (LRA), formed directly and indirectly as a result of Museveni's rise to power.

Although Idi Amin needs no further introduction here, it is worth looking at Museveni's win and how it contributed to the evolution of Kony's war and the resulting devastation and disenfranchisement of the North.

## Enter President Museveni and Fallout in the North

Formed in the aftermath of Museveni's victory, as a result of the brutal treatment and marginalization of the north by Museveni's National Resistance Movement (NRM) government, were the revolutionary factions of Alice Lakwena and Joseph Kony. Alice claimed to be a prophet who received messages from the Holy Spirit, and believed the Acholi could defeat Museveni, though it has been said she never took up arms, other than wooden clubs and stones. She convinced her followers that covering their bodies in shea-nut oil would protect them from the bullets of their enemies, a claim later embellished and used by Joseph Kony, who ultimately replaced Lakwena after her defeat in eastern Uganda. It was the fanatical Kony who would dominate and define the terror in Northern Uganda for the next two decades.

## Kony's Arrival and Tactics

When Kony arrived on the scene, concurrent with Lakwena, she distanced herself from him because of his treatment of and killing of civilians. Following Lakwena's sacking and subsequent escape to Kenya, Kony continued the movement to defeat Museveni, with the stated purpose of building a government based on The Ten Commandments.

The well-established colonial divide that created the north as guards and militants later inculcated military minds, and helped fuel Kony's hatred of Museveni. Although he received some initial support from the Acholi, the focus shifted with support offered by Sudan, who supplied Kony with weapons.

As his local support dwindled, along with resources, he began plundering his own people. Abducting children as soldiers, Kony's methods included rape, the weaponization of HIV, abduction, and mutilation, which included slicing off the nose, ears, and lips, and limbs. Women were abducted to become sex-slaves; the most beautiful going to Kony first, and if rejected, divided up among the soldiers as "wives." Schools, raided for their continuing source of children who, because of their youth and vulnerability could be forced into service, were a never-ending resource providing the majority of Kony's fighters. Villages were destroyed; children forced to kill their parents, or watch as they were clubbed to death. If the child cried, he would be beaten or killed; others were required to

identify their parents' body parts floating in caldrons of boiling liquid.

It's estimated that Kony abducted between 25,000 and 35,000 children, and as late as 2005, an estimated 1000 people per week were being murdered. Since the war spanned several generations, some children were born into service. Regardless of their method of forced enlistment, young children were convinced that if they tried to escape they would be hunted down and beaten or killed, and that angry spirits would torture them. Allegiance became a survival skill.

Kony claimed to be possessed by a number of different spirits who would come to him and direct his actions. He convinced civilians that he could read their minds and they would never escape capture.

People lived in fear of the most normal activities: walking to school, going to church, sleeping (most raids occurred at night). An alert system among locals, devised to communicate the arrival of rebel forces, had family members hide separately in the bush, to prevent the entire family being slaughtered together. Villagers traveled at night to avoid detection by the rebels during the day. Trees and vegetation were cut down in an effort to destroy rebel hiding places—the environmental costs evident to this day.

## The World Responds

According to the United Nations *Office for the Coordination of Humanitarian Affairs,* the war displaced 95% of the Acholi population in three districts of Northern Uganda, Gulu among them. By 2006, 1.7 million people lived in 200 squalid internally Displaced Person (IDP) camps, reported to have had the highest mortality rates in the world. The camps themselves became torture zones, as women were repeatedly raped by their "protectors."

In the first six months of 2005, the LRA is reported to have abducted nearly 1,300 Ugandans; nearly half were children under the age of 15. That represents only *six months* of a *20-year conflict.*

A truce between the Ugandan Government and the LRA was signed on August 26, 2006. The terms of the agreement required the LRA to leave Uganda and assemble in an area of the Democratic Republic of Congo that the Ugandan government agreed not to attack.

Despite the arrest warrant issued by the International Court in 2005, and concerted efforts by the United States Army Special

Forces in 2011, and the Africa Union in 2012, Kony continued with revenge attacks in the DRC, South Sudan, and the Central African Republic.

As of this writing, there has been no news of Kony's capture.

Northern Uganda continues to suffer huge human losses resulting from the weaponization of AIDS, psychological and physical trauma carried by the descendants of the victims, as well as insurmountable emotional, educational and developmental losses.

## The Undercurrent of Disease:

Concurrent with the maelstrom of the war, ongoing diseases against which there is little or no defense took their own victims, and continue to do so. Ebola, HIV/AIDS, Nodding Disease, and Malaria are ongoing variables in an already difficult life.

One of the largest single-country outbreaks of Ebola, a highly contagious and lethal form of Hemorrhagic Fever, occurred in Gulu District and two southern districts in 2000-2001. Subsequent outbreaks have been quickly contained, since the Center for Disease Control (CDC) established a presence in Uganda in 2000.

The incidence of HIV/AIDS, already a factor in Africa, was exacerbated by the realities of war. Babies were born into AIDS, or contracted it via the breast milk of their infected mothers. Children lost their parents, contributing to the huge population of street children, poverty, the spread of other diseases, and an increase in related crimes.

Nodding Disease, whose etiology remains unknown and affects only children, is a neurological disease that causes seizures, blindness, and weakness of the neck muscles, causing the head to drop (nod) forward. Children are often tethered to a tree to keep them from wandering into harm's way.

Onchocerciasis, or River Blindness, causing eye lesions, blindness, and severe itching, is transmitted by the bites of black flies. Intervention by the World Health Organization is beginning to bring this disease under some control.

Finally, Malaria, despite world-wide efforts at eradication, is ever-present, and is, according to the CDC, the third leading cause of death in Uganda, after Neonatal disorders and HIV/AIDS.

Dysentery, typhoid, and schistosomiasis operate constantly in the background due to the lack of clean water and sanitation. In rural areas, drinking water comes largely from boreholes (water wells), often located too close to latrines (allowing waste to contaminate

the well), or are contaminated by livestock. Over half of Ugandans live thirty minutes or more from a water source, and about a third have no latrine. Defecation in open is still practiced, and common for small children.

## North of the Nile

Uganda is land of great environmental and natural resources, generous and gentle people, and some of the most staggeringly beautiful vistas in the world, offering access to wild animal parks and many endangered species. It is also a country of extreme contrasts in economy, infrastructure, geography, climate, education, and wellbeing—so much so that it feels like two countries.

Nowhere are these disparities more evident than in the general sense of wellbeing in the south and the hauntedness of the north—Acholiland.

The casual visitor, entering Entebbe airfield and visiting the more developed cities of Entebbe, Kampala, Jinja and Fort Portal will see a vastly different Uganda from the one experienced north of the Nile, where the devastation of a lifetime of political neglect or suppression and Kony's twenty-year war (being only the most recent) continue in evidence, although much progress has been made in the last few years.

# About the Author

## Where did you grow up?

Although I was born in the Panama Canal Zone, most of my growing up happened in Baton Rouge, immersed in the rich cultural-gumbo of South Louisiana. I say most because I still had a lot of growing up to do when I left for the University of Texas (UT) at seventeen.

My memories are of a world of extremes where spirituality, religion and witchcraft mingled, life was cadenced by hurricane season and fueled with strong dark roast coffee and Cajun food. The Ku Klux Klan marched, the paranormal was normal and I sensed a boogeyman around every corner. An ever-present social divide made real the metaphor wrong-side-of-the-tracks. I know, because we lived there, though the emotional punch of it wasn't felt until, as a pre-teen, we joined an upper-crust downtown church. It was there that I began to witness the variance in access and attitudes, and that learned awareness became a barometer of sorts for later life.

Nothing was quite as it seemed in my childhood world, and it seeded a tendency to question everything. I learned early on that truth is relative, and that both the seen and unseen worlds hold equal sway over life. Over time, my paranormal abilities—inherited from both sides of the family—surfaced, and the need to understand them became a life path and, later, a business.

Road trips to California, Mexico and the Grand Canyon exposed my sister and me to a larger world, and tales of my folks' post-wartime lives in Panama and Trinidad no doubt fueled our drive to discover that larger-world for ourselves. Both of us have explored far-and-wide, served as Peace Corps volunteers and become writers.

Understanding and integrating this continuum of curious events, and the cognitive dissonance it created, predisposed me to seek information and understanding in unconventional ways.

## Why are you uniquely qualified to write this book?

The short answer is that I lived these stories and the life they informed; the more considered response is that the very act of writing offered so many new insights that the process began to take on a life of its own. It's one of the reasons the creative process is often compared to "giving birth."

In the telling of long past events, I found the most interesting part was that the lens through which these were viewed began to change and a new clarity emerged. I began to see my participation in those events differently, and it changed the way I felt about my life and the "reality" of those events.

Observing a process—and living it—generate different insights and interpretations, which are almost impossible for another to describe.

Finally, as with all adventures, there is the physical aspect—a story in its own right, but also the psychological story that gives it meaning and relevance. No two people will interpret even a shared experience in the same way, so one person's inner journey can't really be described by proxy.

## Why did you write this book?

Honestly, when I began, this is not the book I set out to write. My initial intention was to share what it was like to totally step out of the mainstream and jettison a business, an old identity and comfy-trappings at a time when most of my friends were planning cushy retirements. I felt driven to share this rich world I experienced in Uganda, and I had so many stories to tell, I literally couldn't carry on a conversation without another one spilling out.

As I told these tales to friends, and spoke about my experiences at various events, people admitted to being shocked out of their safe-zones into a realization of their lack of awareness of their own privilege and of the challenges other people faced, just to survive. After seeing what Ugandan children sacrificed just for the privilege of going to school, high school students, bored with life and school, left with a little more appreciation for the opportunity to learn.

I thought these stories were worth sharing, and as a writer...well, I had to write!

As I wrote and got to what I thought was going to be, "The End," I realized it wasn't the end at all. And that's where the

mischief started and my inner muse took over, and I literally had no idea where we were going...but I hung on for dear life!

When I'd come home from Africa, I felt like a total stranger in the life and world I'd left. All of my reference points—physical and emotional—had changed; things I'd taken for granted had become treasures, and those I'd once valued had become irrelevant. The events that made up the stories I so wanted to tell became a catalyst for distilling life-going-forward into its most relevant and sacred parts.

As I wrote, the muse took me into the deep recesses of memory, firing dormant neural networks that took me into a house-of-mirrors, where it was difficult to distinguish reflection from the real thing. That triggered a re-evaluation of both past and present, ultimately leading me to a different truth and a more authentic self.

I hadn't expected that and, frankly, it was a little like opening Pandora's box.

It wasn't until the book finished itself that I realized why I'd been so compelled to write it in the first place. The Peace Corps story had only been the prelude, setting the stage for what would become a transformative process, one that I could not have predicted. There are many ways to come to this awareness, and the Peace Corps was my catalyst.

So, this is me, coming out of my own metaphorical closet. Maybe some of the tools I discovered along the way can help others unlock their own doors.

And yeah, it's still a little scary to be so revealed.

Finally—and this is the piece that feels the most vulnerable to talk about, but also, the most profound—I want to share what is possible in healing family history. The memories we hold become our brain chemistry, driving a lot of emotions and behaviors, and sometimes those memories are so old and deeply buried they are a mere capstone for what lies beneath. Those can be healed. It's never too late.

All that said, it started as pure fun, then became an adventure, then therapeutic, then magical and, finally, transformative. There are just no words for it, and I'm not usually at a loss for words.

### What do you think readers will get out of it?

The book is written on so many different levels...it would be lovely if each person simply took what they needed and had some fun.

Stories have always been an alchemical way for readers to insert themselves as a character and travel outside of their regular lives. Some will see this as the fine adventure it was and leave it at that.

For those searching for a "next-step," perhaps the book offers encouragement to take their own leap; to be bold and intrepid. It doesn't have to be as radical as the Peace Corps—there are many ways to step out, to reclaim wonder, to face fears, to heal, to find hidden strengths, and to move beyond who we were taught to be and become who we were meant to be—for ourselves, not others.

My most profound discoveries of possibility, who I am and what I value, have been associated with stepping into new worlds where I didn't have the answers—worlds that challenged me. Sometimes, that new world was around the corner; other times, it was around the world. Possibilities abound!

On a deeper level, I found it's never too late to heal family trauma, to reclaim the self and to reimagine life from the inside out. I found that each little piece of change in me was evidenced in the way I experienced my world. It's a scary thing to be so totally revealed, especially in print. In part, as soon as a truth is written, it evolves. But it's time to be OK with that, and maybe others, reading this, will be OK with finding that for themselves. Sharing it and being vulnerable is an entirely personal decision.

Ultimately, I hope they will feel it worth their time, feel gratitude for what they have and embrace the possibilities of life.

### What will you do next in your life?

I moved to this little town to help with my grandson, and I cherish that, but grandchildren do grow up—mine as well. As that role changes, more time is opening up to create the next chapter.

Using the tools at my fingertips, I plan to re-engage my consulting business to help people take their own next steps, manage their energy and bring the sacred into everyday life.

I've started my first ever vegetable garden, which I guess is kind of a metaphor for the fact that I'm finally putting down roots that won't have to be pulled up in three or four years (though they might), and I'd like to see if I can paint anything other than a stick-man, but the verdict is still out on that one.

And as always, I'm tinkering around with the next book.

I'd like to share the tools that helped me find a different lens through which to view life, to open new doors and to embrace the idea that we really are fully responsible for ourselves, and as we heal

ourselves, everything else heals. Instead of viewing that responsibility as a burden, it's actually incredibly liberating once you know the tools, and you can say "what if" and just go for it!

# Glossary

**Acholi:** both a group of people inhabiting Northern Uganda and part of South Sudan, and the tonal, Nilotic language they speak.

**ActionAid:** An international Non-Governmental Organization whose work focuses on women's rights, social justice and the end of poverty.

**A loko leb Acholi ma nok nok:** Acholi for "I speak Acholi, a little."

**Amuru & Arua:** towns in Northwestern Uganda, where LABE provides services.

**Ankole:** a cattle breed characterized by long parentheses-shaped horns, bred for Royalty, but now common through Uganda.

**Apwoyo (matek):** "thank you," but also used ubiquitously as a greeting. Adding **matek:** changes the meaning to "thank you very much."

**Boda-Boda:** a motorcycle taxi, named thus for motorcycles that used to take contraband from border-to-border. In the Acholi language, the "r" is not sounded, therefore the "r" sounds in border-to-border were eliminated and the term became boda-boda, or boda.

Bore-hole: water-well

**Cenotes:** naturally occurring sink-holes in porous Limestone bedrock, revealing groundwater pools; Mayan Culture considered them sacred.

**Chawa-adi:** Acholi for absolutely NOW.

**Chapati:** an unleavened flatbread made from wheat and water, cooked on a flat skillet.

**COS:** Close of Service, for those who have served their entire commitment, as opposed to the Early Termination (ET) designation for service ended prior to completing the twenty-seven months.

**Cuk madit:** Big market, main market.

**Duka:** small shop

**Entebbe:** one of the three largest cities in Uganda, located in south central, on the banks of Lake Victoria. Home to Uganda's only major airport and famous for multiple movies regarding Idi Amin's hijacking of an Isreali airplane and its subsequent rescue.

**HomeStay:** the roughly two month period during training when volunteers live with a Ugandan family to assist with adjustment.

**Horchata:** a popular Mexican drink made with rice-milk, sugar, cinnamon and vanilla, served cold.

**I buto maber:** A common Acholi greeting meaning: "How was the night?" or "Did you sleep well?"

**IGA:** Income Generating Activity

**Jerrycan** (Jerry Can): a strong, flat-sided container of steel or robust plastic for carrying liquids.

**Karamajong:** an ethinic, semi-migratory group of north-eastern Uganda, known for its cattle herding practices and warlike tendencies.

**Kolongo:** an Acholi town in the north east of Uganda, a day's travel from Gulu.

**Lugandan:** one of the major languages of Central Uganda.

**Matatu:** a taxi van, typically designed for nine, that operates at twice the recommended capacity.

**Matoke:** steamed and mashed green bananas, a staple in the northern Ugandan diet.

**Mefloquin:** a commonly used prophylactic anti-Malarial drug.

**Munu:** Acholi for Muzungu. See Muzungu.

**Muzungu:** any foreigner, not just Americans or Caucasians.

**Nilotic:** refers to people who settled in the Nile River valley (from Tanzania to South Sudan) as well as their languages.

**Nyanya:** Acholi for tomato.

**NGO:** Non-Governmental Organization.

**Panga:** a long (12-18 inches) flat bladed instrument that can be used as an agricultural tool or a weapon.

**Perma-Gardening:** gardening design that relies on naturally available elements and features to create permanent gardens.

**Piki-piki:** any not for hire motorcycle.

**PLE:** Primary Leaving Exam: a comprehensive exam taken at the end of Primary School, which determines the possibility of continuing into Secondary School.

**Posho:** a Ugandan cornmeal dish resembling hard-cooked grits.

**Sigiri:** a small metal cooking stove that uses wood or charcoal fire for heat.

**Slasher:** a long handled, sharp bladed implement with a curved point used for slashing grass or dense brush.

**Steri-Pen:** a portable UV light used to purify water for drinking.

**Tima-kitca:** Aholi for "I'm sorry."

**Tukul:** Mud hut.

**Wakiso:** a town in central Uganda, near Kampala and the site of our Peace Corps training and Home Stay.

# Index

## Also by Nancy Wesson

**Will you be ready when it's time...?**

Whether whittling down to the essentials for a parent moving into a room or two or downsizing for ourselves, ignoring the spirit and basing decisions on health and safety alone could have devastating results.

In this hope filled book you will learn how to:

• Identify needs and desires to create a quality new life
• Cope with the Depression Era mindset
• Create emotionally sustaining environments to nurture the soul
• Ready and sell the family home
• Ask the RIGHT questions to help divest of treasures
• Manage your energy and spirit throughout the process
• Determine when it's time to consider alternative placement
• Perform the ordinary in a non-ordinary way -- allowing you to preserve and heal family relationships

"A creative and inspiring godsend for helping Mom and Dad transition to the next phase of life. Valuable for caregivers, healthcare professionals, and seniors interested in aging with independence, dignity and grace."
    --Jacqueline Marcell, author Elder Rage, host of Coping With Caregiving radio show

"What a truly remarkable and elegantly written book. The information is relevant for every relocation regardless of the age or circumstances of the client."
    --Sally B. Yaryan, Director, Professional Development & Education; Austin Board of REALTORS (r)

ISBN 978-1-932690-54-5

From Loving Healing Press

CPSIA information can be obtained
at www.ICGtesting.com
Printed in the USA
BVHW041510040521
606416BV00011B/1574